Democracy and the Arts

Symposium on Science, Reason,

and Modern Democracy

MICHIGAN STATE UNIVERSITY

DEMOCRACY
& the Arts

Edited by Arthur M. Melzer

Jerry Weinberger

M. Richard Zinman

Cornell University Press

ITHACA AND LONDON

First published 1999 by Cornell
University Press

Printed in the United States of America

Cornell University Press strives to use
environmentally responsible suppliers and
materials to the fullest extent possible in the
publishing of its books. Such materials
include vegetable-based, low-VOC inks and
acid-free papers that are recycled, totally
chlorine-free, or partly composed of
nonwood fibers.

Cloth printing
10 9 8 7 6 5 4 3 2 1

LIBRARY OF CONGRESS

CATALOGING-IN-PUBLICATION DATA

Democracy and the arts / edited by Arthur M.
 Melzer, Jerry Weinberger, and
 M. Richard Zinman.
 p. cm.
 Essays collected here were delivered as
papers in a lecture series and at a confer-
ence sponsored by the Symposium on
Science, Reason, and Modern Democracy,
held in 1994–1995 at Michigan State
University.
 Includes bibliographical references and
index.
 ISBN 0-8014-3541-2 (cloth : alk. paper)
 1. Arts and society—United States—
History—Congresses. 2. Arts—Political
aspects—United States—Congresses.
3. Democracy—United States—
Congresses. 4. Politics and culture—
United States—History—Congresses.
I. Melzer, Arthur M. II. Weinberger, J.
III. Zinman, M. Richard. IV. Sympo-
sium on Science, Reason, and Modern
Democracy.
NX180.S6D447 1998
700′.1′03—dc21 98-30417

CONTENTS

ACKNOWLEDGMENTS

This is the fourth volume of essays to be published by the Symposium on Science, Reason, and Modern Democracy and the third to be published by Cornell University Press. Established in 1989 in the Department of Political Science at Michigan State University, the Symposium seeks to bridge the gap between the intellectual and political worlds. To this end, it sponsors research, teaching, public lectures, seminars, and conferences on the great debates that shape the politics of contemporary liberal democracies. All the essays collected here were written for the Symposium and delivered as papers during its sixth annual program: a lecture series that ran from November 1994 through April 1995 and a three-day conference held in April 1995. Two of the essays have since appeared elsewhere. Stanley Crouch's essay was published as the introduction to his book *The All-American Skin Game, or, the Decoy of Race* (New York: Pantheon Books, 1995). Greil Marcus's essay appeared in *Common Knowledge* 4 (Winter 1995) and, in an expanded form, as a chapter in his book *Invisible Republic: Bob Dylan's Basement Tapes* (New York: Henry Holt, 1997). We thank these contributors for permission to reprint.

The Symposium's 1994–95 program and, indeed, all its activities were made possible by grants from the Lynde and Harry Bradley Foundation of Milwaukee, Wisconsin; the Carthage Foundation of Pittsburgh, Pennsylvania; the Earhart Foundation of Ann Arbor, Michigan; and the John M. Olin Foundation of New York City. Once again, we are grateful for their support.

For almost a decade, Michigan State's Department of Political Science has extended its hospitality to the Symposium. Throughout this period, the College of Social Science and James Madison College have assisted us in many ways. We thank our colleagues in each of these institutions. In particular, we thank Kenneth E. Corey, dean of the College of Social Science; Brian Silver, former chair of the Department of Political Science; William Allen, dean of James Madison College; Jacqueline Payne, director of development in the College of Social Science; and Alice Behnegar and Nasser Behnegar, the Symposium's postdoctoral fellows for 1994–95, for their special contributions during our sixth year. We also thank Bob Culp and his staff at Riverhouse Graphics for their fine work on our behalf. As always, we are indebted to Karen Battin, Rhonda Burns, Iris Dunn, and Elaine

Eschtruth, the administrative staff of the Department of Political Science. We are especially grateful to Ms. Battin, the Symposium's administrative co-ordinator, for her help in preparing the manuscript for the press.

In addition to the authors whose essays are included in this volume, the following individuals played important roles in the Symposium's 1994–95 program: Susan Bandes, Alan Brangman, Werner J. Dannhauser, Michael Valdez Moses, Arnold Jay Smith, Linda O. Stanford, Norma Thompson, Derek Walcott, and Kenneth Waltzer. We thank them for their thoughtful contributions.

Finally, we thank Roger Haydon and the editorial staff of Cornell University Press.

<div align="right">

A. M. M.

J. W.

M. R. Z.

</div>

East Lansing, Michigan

Democracy and the Arts

Introduction

Arthur M. Melzer, Jerry Weinberger,
and M. Richard Zinman

Human beings are artistic animals no less than political ones. Everywhere, they are found in groups; and everywhere, they are seen to dance, sing, and tell stories. What, then, is the proper relation between our nature as social beings and our nature as artistic beings, between politics and culture?

This curious and difficult question is at least as old as recorded political thought. It was Plato, after all, who maintained that any change in musical tastes must bring a corresponding change in regime. And Aristotle's *Poetics* is a highly political book. From a somewhat different point of view, the ancient Greeks seem the very embodiment of this question, for one cannot contemplate the extraordinary efflorescence of artistic genius among them

without wondering about its connection to their equally remarkable achievements in the realm of democratic politics.

To be sure, among those who take a particularly narrow view of politics or art (or both), the question of their relation may temporarily be lost to view. Think of Hobbes and Locke, for example. But no sooner does one entertain more capacious views than this vital issue reasserts itself, as can be seen in the thought of Rousseau and later in Hegel, Nietzsche, and Heidegger.

Perennial as it is, however, this question has assumed a peculiar form and particular timeliness today. Over the last decade, politics in the United States seem to have taken a "cultural turn." The traditional issues of economic well-being and individual liberty, for example, have ceded ground to issues of ethnic and cultural identity, which largely center on music, language, literature, and other forms of artistic self-manifestation. In a word, our famous obsession with *consumption* seems to be yielding somewhat to a pressing new concern for *expression*.

This cultural turn might also be described, from a slightly different point of view, with reference to the changes wrought by the end of the Cold War. This epochal event marked the end, for the time being at least, of the era of "great politics," in which people entertained transfiguring hopes for what the state might be and do. Yet, it seems that, deprived of such hopes, people have grown more impatient and resentful of the shortcomings of the state as it is, contributing to a widespread demand for political retrenchment and smaller government. Displaced in this way from the political sphere, however, our habitual hopefulness and eagerness for change have not altogether vanished but relocated. In the face of deep political pessimism, there continues to be a widespread feeling of energy and dynamism in many circles. Much of this hope is obviously lodged in the sphere of technology, where computers, the Internet, and the like sustain our faith in the future. But increasingly people have turned with vague new expectations to the realm of culture. It is not that we anticipate great new works of art, perhaps, but great changes in the methods, the media, and the meaning for our lives of art and entertainment.

It is a familiar observation that, over the past half century, some of the deepest changes in American society have occurred at the level of art and entertainment: the rise of television in the 1950s, the development of an almost obsessive interest in popular music in the 1960s, and, more generally, the growing reach and authority of popular culture. These changes continue to progress as audio and video technology advance toward virtual reality, as artistic expression becomes increasingly multicultural, as the distinction between popular and high culture continues to blur, as American popular cul-

ture becomes increasingly global in reach and academically respectable, and as entertainment becomes an ever more central part of modern life. In sum, our post–Cold War malaise, deflating the political realm, seems to be prompting a new focus on culture. Oppressed by intractable social and economic problems — drugs, inequality, the underclass — we tend to believe that if significant change is still occurring, it is not so much because we are finding new ways of managing and controlling our world but because we are inventing new ways of representing, narrating, and experiencing it.

One finds evidence of this cultural turn also in the intellectual and academic sphere, where the most dominant and dynamic force over the past two decades has been postmodernism. This movement may be fairly characterized as "artistic" in a number of respects. It finds its primary home in the arts, including architecture, literature, and literary theory. It involves a sort of epistemological transvaluation that privileges the ways of thinking and valuing characteristic of the aesthetic sphere over those of the technological. Indeed, it tends to regard Western science as one form of narrative, ultimately no more valid and no less artistic than others. In short, the intellectual movement most characteristic of our times involves the long-awaited triumph, not to say revenge, of literary minds over scientific ones.

With the contemporary cultural turn forming the backdrop — adding its unique perspective, interest, and urgency — we turn to examine the traditional question of art and politics. This question may be elaborated, in the American context, in terms of two primary issues: whether and how art serves democracy, and whether and how democracy serves art. These questions will become more concrete through a brief survey of some possible answers.

How art serves democracy is seen differently depending on one's understanding of democracy. The issue was argued most forcefully and thematically by the classical republican tradition, which maintained that the unity and stability of popular government have no sound foundation apart from the civic virtue of the people. Thus, a primary goal of the republic must be to foster virtue through education; and at the core of such education are the arts and entertainments to which the citizens will be exposed from their youth. Art is the essential vehicle for moral education partly because, reaching beyond rational precepts and principles, it is able to appeal to the imagination and emotions and to present concrete models for imitation. Furthermore, art is concerned with beauty, and morality or nobility is largely an aesthetic phenomenon. Through exposure to fine art, the individual becomes high-minded and "cultivated" — that is, a discerner and lover of

beauty, including moral beauty, in all its forms. Thus, of all forms of government, democratic republics have the greatest need for what Schiller termed the "aesthetic education of man."

By contrast, the liberal tradition, which is less enamored of civic virtue and more suspicious of the regimentation and censorship thought necessary to foster it, has tended to deny to art any official, political role. Nevertheless, within liberal states, social critics have often turned to art precisely as a countercultural agent — as one of the few elements of civil society capable of combating the inherent defects or dangers of democracy, especially the tyranny of the majority. Of course, this tyranny has been variously understood. Cultural conservatives, along with Frankfurt School socialists, interpreting it as the tyranny of mediocrity and mass culture, have looked to high art as a counter-egalitarian force, something to lift the people out of vulgar conformity and materialism and raise the tone of democratic life. Alternatively, critics on the feminist and multicultural Left, emphasizing the tyranny of the elite culture over the disadvantaged, have turned to art and entertainment as a counter-majoritarian force: an agent of "subversion" and social change that can shock the majority out of its prejudices, promoting genuine equality and respect for minority cultures. In sum, there have been a great variety of democratic theorists and a corresponding variety of views on the proper role of art. But almost all theorists have agreed that democracy, based as it is on the general tastes and widely dispersed sentiments of the people, is uniquely dependent on art as the social force that can best mold those tastes and sentiments.

But if art is so necessary for democracy, is democracy, over the long term, good for art? Where funding and support are determined by mass tastes and crass commercialism, many have argued, it is hard to see how great art can survive. Moreover, is there not a conflict of principle between the egalitarian ethos of democracy and the elitist ethos of true art and high culture, or between the freedom-loving, rule-hating, iconoclastic spirit of democracy and the disciplined, structured, form-loving essence of artistic greatness? Yet, others argue that, on the contrary, the equality and freedom of democracy, by releasing new talents and creative energies and by encouraging the growth of myriad niche markets, provide the best conditions for artistic achievement.

Or is this whole question, which uses art as a standard to judge democracy, itself questionable? It is based on the problematic assumption that we possess an absolute transpolitical or transhistorical definition of great art. The alternative approach argues that if democracy comes up short by the

traditional standard of art, that indicates a problem with the standard, which is, after all, a holdover from predemocratic times. We need to be more fluid and experimental, to remain open in nonjudgmental readiness for the surprising new ways in which art will manifest itself in our democratic or postmodernist age.

On this approach, which makes the definition of art relative to the regime, the crucial issue is not what happens to great art in a democracy but what constitutes democratic art. Within each artistic genre, we might ask, is there a specifically democratic form? Is rock 'n' roll democratic music? And among all genres, is one the most democratic? Perhaps cinema is democratic art and poetry aristocratic art. More generally, is there a specifically democratic way of comprehending the meaning or purpose of art as such: what art is, what it does, and how it matters to us? In democracies, does art take on the role formerly played by religion, or sink to that of entertainment, or find some new significance and function as yet without a name?

Yet this regime-relative approach also has its problems. Implicitly or explicitly, it tends to assume that whatever art is, it *must* be present, even equally present, in all regimes or historical periods. Why should this be so? Those who raise the question, however, and who claim to see a decline in art are easily denounced as elitist and undemocratic. More generally, this approach encourages us to look at what flourishes in a democracy and to consider that art. But does this not ultimately involve us in a worship of success and majority taste, the final triumph of the ethos of democracy over that of art?

These are among the questions and answers considered in this volume. It opens with essays on the effects of democracy on the arts, in particular on the arts most associated with popular tastes: cinema and the novel. Robert Brustein leads off with a general consideration of the relationship between high and popular culture in democratic America. During the nineteenth century and a good portion of the twentieth, the high and the popular arts often cross-fertilized each other. But with the culture wars of the 1950s — involving such intellectuals as Dwight Macdonald and fought in such periodicals as *Partisan Review* and *Commentary* — a breach developed between high and popular art, with the former ultimately suffering defeat at the hands of democracy and antielitism. The result has not been happy, according to Brustein. We now see the arts debased and politicized from within by multiculturalism, while they are assaulted from without by right-wing moralizing and left-wing social engineering. In the absence of any viable political alternatives to laissez-faire capitalism, we expect the arts to do the work once ex-

pected of political life, and we expect high culture to compensate for the failures of mass society. Until politics and the arts are restored to their own proper spheres, the future does not look good for the arts.

John Simon then reflects on the artistic potential of the most democratic of all the arts, the movies. There is in principle no reason the movies cannot be high art, or even the *Gesamtkunstwerk* envisioned by Wagner. No other form of expression combines more aesthetic elements: storytelling, visual images, music, architecture, sculpture, and fashion. Yet, despite this potential, the movies face three major obstacles to becoming a genuinely high art. First, the manifold elements have so far been too much to handle; the very promise of the movies has so far outstripped the available genius. Second, the movies are subject to the tyranny of the box office. The VCR has not loosened this tyranny of mass taste. On the contrary, the movie audience now thinks of the film as a commodity to be used at home, consumed in bits and pieces according to convenience. Third, those who write about and criticize the movies, and who could thus demand more of them, are themselves the products of the movies, individuals who know everything about films and little about anything else. Ignorant of painting, music, literature, foreign languages, and even life itself, contemporary critics lack the horizons to see what is missing from the movies made today.

According to A. B. Yehoshua, the novel is the most democratic of literary forms: It is open in structure, employs varied voices and perspectives, dwells on the commonplace, gives the reader time to reflect, lays bare its process of creation, and is open to nonfictional materials that reduce the authority of the author. Yet, despite these facts, the greatest novels were written in predemocratic times, and, it must be said, contemporary democracy does not seem to be the most fertile ground for the novel. In recent times democracy has debunked the hero, alleviated the force of such external necessities as poverty and social class, reposed public morality in the journalist, become obsessed with minority interests and ethnic identity, raised the critic to the status of expert, and tended to impose the judgment of the marketplace. Yehoshua warns that if the novel is to be restored to its once great height, then writers of the future will have to resist these tendencies.

The focus then shifts to the most concrete intersections of politics and the arts: the museum and public architecture. Arthur C. Danto considers the changing relation between the museum — or, better, the world composed of artists, artworks, museums, and curators — and the masses for whom that museum exists in democratic times. It was once believed that the great artistic masterpiece could redeem the bleakness of modern life and that the museum could and should function as a kind of aesthetic missionary to the

people. Now, however, a more relativistic view prevails, in which art and museums are seen as reflections of group experience. Pushed to its most extreme conclusion, this new view leads to the doctrine that anything can be a work of art. For Danto, however, a work of art must embody a genuine meaning to which people can connect, a criterion that still leaves room for more traditional standards of excellence and creative genius.

Carroll William Westfall next discusses the transformation in architecture from classicism, which saw its role as primarily public and political, to modernism, which rejected the notion that architecture should be governed by public responsibility and norms. Greek classicism was political but not slavishly so, since it reflected natural truths — eternal grace and harmony — independent from and ultimately critical of any particular political regime. Westfall shows how, from the early Christian era through the Renaissance, classicism gave way to neoclassicism, and architecture began to serve the authoritative principles of political regimes. Neoclassicism reached its zenith — or nadir — in the public architecture of the Third Reich. Actually, the Nazis used two styles of architecture: bombastic neoclassicism, for their showy public buildings, and cold modernism, for their more practical endeavors, such as factories and death camps. American public architecture was long governed by a genuine classicism, but the false interpretation of Nazi neoclassicism as genuine classicism undermined our revered tradition. The ironic result is that we now build wholly according to the modernism that the fascists reserved for their less visible, and often diabolical, activities.

From bricks and mortar, the focus shifts to the least material of the arts: music. In no other genre has America made more original contributions. In "Serious Music," John Rockwell argues gracefully that music is alive and well in contemporary America. Although it is true that market forces and institutional size and rigidity have exerted vulgarizing or stultifying effects, genuine quality has emerged with heartening frequency in the context of our rambunctious democracy. Good musical taste is not threatened by democracy. In fact, genuine good taste may best be generated in a society like our own. Individualism, innovation, and the constant interplay of disparate musical traditions prevent rigid hierarchies and fixed categories, which are the true enemies of musical discernment.

According to Stanley Crouch, jazz is the highest American musical form. But jazz emerged from earthy roots, the blues, which broke the lightness and maudlin character of American popular music. For Crouch, jazz is American in a deeper sense than mere provenance: It reflects the very essence of our constitutional democracy. Eschewing cheap sentimentality and superficial rebelliousness, jazz and the blues combine the hopeful spirit of redemption

with a realistic appraisal of human frailty and folly, just as does our Constitution. And like the Constitution, jazz requires improvisation within norms that are not established in some prior and rigid conception but that develop in the playing, in the doing. Blues and jazz grew out of the African American experience; however, their true greatness rests not in the ties to this experience but in their "epic frame of emotional and intellectual reference, sensual clarity, and spiritual radiance." With its hope and its realism, its reliance on individual virtuosity, and its pragmatism, jazz speaks to the heart and soul of our democracy.

Greil Marcus next offers an evocative and poetic reflection on American folk music. Focusing on Harry Smith's 1952 *Anthology of American Folk Music*, and especially on Clarence Ashley's strange performance of "Coo Coo Bird," Marcus tells us that folk is hardly the simple music of the plain folks, let alone a mere vehicle of protest for the downtrodden. Rather, American folk music expresses a world of strange images and contradicting possibilities: rebelliousness and fatalism, violence and redemption, cruelty and compassion, magic and religion — the chaotic sea of human experience on which majoritarian power and politics always float. By revealing this world to the broader and established culture the great folk artists soared high and broke the chains that bound them to some parochial locale. Folk music is about the "old, weird America," but in fact it tells a story that, one should hope, still rings true.

In our hyperdemocratic culture, the claim that *everyone* is an artist should come as no surprise. Nowhere is this claim more alive than in the world of fashion, the aesthetic realm in which each and every one of us can make a "statement." Anne Hollander shows how the world of fashion —first for men and much later for women — reflected the rise of modern democratic life and values. The ready-to-wear man's suit evolved slowly as an expression of rebellion against court dress. Ultimately combining classical naturalism and the dress of the rural and working classes, the man's ready-to-wear suit marked the egalitarian victory of abstract and stable elegance over the sensuous unpredictability of aristocratic clothing. Aristocratic caprice flourished much longer in women's fashion, and it survives in the world of haute couture. In recent times, the man's suit has become the formal symbol of democracy — the garb of the lawyer and the diplomat —while elegance in all other dress is increasingly influenced by plebeian hints of violence and danger. In democratic fashion, there is a relentless movement from high to low and from the safe and staid to the daring and lawless.

If fashion is art and all are artists, then surely we must live in times when traditional views of aesthetic experience have seen better days. From classi-

cism to modernism, the various aesthetic doctrines all maintained that art reflects the single, eternal truth about life. In the postmodern age, such confidence is disparaged as naive, dangerous, or both. Gianni Vattimo defends the postmodern view. Our time is characterized by the "end of metaphysics," the end of the belief that some natural and eternal truth orders our moral and political lives, and it is mass communication that makes this theoretical skepticism the commonplace possession of society as a whole. In such a world, no work of art can be taken to disclose authoritative truth. For Vattimo, this mass-market relativism need not produce debasing vulgarity or totalitarian violence. We must be careful that our judgments of mass society not presume metaphysical standards no longer operable, and we must accept that the babel of mass society can be countered only by encouraging more babel. It is possible that commonplace relativism can lead to what Vattimo calls a pure exceptionalism: the near-religious gravity that results when individuals come to see that they live only on the foundation of their own utterly free choice and responsibility.

If postmodern culture is filtered through mass media, then television must play an important role. According to Martha Bayles, our opinions about the potential of television as an art form have been determined by two intellectual trends dating from the 1950s: communications theory and the Marxist critique of mass society, each of which has a pessimistic and an optimistic strand. For communications theorists, television is the vehicle for either the destruction or the salvation of civil society, the voluntary associations and institutions that mediate between the isolated individual and the modern state. For Marxists, especially of the Frankfurt School, television and the mass media in general are either the means to establish technological totalitarianism or, as was first and foremost argued by Walter Benjamin, the technological means that can liberate art from its mystifying and thus enslaving fetishism. This latter view is the basis for the postmodern perspective that art and the aesthetic as traditionally understood are now dead. According to Bayles, the Benjaminite view that technological reproducibility has demystified art depends on a wholly false picture of the actual arts. Many of these arts — not least among them the theater — depended on reproducibility from the start. Herein lies a lesson for our understanding of television, which incorporates many of the traditional art forms and is thus much less novel, and more capable of becoming real art, than we think.

The book closes with Paul Cantor's explanation of how postmodern irony and relativism grew out of modernist certainty. At first glance modernism seems confidently rooted in the truths of functionalism, realism, and utilitarianism. Thus, modernism was, in Gianni Vattimo's terms, the last meta-

physical dogmatism. But all along, says Cantor, modernism had one foot in nihilism — in the "truth" that all cultures are grounded on illusion. The "truth" disclosed by modernism was that there is no truth regarding the ways of life, and so from the beginning modernism contained the seeds of its own demise. It was inevitable that the modernist aesthetic should eventually lose its nerve, its sense of mastery and authority, and give way to the post-modern and hyperdemocratic aesthetic that eschews all hierarchy. For Cantor, Samuel Beckett's *Waiting for Godot* captures life at this historical moment, when the principle of equality has replaced all other standards of morality and evaluation. In this terminal age, "difference" is at once all and nothing: all, since there is no rank order; nothing, since no one form of life can stand out from the rest. For Beckett, modern freedom has been bought at a great price: In the world of postmodern relativism, by losing all sense of what is worth dying for, people lose all sense of what to live for.

Democracy and Culture

Robert Brustein

More than 150 years ago, Alexis de Tocqueville wrote in *Democracy in America*:

> I do not believe that it is a necessary effect of a democratic social condition and of democratic institutions to diminish the number of those who cultivate the fine arts, but these causes exert a powerful influence on the manner in which these arts are cultivated. Many of those who had already contracted a taste for the fine arts are impoverished. . . . The number of consumers increases but opulent and fastidious consumers become rare. . . . The productions of artists are more numerous, but the merit of each production is diminished. . . . *In aristocracies, a few great pictures are*

produced; in democratic countries a vast number of insignificant ones. [Emphasis added]

These Delphic remarks, inscribed after a visit to our shores in the early years of the Republic by a foreigner who is still among the most prophetic commentators on American life, in effect defined the problems that serious or high culture would henceforth encounter in an increasingly massified and industrialized society. What Tocqueville prophesied was that among the sacrifices a political democracy might be forced to make on the altar of egalitarianism would be a civilization of real importance. American culture, in his view, would become flooded with unimportant forms of expression, genuine works of art being rare and often unacknowledged, and artistic standards would be determined not by the intrinsic quality of the art but by the extrinsic size of the audience. Put another way, the evolution of American culture would be based on a continuing tension, and later on a state of hostility, between the minority expression called high art, embraced by a decreasing number of "fastidious consumers," and what constituted the culture of the masses.

Tocqueville, though an aristocrat himself, was highly partial to the new political experiment being tested in this country, but he yearned for a system that could join a democratic politics with a meritocratic culture. He correctly saw that, without access to the civilizing influence of great artworks, the voting majority in this country was bound to remain benighted. Only art and education could provide the synthesis needed to evolve a more enlightened and cultivated electorate. There were times when this synthesis looked achievable. In the nineteenth century, certainly, high art and popular culture seemed to coexist in healthy, if often separate, compartments. Not only were Hawthorne and Emerson traded in the same bookstalls as penny-dreadful novels, but also traveling troupes performing Shakespeare, admittedly in bowdlerized versions, attracted wildly enthusiastic audiences from the most primitive frontiers.

For a period in the twentieth century, high art and popular culture were even to enjoy a brief honeymoon. Certainly, serious American artists in the first half of this century drew great infusions of energy from indigenous American forms. Try to imagine Gershwin without the influence of black music, or Copland without access to Mexican and Latin American dance rhythms, or Bernstein without the influence of jazz, cabaret, and rock. T. S. Eliot's metrics, like those of e. e. cummings, owe a lot to vaudeville and the music hall: His dramatic fragment, *Sweeney Agonistes*, even climaxes in a minstrel show. It is also true that most twentieth-century American novels,

beginning with those of John Dos Passos, have been deeply indebted, in their episodic structure and cinematic sweep, to Hollywood movies. And of course Robert Rauschenberg, Jasper Johns, and Roy Lichtenstein, indeed virtually everyone associated with the Pop Art movement, have been indebted to such popular visual forms as cartoons, comic strips, newspaper print, and advertising.

The channels of exchange have flowed the other way, too. Neither American advertising nor the world of fashion would have been able to generate many original ideas without open access to the iconography of high art. No sooner does a new visual artist emerge in this country than his or her breakthroughs are appropriated by Madison Avenue and Seventh Avenue. Similarly, the history of the movies would have been sadly impoverished had studios been unable to feed off contemporary literature and theater. So intimate were the relations between high and popular culture, in fact, that it was sometimes difficult to determine whether an artist like Andy Warhol belonged more to bohemia or suburbia, whether his true home was a Greenwich Village factory or the creative department of Batton, Barton, Dustine, and Osborne, a Madison Avenue advertising agency. Then again, such respected figures as F. Scott Fitzgerald, William Faulkner, and Nathanael West, among countless other American writers — not to mention such expatriate Europeans as Bertolt Brecht and Aldous Huxley — spent almost as much time huddling in script conferences in Hollywood as bending over writing desks in their studies.

The interdependence of popular and high art in our country had both positive and negative effects. One obvious advantage was economic. The commercial system subsidized a lot of needy artists whose royalty incomes would have normally been insufficient to pay for typewriting paper. It is true that this system also distracted these artists from their real work, though not as much as commonly assumed. Fitzgerald wasted his time writing such third-rate movies as *Winter Carnival*, but his motion picture studio experience also inspired a glorious Hollywood novel, *The Last Tycoon* (which in turn inspired a bad movie). It could be argued that working with such popular forms as the detective novel, science fiction, and the screenplay provided a stream of energy that kept high culture hardboiled, vigorous, and vital. Still, the relationship between the artist and the commodity culture was always uneasy. And it soon began to sour, curdled by a number of intellectuals who were to regard the participating artist as a sellout or, worse, a collaborator in a mass art that was having a brutalizing effect on American minds.

The fear that popular culture would absorb high art had always worried social commentators, from Tocqueville on, but that fear intensified during

the culture wars of the 1950s. At that time, some may remember, such crusading highbrows as Dwight Macdonald began protesting the power of "Masscult" and "Midcult" to debase and overshadow "High Cult" (even Macdonald's terms were influenced by the mass media), while their opponents, usually representatives of the value-free social sciences, were defending popular or mass culture as the more democratic art. And more democratic it was if measured by statistical instead of qualitative criteria — as were the commodities most often consumed by the masses.

A great poet like Walt Whitman was also capable of believing in the possibility of a democratic American art, but somehow it was more conceivable in the nineteenth century to imagine democratic vistas with unclouded horizons. In our time, this has become increasingly difficult. The cultural wars of the 1950s, raging in such periodicals as *Partisan Review* and *Commentary*, resulted in a hostile backlash against intellect, art, and high culture, eventually spreading, as we shall see, to include the whole construct of Eurocentric civilization and its "dead, white, male" artists and intellectuals, as they were scornfully identified. It was a time when competing special-interest groups demanded recognition for their own forms of cultural expression, often identifying traditional and avant-garde art as " elitist," to use the populist epithet that was henceforth to control the terms of the debate. This action culminated in a major retreat — the surrender of most of the standards and values that make a serious culture possible. I do not suggest that inspired artists were no longer able to function in America, but what was once a hospitable climate for their work was turning mean and indifferent. Native talent may be as abundant as ever, but never in recent years has it been so inadequately evaluated, published, produced, disseminated, and supported.

Although the ongoing war on the arts contains important economic components related to the business cycle, its thrust has been mainly political. Antiart forces advance by means of a three-pronged incursion — from the right, left, and center of the political spectrum, all claiming endorsement from the majority. One of the homes for these incursions is the National Endowment for the Arts (NEA) — and that is curious and sad, since in its early years this agency did a lot to maintain and encourage artistic standards. Under the Johnson and Nixon administrations, when the NEA was run first by Roger Stevens, later by Nancy Hanks, and the total budget never rose above $100 million, the agency was not yet significant enough to be treated by Congress as a political football. After the Carter administration appointed the populist Livingston Biddle as chairman, however, the emphasis of the NEA shifted from the support and encouragement of serious American art to its "dissemination," which is to say from the artist to the public. Simulta-

neous with this change, after the NEA budget began to inch toward the current $176 million mark (where it has been flat or shrinking since 1980), Congress began to make serious inroads into NEA decisions. Biddle explained his populist stance by announcing that "the voice of the constituent is the one most clearly heard by Congress," which was his way of saying that instead of supporting the artist, the NEA was now courting the voter and those who represented him.

In short, the National Endowment for the Arts, in company with its sister agency, the National Endowment for the Humanities, was now in the process of being "democratized." But that process went deeper than the intervention of pressure groups, vested interests, and meddling politicians. It was the very politics of consensus American democracy that began to influence the policies and appointments of these federal agencies. Once fully professional and oriented toward the artist, these agencies were beginning to spread their relatively meager monies to educationalists, audiences, and amateurs as well. This change was inspired by the essentially political assumption that any resources generated by the people should directly benefit the people, as if there were not enough precedents — in medical, space, and scientific research — for identifying and subsidizing those best qualified to make advances in specialized fields. The concept of excellence and expertise — Tocqueville's meritocratic achievement within a democratic society — was perfectly in harmony with our founding ideals. Indeed, it informed the constitutional notion of an electoral college, a group of presumably qualified intelligent people who were elected by the voting majority to select the chief executive. It was a concept now being abandoned in favor of such extra-artistic concerns as advocacy, arts appreciation, geographical distribution, dissemination through the media, and, later, multiculturalism and cultural diversity.

The democratization — more accurately, the *politicization* — of the NEA exploded with full force after President Bush appointed John E. Frohnmayer as chairman. It was then that controversial grants to Robert Mapplethorpe and Andres Serrano, among others, aroused the fiery wrath of such paleolithic conservatives as North Carolina senator Jesse Helms, who took the position that the government should not fund any artistic work offensive to the majority. Such was Helms's power that he even persuaded Congress to impose content restrictions on grantees in the form of a new obscenity clause that all applicants were obliged to sign. To his eternal credit, the late Joe Papp declared that he was willing to sacrifice NEA funding rather than endorse this document. And a successful class-action suit by Bella Lewitzky resulted in the provision being struck down as unconstitutional.

The attack on the arts from the right of the political spectrum was basi-cally moralistic. "If someone wants to write nasty things on the men's room wall, the taxpayers do not provide the crayons," said Helms, whose disdain extended to all forms of modern art that did not resemble the pastoral North Carolina scenes on the walls of his office. A letter signed by twenty-seven senators and written on the stationery of Senator Alphonse D'Amato of New York endorsed Helms's position: "This matter does not involve freedom of expression. It does involve whether 'taxpayers' money should be forced to support such trash."

"It is not the function of art," another political critic affirmed not too long ago, "to wallow in dirt for dirt's sake, never its task to paint men only in states of decay. . . . Art must be the handmaiden of sublimity and beauty and thus promote whatever is natural and healthy. If art does not do this, then any money spent on it is squandered." This comes not from the senatorial chambers of Jesse Helms or Alphonse D'Amato but from a speech made in Nuremberg by Adolph Hitler, inveighing against "degenerate" modern art. Clearly, those who pretend to speak on behalf of the "people" eventually end up telling the people what they should think.

Frohnmayer not only punished those institutions responsible for the Mapplethorpe and Serrano shows. He canceled a grant for a New York art exhibit because he found the *brochure* too political (it was blistering in its criticism of legislators like Helms). Then an odd thing happened. As Frohn-mayer matured in office, he was converted into a born-again civil libertar-ian, defending the rights of beleaguered artists so vigorously that President Bush, yielding to pressure from Pat Buchanan, fired him. Frohnmayer's tem-porary successor, Ann-Imelda Radice, was, if anything, even more respon-sive to right-wing pressures on the arts. But despite her need to placate the conservatives, it was under her brief regime, paradoxically, that populist policies gained the greatest purchase at the NEA. First, she declared that the agency would henceforth be more responsive to majoritarian or popular de-mands when handing out money, thus tainting the originally countermarket strategy of the NEA with marketplace values. Then, she made it official pol-icy to fund every species of ethnic and racial expression, regardless of its in-trinsic value as art.

The attack on the arts from the politically correct Left proved just as dis-turbing in its way as that from right-wing minions of moral correctness. And it is significant that both sides claimed the endorsement of the democratic majority. For the Right, this usually meant those clean-cut Americans who sip vanilla sodas in Norman Rockwell paintings and Thornton Wilder plays, when they are not walking a dog named Spot down a brightly lit Main Street.

For the Left, the majority was represented not by white Protestant Anglo-Saxons but by those previously excluded from the cultural banquet, a diverse mixture of racial, sexual, and ethnic constituencies summed up by the catchwords "multiculturalism" and "cultural diversity." What often occurs under the umbrella of these terms is less a widening than a narrowing of artistic possibility — "a violent turn," as Roger Kimball noted in a *Partisan Review* symposium, "against Western liberalism and its tradition of rationality, respect for individual rights, and affirmation of a common good that transcends the accidents of ethnic and racial identity."

The cultural product of this tribalist approach could sometimes be regarded as art. More often, it was a form of handicrafts. An NEA brochure proudly boasted of its financial assistance to "Hmong needlework, coastal sea-grass basketry, southeast Alaska native dance, American Indian basketry and woodcraft, Pacific Island canoe building and Appalachian banjo playing." I am surprised it left out Yoknapatawpha County bear hunting, Venice Beach snorkeling, and hillbilly belly scratching.

No sensible person denies that we live in a diverse society, or that works of art can be created by people of every color and persuasion. It is essential that talented artists be honored regardless of origins; intercultural exchange can be a source of great artistic refreshment. Identifying and encouraging such talent is precisely what Martin Luther King meant when he said that people should be judged by the content of their character and not by the color of their skin. But he was talking about equality of opportunity, not equality of result or proportionate representation. Artistic achievement is not, like the right to vote, guaranteed to every American. It must be earned. Multicultural grantsmanship sometimes helps increase the visibility of deserving minority artists, especially in the performing arts, which is a highly welcome move. But indiscriminate awards, made without regard for quality, are an extension of our passion for social engineering. As H. L. Mencken wrote: "Every third American devotes himself to improving and lifting up his fellow citizens, usually by force; the messianic delusion is our national disease." Trying to compensate for the failures of society in an area least qualified to be an avenue of social change, the multiculturalists threaten to sacrifice hard-won achievements for the sake of evangelical gestures.

What accounts for this confusion of realms? I believe it results from our incorrigible tendency to muddle art and politics. For a number of years now, American culture has been asked to shoulder obligations once considered the exclusive responsibility of the American political system, which is another way of demanding that the arts be "democratized." This activist impulse in culture has increased exponentially in recent years, one suspects be-

cause legislative solutions to the nation's social problems have been largely abandoned or tabled. Instead of developing adequate federal programs to combat homelessness, crime, disease, drug abuse, and racial tension, our governing bodies have responded with depleted federal subsidies, dwindling programs for the poor and unemployed, congressional boondoggles, and other instances of systemic inertia. Aside from the debates over competing health care programs, and a welfare reform plan that has managed to reduce rather than increase support for the poor, the most significant action advanced for solving America's more urgent social needs has been to increase the cultural representation of minority groups.

This strategy for ignoring social problems clearly intensified during the Reagan-Bush administrations, with their neglect of economic inequities and indifference to social injustice. The powerful conservative revulsion against traditional liberalism led not only to a restructuring of national power but also to a redistribution of the country's wealth, while the burgeoning deficit and a growing taxpayers' revolt frightened lawmakers away from passing any incremental social programs. Add to these political and economic retrenchments a new ideological vacuum created by the collapse of the Soviet Union. The failure of communism discredited not only Marxist economic theory but also the related though considerably milder platforms of socialism, liberal humanism, the welfare state, the New Deal, the Great Society, and perhaps even the whole construct of traditional Democratic Party politics. For the first time in more than a hundred years, there exists no viable theoretical alternative to laissez-faire capitalism, with its unregulated greed and unequal income structure, no collective idealism to temper unrestrained individualism, no Marx or Keynes to dispute with Adam Smith or Milton Friedman, not even a national publication (if we discount the intellectually impoverished *Nation* and *Village Voice*) that still gives voice to opinion on the radical Left.

This is not the place to debate the strengths and weaknesses of opposing political ideologies. What I am arguing, rather, is that the weakening of the political Left and the absence of a genuine political dialectic have led to paralysis in an arena of social action usually serviced by legislation. It is because of this inertia that the nonprofit cultural sector, which is to say high art, is being pressed into compensatory service, as a way of sustaining hopes disappointed by the political system. The result is a scene that would be comical were it not so disheartening — a limping gaggle of have-not geese honking loudly for the same small handful of feed. Not only is America's underclass crippled by poverty and hopelessness but also federal money for artistic projects remains pitifully inadequate by comparison with other civi-

lized countries, while the NEA continues to stumble on the brink of extinction every time it invests $200 in a controversial grant. Staggering under massive deficits, and teetering on the edge of bankruptcy, our nonprofit cultural institutions are nevertheless being asked to validate themselves not through their creative contributions to civilization but on the basis of their community services. Once again, Alexis de Tocqueville described this condition when he predicted that serious art in the United States would always be asked to justify itself on the basis of utilitarian criteria: "Democratic nations," he wrote in *Democracy in America*, "will habitually prefer the useful to the beautiful, and they will require that the beautiful be useful."

Current pressures on the arts to be useful cause funders to measure their value by outreach programs, children's projects, inner-city audience development, access for the handicapped, artists in school programs, and so on, in addition to demanding proof of progress in achieving affirmative action quotas among artistic personnel, board members, and audiences. This social view of culture has some undeniable virtues, and there are unquestionably deep humanitarian impulses governing the new philanthropy. Given the limited resources available for both social and cultural programs, the civic-minded agencies that disburse grant money no doubt sincerely believe that a single dollar can fulfill a double purpose, just as many contemporary artists would prefer their works to function not only as forms of self-expression but also for the public good.

Looked at in the long perspective, however, the push to transform culture into an agency of social welfare is probably doomed to failure. To demand that creative expression be a medium for promoting minority self-esteem may seem like a thrifty way to respond to the urgent needs of the underclasses. But whatever the immediate effects of such well-meaning civic experiments, they are not long lasting. Culture is not designed to do the work of politics; nor will promoting inspirational role models even begin to compensate for the unconscionable neglect of arts education in our schools. No wonder inner-city children prefer rap or salsa when no teachers have been employed by the system to expose them to serious theater, art, or music. No wonder the infrequent visit of a performance artist or a dance company on a grant often leaves these children baffled and sullen when no money exists to stimulate their imaginations. Anything short of daily arts education in the public school curriculum will register as little more than tokenism. Indeed, cosmetic procedures may even be exacerbating the problem by varnishing its surface instead of probing its roots.

Whatever the fruitless effect on education, philanthropy's insistence on administering nonprofit funding according to utilitarian rather than tradi-

tional aesthetic criteria is almost certainly likely to doom the arts as we know them. It is very ominous, indeed, that the word "quality," the standard by which art has habitually been measured, is now avoided in most funding circles, being considered a code word for racism and elitism. This is true not only in federal, state, and city cultural agencies, where politics dictates that the arts will be subject to populist and egalitarian pressures, but also in most private funding organizations. With a few lonely exceptions (most notably the Andrew W. Mellon Foundation), large and small private foundations now give their money not to general support as in the past but overwhelmingly to special programs conceived by the officers of the foundation. Active rather than receptive in relation to the choices of artists and the programming of artistic institutions, the foundation world is now engaged in what I have elsewhere called "coercive philanthropy." Artists and institutions are obliged to follow the dictates of officious program directors or be exiled to an economic gulag.

The Lila Wallace–Reader's Digest Fund, for example, which handed out $45 million to the arts in 1993, describes its three-year program for resident theaters in the following manner: "To expand their marketing efforts, mount new plays, broaden the ethnic makeup of their management, experiment with color-blind casting, increase community outreach activity and sponsor a variety of other programs designed to integrate the theatres into their communities" and to encourage "dynamic interactions between artists and communities . . . to develop new audiences . . . [and] to address the interests of children and families." These are all benevolent social goals, but they are also all peripheral to the true work of most theaters.

What the foundation fails to "expand" or "broaden" or "sponsor" is an artistic goal. As a result, the great preponderance of Wallace funds each year, to quote a few typical citations from recent grants, goes to increasing "the African-American audience" or "doubling the number of Asian Americans in the overall audience" or "increasing the number of Latino theatregoers to 40% of the audience" or deepening "the involvement of . . . Latino immigrants, emerging Latino business and professional leaders" or attracting "new theatre audiences from . . . Hispanic concert-goers and African-American concert-goers" or diversifying "through the addition of actors of color . . . with the input of its new African-American artistic associate" or including "greater promotion within the African-American community" or developing "new audiences from New York City's Asian-American communities," and so on. In 1993, only one award went to an institution proposing a project with any artistic dimensions, and that one was designed to broaden the base of children's audiences.

Similarly, the Rockefeller Foundation, once among the most enlightened supporters of artists and artistic institutions in America, now disburses about $14 million annually, mostly to humanities programs but also to arts projects indistinguishable from its Equal Opportunity and Social Science Research grants. Rockefeller's Arts and Humanities Division describes its mission as encouraging scholars and artists "whose work can advance international and intercultural understanding in the United States . . . extending international and intercultural scholarship and increasing artistic experimentation across cultures." It should be noted that "international and intercultural understanding" no longer includes any understanding of Europe. To judge by the grants, the phrase refers almost exclusively to African, Asian, and, especially, Hispanic countries and cultures. As a result, Rockefeller's three granting categories advance such noble objectives as "Extending International and Intercultural Scholarship," "Fortifying Institutions of the Civil Society," and "Increasing Artistic Experimentation Across Cultures," while the grants go almost overwhelmingly to African American, Native American, Asian, and Latino artists or institutions engaged in social objectives. (In 1993, Rockefeller's largest grant, amounting to $925,000, was awarded to the "Intercultural Film/Video Program" in order to enable visual artists not to experiment with new visions or to advance film and video techniques but, rather, to "create work that explores cultural diversity.") One is not surprised to learn that Rockefeller is considering a new play initiative designed to fund works that deal with an issue the program directors call "conflict resolution." Only heaven will help the playwright with other issues in mind.

As for Ford, whose enlightened arts division under W. McNeill Lowry was largely responsible for the massive explosion of American nonprofit dance, theater, symphony, and opera companies since the 1960s (including many racially diverse institutions), support for cultural projects has now slowed to a trickle, and the lion's share of program budgets goes to urban and rural poverty, education, governance and public policy, and international affairs. This is entirely understandable, given such pressing needs at home and abroad. But once again a radically reduced arts budget goes to institutions devising projects similar to the foundation's civil rights and social justice programs. Ford describes its arts division as pursuing two goals — "cultural diversity and strengthening creativity in the performing arts"— and adds: "Both goals have become increasingly interconnected, particularly since mainstream arts institutions have become more interested in culturally diverse art and audiences in recent years. At the same time, much of the new performing art the Foundation has supported has been that of minority artists and arts organizations."

One might question whether this new "interest" on the part of mainstream arts organizations, genuine though it may be, is as obsessive as reflected in recent foundation grants. Has this passion for culturally diverse art arisen spontaneously, or is it the result of external pressures, notably a desperate need to qualify for subsidies? Whatever the answer, there is no doubt that a lockstep mentality is ruling today's funding fashions, in which the flavors of the year (or decade) continue to be cultural diversity and multiculturalism. Examples can be furnished from any number of private foundations, not to mention federal, state, and civic funding agencies, and from such private corporations as AT&T.

Even the John and Catherine T. MacArthur grants, originally devoted to identifying and rewarding American "genius" regardless of race or ethnic background, recently developed a largely multicultural agenda under its program director, Catharine Stimpson. As a result, of the four grants awarded to performing artists in 1995, three went to people of color, and not all four could be characterized as geniuses. Arthur Mitchell of the Dance Theatre of Harlem and Bill T. Jones of Bill T. Jones/Arnie Zane & Company would be on anyone's list of deserving artists, and I suppose a case might be made for anointing Jeraldyne Blunden, who founded the African-American Dayton Contemporary Dance Company. But the fourth grantee, the white male, is listed as a "theatre arts educator," and his qualification for genius was that he founded "a theatre company for inner-city children of Manhattan's Clinton Neighborhood and the Times Square welfare hotels." This project is no doubt of significant value, and its director deserves support, recognition, and funding. But the question remains: Was this award given to a "genius" or to a deeply committed social worker?

It is difficult to criticize such philanthropy without being accused of insensitivity to minority artists. So at the risk of stating the obvious, let me once again emphasize my view that there is no shortage of truly accomplished talents of every race, sex, and ethnic background in the United States. At the same time, I believe I speak on behalf of qualified artists of every race, sex, and ethnic background when I question the *criteria* under which such grants are being awarded. It may be just another form of plantation paternalism to bestow largesse on minority artists regardless of their abilities, to use different yardsticks for artists of color, to reward good intentions rather than actual achievements, for self-esteem is rarely achieved by means of abandoned standards. It may also be a serious error to assume that all the foundation dollars being poured into developing inner-city audiences are successfully democratizing American culture. What we need is some rigorous documentation regarding the effect of these grants. And, in-

deed, a survey commissioned by the Lila Wallace–Reader's Digest Foundation suggests that what typically attracts minority audiences to the arts is not mass infusions of audience development money, or even special racial or ethnic projects, but the *quality* of the art itself.

Whatever its success in the community, the new coercive philanthropy is having a demoralizing effect on artists and artistic institutions. The entire cultural world is bending itself into pretzels to find the right shape for grants under the new criteria. In 1995 a report issued by the American Symphony Orchestra League threatened the constituency of this service organization with loss of funding if orchestra programs did not start to "reflect more closely the cultural mix, needs, and interests of their communities." To accommodate cultural diversity, in short, these institutions were being pressured to include popular, folk, and racial-ethnic expressions in their classical repertoire, as if there were not sufficient outlets (and acclaim) for this music in the popular culture. No doubt in response to this offensive ultimatum, a "Diversity Initiative Consultant," hired by the management of a major symphony orchestra, issued a memorandum to that symphony's "family" in the form of a questionnaire designed to induce "cultural awareness" and "to elicit your perceptions of the organizational culture and diversity of cultures in your work environment."

The dopey questions were framed in a benevolent enough fashion ("Have you realized that your own upbringing was not the same as other races or cultures?" "Have you avoided people of a different or certain racial, ethnic, or cultural group?"). But I trust I am not alone in detecting a certain Orwellian cast to these diversity experts who roam the corridors testing everyone's sensitivity to racial slights. In the corridors of culture, they begin to inspire an atmosphere of fear, constraint, and mistrust. It may not be long before anxious employees, prodded by the batons of vigilant thought police, will be fingering fellow workers for neglecting to display sufficient "tolerance" or "sensitivity" as measured by such politically correct indicators.

It is not surprising, at a time when tribalism has begun to shatter our national identity, when the melting pot has turned into a seething cauldron, that philanthropy should rush to the aid of racial, ethnic, and sexual groups clamoring for recognition through the agency of creative expression. But in order for a group with special interests to achieve power, influence, strength, and unity, it must display a common front. And this often means suppressing the singularity of its individual members and denying what is shared with others, neither of which is a good condition for creating the idiosyncrasy and universality associated with great art.

What seems to get lost amid this separatist clamor for cultural identity is

that the most pressing issue of American democracy today is not race or gender or ethnicity but what it has always been — the inequitable distribution of the nation's resources, which is an issue of class. This makes our concentration on culture as an open door to equality and opportunity look like a diversion from the pressing economic problems that afflict our more indigent citizens. It reminds me of how, beginning in the 1950s, our attention was distracted from the depredations of an unregulated economy and focused on the evils of network television. As I observed thirty years ago in "The Madison Avenue Villain," since the whole purpose of the mass media was to peddle consumer goods, to hold the account executive or the television packager responsible for brutalizing mass culture put the blame on the salesman for the defective products of his company. In short, by concentrating on the "wasteland" of mass culture instead of the economic necessities driving it, we were effectively blocking a remedy, which could only be political.

Much the same seems to be happening today, except that while we are still blaming the failures of our mass society on mass culture (consider the debates over television violence), we are now asking what remains of high culture to compensate for the failures of our affluent society. Yet, by forcing artistic expression to become a conduit for social justice and equal opportunity instead of achieving these goals through the political system, we are at the same time distracting our artists and absolving our politicians. But it seems to be an American tradition to analyze a problem correctly and then come up with the wrong solution.

The right solution, I believe, will be formulated only when we recognize that we are all members of the same family and that the whole society bears responsibility for the woes of its more indigent relatives. This means responding to unemployment and its consequences in crime and drug abuse with a strong legislative initiative such as that employed in the 1930s by Roosevelt and the New Deal — a new civilian conservation corps to turn guntoting inner-city youth into skilled artisans repairing roads and building bridges, a reformed welfare system that emphasizes the dignity of work, a public education system devoted to teaching subjects and developing skills rather than promoting diversity and managing crowd control, and, yes, a federal works project to provide opportunities for anyone who seeks employment, including artists. All this, of course, takes pots of money, but we Americans, for all our complaining, are currently the most undertaxed citizens in the Western world, and we are in a deepening crisis that needs attention. It will not be resolved by demolishing the fragile culture we still have.

But perhaps that culture has already been demolished. Certainly, the

High Cult and Mass Cult debates could not be held today. The once proud and confident highbrow has fled the field, pursued by a hail of arrows shaped in the form of derisive epithets. And the most cunning of these is the word "elitist," now shaped to mean aristocratic or exclusionary when its etymology simply refers to leadership. Without an elite in the arts, we have no leaders, which is to say we have no vision, which is to say we have no arts.

Is Tocqueville once again confirmed in his belief that a meritocratic art cannot survive in a democratic society? He is certainly right that the concept will always cause tensions. Each age chooses different weapons for its war on the serious arts, but the nature of the war remains the same. Have you ever noticed how the few remaining radio stations that broadcast classical music tend to be drowned out by the stronger signals of rock? That seems to me a metaphor for the fate of high art in our democratic society. It is not what our founding fathers envisioned when they conceived the American republic. It is not the way to celebrate American pluralism. It is not a healthy sign for American democracy.

Movies: The Democratic Art?

John Simon

The first problem that confronts a critic discussing movies as a democratic art is: Are movies an art in the first place? There have been writers on film — I hesitate to call them scholars or critics — who professed to doubt that it was an art. Hollis Alpert, for instance, was such a one. He found it safer and easier, I suppose, to write his stuff if he could evade responsibility for it by pretending that he was writing only about an entertainment. That, to be sure, was in the old days when he was ghostwriting Lana Turner's memoirs; by the time he progressed to a book about Fellini, he may have changed his tune.

But even the most celebrated and beloved American film critic was uncomfortable with the notion of film as art. I am referring, of course, to Pauline Kael. She was (I speak of her in the past only because she has stopped writ-

ing) too smart to deny movies the status of art, but she worried about what people, critics included, understood by the term "art." She was always afraid that someone like Dwight Macdonald would insist on movies becoming "high art," a notion she abominated; and she was equally concerned that people such as Jonas Mekas and Susan Sontag would insist that movies had to become experimental or far-out or weird — or just slapped together by cheeky amateurs and pseudo-artists like Andy Warhol and Jack Smith.

As a result, we find Kael writing in 1964: "In this country, respect for High Culture is becoming a ritual." How wrong she was! Almost thirty-five years later — except in a few artistic, academic, or intellectual enclaves, and certain snobbish megalopolitan milieus — no one gives a damn about high culture, and most people would be hard put even to define it. And those few who could probably would keep mum, lest they commit a sin against political correctness in our hapless society, which has a great deal of "multiculture" and virtually no culture.

Miss Kael continued (in the introduction to her first collection, *I Lost It at the Movies*): "If debased art is kitsch, perhaps kitsch may be redeemed by honest vulgarity, may become art. Our best work transforms kitsch, makes art out of it; that is the peculiar greatness and strength of American movies." She went on to instance Huston's *The Maltese Falcon* as "a classical example." I am willing to concede that an exceptional thriller is a humble sort of art. But we part company when she writes: "Our first and greatest film artist D. W. Griffith was a master of kitsch: the sentiment and melodrama in his films are much more integral to their greatness than the critics who lament Griffith's lack of mind [!] perceive."

Yet, I am afraid that is what Griffith was: a great inventor as technician and a mindless hack as artist. The one does not exclude the other, but a critic should be able to tell the difference: One who has form without content is no more an artist than one who has content without form. Only when both are present and fused can there be talk of art. *City Lights* has both; *Citizen Kane* has both. The content of any and all of Griffith's films, whether or not they show the Ku Klux Klan triumphant, is trash. And trash, or kitsch, cannot be redeemed by honest vulgarity: Two minuses do not add up to a plus. Griffith had no conception of what art was, and in a highly complex medium such as film there can be no unconscious art.

But why should not film in the right hands be art? Why, in fact, should it not be the *Gesamtkunstwerk*, the global art form of which Wagner dreamed? It has the gift of storytelling as much as fiction has; it has the gift of creating images as much as painting has. From music, it inherits much more than the background score: its deployment in time, its alternation of tempos, its abil-

ity to go from a populous long shot corresponding to an orchestral *tutti* to a detailed close-up equivalent to a solo passage. From sculpture, it inherits the ability to make its subject visible from all sides; from both sculpture and painting, the gift of freezing an action in time and space.

From architecture, film inherits just about everything. It can build more easily than architecture can (whichever section of a building it needs, rather than the whole) and define people in terms of their habitats — indeed, show how these habitats shape human lives. And from theater, it inherits all kinds of acting and directing techniques, although it must be careful not to take them over too slavishly, as well as the uses of illusion, with which the theater has been experimenting for centuries. Even from such a lesser art as fashion, film has learned how to enhance human beauty through costuming. With all these arts as its counselors or handmaidens, why should film not be an art?

There are, however, some obstacles to overcome. One is the complexity, the multifariousness of film, which requires the film artist to juggle with more balls than a poet, painter, or composer. But if the filmmaker is a true artist, then such skills will prove achievable. And he or she can draw on complementary artists or technicians for help: cameramen, designers, vocal coaches, and the rest. He or she may even have the good sense to hire a real composer rather than a Hollywood hack to write the score.

And, yes, film is a collaborative art, necessitating in the director the skills of an orchestra conductor — it is not just a matter of writing a sonnet with a pencil and paper, though that is not easy either. But all difficulties dissolve before a much greater one: the tyranny of the box office. This is a peculiarly democratic tyranny if we include under the heading democracy the kind of capitalist laissez-faire under which our democracy thrives. And so because film must, in this country, first please the capitalists who bankroll it, and then the public that pays back the capitalists with interest, it is clearly the most democratic art: democratic at both ends — at the start, to get made in the first place, and at the finish, to make money and enable the filmmaker to keep working. And that may just be more democracy than an art can stand.

Art, let's face it, is not democratic, not egalitarian; art is inherently elitist, exclusionary, despotic. It is self-assertive and inimitable and thus basically antidemocratic, although there have been, as it were, people's artists, whose existential vision happened to coincide with what their society believed and wanted. In literature, Dickens is the usual example of the panderer to his public who nevertheless emerged as an artistic giant. In film, Ford, Hawks, and, despite his darker vision, Hitchcock fall into that category. Ford's ideas about westward expansion, Hawks's about both screwball comedy and action flicks, and Hitchcock's about thrillers were all ways of catering to the public

while also satisfying personal needs. If their work is compared to what Bergman, Bresson, or Antonioni saw fit to create, then it becomes plain that these directors wanted something other than what is craved by the large majority of moviegoers; yet, they managed, up to a point, to impose their visions on the public.

Why is it that none of these latter, and I would say greater, directors was American? The obvious but incomplete answer is that their films cost less to make and so could afford to be aimed at a more select audience. This is where that so very democratic tyranny of the box office comes in. There are essentially two kinds of censorship in film: by the authorities, such as the state or church, and by the box office (i.e., the paying customers). Of these censorships, the former is more harmless, sometimes downright beneficial. We have observed how in totalitarian countries filmmakers exercise their ingenuity to get their hidden message across. Repression forces them into such devices as metaphor, symbol, allusion, suggestion; it makes poets of them as direction becomes indirection, insinuation, ambiguity — exactly as it is in the realm of modern poetry.

I am not advocating that we give up our democratic ways just to make better movies. Nevertheless, the censorship of the box office is the more ferocious one, harder, if not impossible, to circumvent. A severely cut film, or even a banned one, can outlive its professional censors — be made, or released, uncut after they are gone; but one that sells poorly has a way of disappearing forever. The simple and horrible fact is that when something costs as much as even an average American movie, it must recoup, recoup, and recoup. It must sell itself to a great many more people than attend stage shows and concerts, by which I do not mean rock concerts, which have nothing to do with art. It must appeal to many more people than go to art galleries and museums, or read serious prose or poetry. Yet, it is to this minority that a movie must usually address itself if it is to be art.

It is possible for a work of art to reach both the broad and the more advanced public. But this tends to happen much later, after the broad public has been educated to appreciate those works of art, and even then we must wonder how much of that appreciation is mere lip service. Unless, of course, there is hype: the kind of publicity that lures, cajoles, bullies people into seeing an art film, as the thing used to be called. Yet, even hype works only in the big cities, and its effect, though intense, tends to be short-lived. "The public," said Debussy, "has no taste, and never will have."

We can assert, with only the slightest exaggeration, that in our society film is either an art and loses money or makes money and is not art. Luckily, films can be imported more readily than foreign books, which require more

translation than mere subtitles. But subtitling, too, hits a snag. Except for sophisticated megalopolitan audiences, American moviegoers do not want to read subtitles. I guess people who hate reading do not want it to sneak up on them like that. Not to mention that only a part of the dialogue can make it into the subtitles, and even that is often poorly rendered by hacks. And so, unless the foreign film has some sensation value, it gets shown only in a few major American cities.

We cannot, in any case, survive on a diet of foreign films, and when we consider what difficulties films in other countries have competing with imports from America, we may justly fear for the future of the foreign film. That is why the French and German governments, say, have resorted to regulations that oblige exhibitors to show a certain percentage of domestic films. Though American movies were always popular abroad, there was no need for a quota system. What has happened?

I can assume only that global stultification has taken place, especially since the evil Soviet empire is no more, and without such a foil our good empire may not seem all that shiny. But America fascinates the rest of the world by virtue of certain myths: of Hollywood, glamour, affluence, easy living, infinite opportunity, freedom of every sort, and all the rest of the great mythic half-truths. Yet, having been constant over the years, this lure does not explain the recent, more drastic imbalances. It follows that the inability to deal with more demanding, artistic films and the increased craving for mindless entertainment have become universal problems.

True, we are always told that only the cream of the foreign crop gets imported, that trash is plentiful everywhere, not only in our democratic society. Yes, but our trash is richer, grander, trashier. An invasion of assorted prehistoric monsters, say, as opposed to one measly Godzilla, can come only from Hollywood. We can afford to make and export the best trash money can buy. And then there is the whole American mentality.

There is still something left in Europe and Asia of the traditional respect for art and the artist. It has to do with education, the sense of history, and even politics, which in Europe tend to have a more intellectual cast. In this country, where art never played a major historical role — unless you believe that Harriet Beecher Stowe started the Civil War (or, unlikelier yet, that what she wrote was art) — technology was always in the forefront. And so, cinematically, our car chases, our disasters, our star wars, and our dinosaurs emerge as the best. Since there are enough people the world over who crave technology, which is to say schlock, Hollywood thrives. Yet, it is not in dinosaur movies that the intricacies of the human soul will be scrutinized.

What, with all the forces militating against it, were the chances of art being created in the American movies released during 1994? What could qualify as art? Could it have been, perhaps, *Forrest Gump*, which was a smash at the box office, made it to many ten-best lists (and also some ten-worst ones), and was a prime candidate for the Oscars, those most ludicrous awards known to man? No less absurd, though, are the ten-best lists. Why, in a typical year, pad the honor roll up to ten, or, in an *annus mirabilis*, whittle it down to that number? Because in this populist democracy of ours, the perfect ten has become a mystical concept, whether applied to the allure of Bo Derek or to some other paragon.

So, too, Forrest Gump is the perfect ten of idiot savants and thus better than the imperfect rest of us. Weird as this notion is, that is the lame-brained proposal of the movie, though Gump is nothing like his nearest European equivalent, the Good Soldier Švejk, a fellow crazy like a fox, whose madness has plenty of method. Nor is Gump the Holy Fool of Christian literature on the model of Perceval, the bringer of the Grail. He is merely one of those variously disadvantaged, whose adulation throws another spanner into our already crippled system of values.

What about *Quiz Show*, then? Might it be an art film? It exposes the corruption behind the high-stakes quiz shows that once held the country in thrall, but it falsifies the facts. Granted, art does not have to adhere to facts, but if it exalts someone — in this case Richard Goodwin — to heroic status, then it should be for better reasons than that he was one of the film's producers. There is something unsettling about a movie that castigates others for the very thing it is doing: playing with loaded dice.

Oliver Stone's *Natural Born Killers* is not art either, because art does not consist of throwing everything pell-mell into the kitchen sink and expecting it to mean something. At most, it could be called "32 Ways of Going over the Top," in which respect it scarcely differs from such universally execrated horrors as *The Hudsucker Proxy* and *The Road to Wellville*. Art means, among other things, control, though the megalomaniacal filmmaker may perceive any sort of self-control as an abrogation of his God-given (or is it godlike?) freedom. But what are we to do with reviewers and audiences who manage to find virtues in something like *Interview with the Vampire* or the equally risible book on which it is based? No less pathetic is a film such as *Legends of the Fall*, which tries to graft the macho adventure thriller onto the two-handkerchief weeper and manages to make hash of both genres, the masculine and the feminine.

Or take the two attempts by young independent filmmakers that elicited

a fair amount of critical enthusiasm, mostly unshared by audiences: *Barcelona* and *Spanking the Monkey*. The one was too pat and slick to be art, the other too clumsily amateurish. (I leave aside *Hoop Dreams*, for documentaries are, so to speak, a whole different ball game.) And what of *The Last Seduction*, an attempt at a genre film? Well, even a film noir must not lapse into the darkest illogic. And then there was that most acclaimed film of 1994, *Pulp Fiction*. It has some good cheeky dialogue and a couple of effective scenes, but there are long sections that are totally sucked out of the thumb. It exudes a smart-ass attitude lacking all respect for the niceties of possibility, let alone probability.

Even more unsatisfying is a picture such as Alan Rudolph's *Mrs. Parker and the Vicious Circle*, which self-consciously labors to be an art film and loudly screams, "Look, Ma, I'm cultured!" only to end up as a piece of perfect boorishness. Or take the equally pretentious film of Rudolph's sponsor, Robert Altman, *Ready to Wear*, which falls into that most dismal of categories, the toothless satire. The movies that came off best in 1994 were among those that made no pretense at art: *Disclosure*, *Speed*, *Clear and Present Danger*. They settled instead for skill, cunning, and craftsmanship and proved to be good, solid entertainment. Finally, there was one film better than that, Robert Benton's adaptation of *Nobody's Fool*, a novel by Richard Russo: a decent movie about real people but with some troubling lacunae in the screenplay.

Let us see now how the failings of these films are related to their being made in and for our kind of society. *Forrest Gump* allows the common man and woman to feel (1) superior to its hero and thus (2) entitled to do at least as well in life: have an affair with at least as fetching a creature, meet at least as many presidents, and make out at least as well in business. In *Quiz Show*, we see how a minor public servant, Richard Goodwin, cleans out the Augean stables of television quiz programs. That it did not quite happen that way does not matter: The image of one honest man successfully battling a corrupt machine is endlessly satisfying to the man in the streets when he becomes the man at the movies, if not indeed, vicariously, the man on the screen.

Natural Born Killers is a bit harder to read. It was not very successful, although I have met some young film critics who swear by it. I am not sure that a pair of serial killers who get away with murdering fifty-two people, found their own happy family, and drive idyllically cross-country in their minivan is something that speaks to the hearts of America. But as long as the law is represented as disgusting and television journalism as revolting — and the

outlaws are passionate and witty lovers — adherents of the film can be found. A bit of misrule, a whiff of anarchy, and the heroic battle cry "Up yours!" are not that easily dismissed. And if the film is full of irrelevant inserts of every kind, if it shuttles between color and black and white, if it cuts away repeatedly to cartoon characters and is unafraid of appearing grotesque, then people will assume there must be something to it, after all. Art, most likely.

Any movie in which someone undesirable, unsuccessful, un- or supernatural is treated as heroic or tragic must also be, in its infinite compassion, a work of art — or so the assumption goes. If *Interview with the Vampire* makes sucking blood look as tragic as shedding it in a good cause, then it must be informed by some superior wisdom. And a vampire Lolita must seem especially gratifying to adolescent girls: finally, a profession — vampirism — that offers equal employment opportunities to twelve-year-old females.

With *Legends of the Fall*, no one should feel left out. Brad Pitt, as the long-haired blond superman with the operatic name of Tristan, gets the better of everyone, starting with his doting father. He can outstare a grizzly bear, capture single-handedly a stable full of mustangs in one outing, take on the entire German army in World War I, cut out his fallen brother's heart to bring it back for burial in the lone prairie, have a juicy affair with his dead brother's fiancée and *then* nobly give her up, marry an exquisite Indian maiden who loved him since childhood, outwit government-protected gangsters in the bootleg trade, and, when those varmints kill his beautiful squaw, unite his divided family in a shootout that destroys the forces of evil. In between all that, he finds time to sail off to the South Seas in his schooner and become Great White Father to the natives. Now, this is a truly democratic movie, featuring a hero of three — count 'em — three continents. He may not make love to as many Spanish girls as the hero of *Barcelona*, or crawl into bed with his mother, like the protagonist of *Spanking the Monkey*, but in every other way Tristan has it made.

What happens, though, in a democratic society such as ours when a filmmaker picks a literary subject, as in the case of Rudolph's *Mrs. Parker and the Vicious Circle*? First, he chooses for his heroine the hard-drinking and hard-loving Dorothy Parker, whose writings would not tax the average high school student. He then surrounds her with her fellow wits from the Algonquin Round Table, each allotted a couple of minutes of screen time — no less and, with two exceptions, no more. Then he has his leading actress unburden herself of a handful of the best-known Parker epigrams in the most awesomely reverential way. He periodically interrupts the story and, against a black background, has her solemnly deliver some of the better-known Parker

verses. Alas, he cannot work in the short stories. The entire enterprise drips with smugness, to the point that Jennifer Jason Leigh's Parkerian accent verges on the incomprehensible.

The *New York Times* of January 3, 1995, stated that "Family movies are in at the box office. Social comment seems to be out." Family movies, indeed. Every major comic strip becomes a movie, usually a super-production; ditto yesteryear's smash radio serials. Anything that has a role in it for Macaulay Culkin or another current child star becomes a movie. Yet, how many parents take off on a trip and accidentally leave one of their kids at home? (Quite a few may want to, but that is another story.) The two hits of the 1994 holiday season were *Dumb and Dumber* and *The Santa Clause*. In that light, perhaps it is heartening that *Disclosure*, despite being castigated by all the feminist reviewers and their male camp followers, turned into a hit, says the *Times*, "largely because it's one of the few movies that appeal to older (over 25) audiences." We must conclude from this that the paper's two main film critics, women who both hated the film, must be under twenty-five. Still, it is interesting to learn what "older" means.

It would be equally interesting to define "audience." Oscar Wilde had this to say about his: "The nineteenth-century dislike of Realism is the rage of Caliban seeing his own face in a glass. The nineteenth-century dislike of Romanticism is the rage of Caliban not seeing his face in the glass." Today's audience is similarly divided between those who desperately want to escape from themselves and those who bitterly resent not seeing characters just like themselves. Both attitudes are conducive to missing what is actually portrayed. I can understand why a minority that has not seen itself much or correctly represented on screen finds it thrilling to get full representation there. But such recognition has nothing to do with artistic quality or appreciation of art.

The democratic passion for egalitarianism gets in the way of art. If the stuff we capture on our camcorder is as good as what we see at the movies, if our modest home screen is the equivalent of the large theatrical one, if movies are watched more and more on television and VCRs (as we talk among ourselves or go to the kitchen for another beer), if we can channel-surf for another movie the moment we lose interest in one, then the dignity and efficacy of film become severely undermined. Have you not noticed nowadays the to and fro in any movie theater during the screening of a film? Somehow it is almost always during crucial scenes that these sundry exits and reentrances stampede across your feet. It all fits in with the notion of film as commodity, something that belongs to us to dispose of as we see fit, rather than of film as art, something so big that we belong to it.

What, then, is the influence of the camcorder-wielding, TV-saturated, and VCR-enslaved audiences on the cinema? In one word: deleterious. It pushes filmmaking willy-nilly into areas that will not readily translate into home watching or home filming. For such an audience to make the effort to catch a movie in a theater may well mean that the film must be of the sort that requires showing on a large screen (truth to tell, all movies do). It must have epic dimensions, or some aspects unsuited for the kiddies to view on the home screen, or idols best worshiped in a size larger than life. This limits theater attendance, even though that is still what directors want and although crafty producers may settle for television and video store profits.

Perhaps it is time to stop bemoaning the lack of art and simply regard movies as entertainment. If that satisfies the needs of large numbers of people, then is that not enough to merit equal consideration? The answer is that art and entertainment are not polar opposites, that boring art is no art at all, and that art is merely entertainment that says the most, says it best, and will keep saying it in perpetuity to those who have the senses and the sense to receive it. Or, more succinctly, art is that entertainment which best stands the test of time — time whose sieve is the supreme critic of all.

Even after saying this, we still must consider the democratic validity of something that merely entertains on an unexalted level but ecumenically. In other words, what about entertainment that has little height or depth but a great deal of breadth: a silly comedy, a frilly romance, a gripping yarn, or a catchy fantasy that appeals, however momentarily, to a wide audience. Is this to be despised? Despised, no; acknowledged and remarked upon, yes; bowed down to in admiration, no and again no! This sort of movie engenders arguments but does not merit serious discussion. I would call it the equal of sports or most television programs, something to watch with your family and friends and jovially debate with them. It would not be worth a review or lecture if something better were available. Something better, however, usually is not.

That, manifestly, is a critical position and leads us to the problem of film criticism in a democratic society, which I have thus far only skirted. From the very beginning, two divergent, indeed contradictory, attitudes about film have coexisted. There have been the detractors, such as the noted German professor of aesthetics Konrad Lange, who declared way back in 1913 that movies were made by "semieducated, aesthetically insensitive, ethically indifferent, in short, mentally inferior people." (Eight decades later, one is tempted to say that the situation has not changed very much.) But there were also those to whom this did not matter, such as Terry Ramsaye, an engineer turned journalist, and then producer of Chaplin comedies, newsreels, and

adventure films. Eventually, he became editor of the *Motion Picture Herald*. In 1926, Ramsaye published *A Million and One Nights*, an influential history of the movies up to 1925. In it we read:

> It is only by . . . recognition of the organic character of the motion picture and its consequent interrelation to all of the organism of mankind and society that it can be understood. Critics and forecasters, academic, professional and commercial, are continually committing themselves to error, because of their failure to see the screen as one of the strands of the yarn of life, with an infinity behind and ahead. The motion picture is as irresistible as the life stream behind it. It persists as a fundamental expression of that stream. Men and their movements which appear to control it are merely riding on its surface for their hour, and their operations are little more than evidences of the currents below. They who think they are creators and masters of the motion picture are its servants.

These antithetical views of the cinema — the Olympianly snobbish and the Jungianly demotic — show signs of remaining with us forever. They do not merely characterize the persons holding them; they are also germane to the nature of the movies. There is a whorishness about the way the typical movie solicits the goodwill of the broad public. It reminds me of the last sentence of Pauline Kael's last movie review, referring to the character played by Sarah Jessica Parker in *L.A. Story*: "She is the spirit of L.A.: she keeps saying yes." Such facile affirmation is the obverse of the artist as rebel and naysayer, as he or she is often perceived in the other arts. In the introduction to his 1960 collection of essays, *No! in Thunder* (a title derived from Herman Melville), Leslie Fiedler puts it this way:

> It pays to be clear about the nature of the "No! in thunder," which is quite different from certain lesser *no*'s in which a thriving trade is always done: the *no* in newsprint, for instance, and the *no* on manifestoes and petitions. A play written in the 1950s about the Salem witch trials, or a novel of the same period celebrating the revolt of the Maccabees, despite their allegorical intentions, are cheats, exploitations of the pseudo-*no*. Even the attack on slavery in Twain's post–Civil War *Huckleberry Finn* — or, for that matter, in Mrs. Stowe's pre–Civil War *Uncle Tom's Cabin* — like the anti-McCarthyite fiction of the recent past or an excoriation of segregation right now, carry with them a certain air of presumptive self-satisfaction, an assurance of being justified by the future. They are Easy No's, merely disguised *yes*'s by anticipation, tomorrow's *yes*'s. The "No! in thunder" remains a *no* forever; like the *no* implicit in the whole work of the Marquis

de Sade, or the deeper *no* of *Huckleberry Finn* — Huck's *no* to womankind, the family and organized society, which remains to this very day a *no*.

Note that this was written before political correctness, when such finickily extreme positions were somewhat more tolerated. But let us set beside this view its opposite, from an essay by the English novelist and critic C. E. Montague, entitled Wildeanly "The Critic as Artist." Discussing Ruskin and Pater, Montague writes:

> In spite of a hundred perversities, Ruskin's outburst of ecstasy at sight of St. Mark's is one of the highest jets of critical force and beauty ever cast up by the human mind; it has that surpassing energy of joy and admiration. Pater may be wholly wrong, in a minor sense, in his interpretation of the "Mona Lisa" at the Louvre, but still the celebrated tirade on that subject is a supreme piece of criticism; an apt mind has been stirred up and has poured itself out nobly in adoration of what it believed that it saw. That is enough; the great passage remains an example of criticism in all the wonder and glory of a lofty vehemence not given to common minds.

I chose examples from literary criticism to convey that the stakes are high: intellectually, morally, stylistically. In film criticism, the discourse is generally nowhere near so elevated. Was the following written by a film critic?

> Film is nothing other than the democratic form of court theater. It heightens intimacy to the nth degree, to the point where it runs the risk of being the quintessential pornographic art, which forces the spectator into the role of the voyeur, and the popularity of the movie stars lies only in that everyone who has seen them on the screen also gets the feeling of having already slept with them — that's how well they are shot. A close-up is in itself indecent.

From a film critic, no; this is from a lecture by the great Swiss playwright and novelist Friedrich Dürrenmatt, who nevertheless was grateful to the cinema, and continued: "It is unimaginable what would have to be played in today's theaters if movies had not been invented and movie makers were writing plays."

There was a time when some film critics wrote as well as that in their reviews. Thus, about the film version of Penelope Mortimer's novel *The Pumpkin Eater*, Dwight Macdonald pronounced:

> It has been often observed that women don't enjoy pornography because their eroticism is more emotional and less sensual than men's, but I haven't seen it noted that precisely because of this difference the woman's

novel performs for female readers the same humble task of titillation that pornography does for men. If the pornographic hero is a sexual athlete, the heroine of the woman's novel is an athlete of the emotions whose feats of feeling are described in lubricious detail, while the males are reduced to objects of sentimental lust no more individualized as human beings than are the stripped beauties, of whom one learns nothing beyond their anatomy, who satisfy the physical lusts of the males in pornographic fiction. Because for some reason sentimental orgies are not considered immoral in our culture, the woman's novel has always circulated freely, without interference from the police, though it could be argued that its debauchery of sentiment is more damaging to morality than are the pornographer's boldest fantasies.

What I find most interesting about this passage is that, although it appeared in Macdonald's movie column in *Esquire*, it was in some ways a disquisition on the novel, though with obvious bearing on movies in general and *The Pumpkin Eater* in particular. Most movie reviewers today do not discuss fiction or anything else outside movies, for the very good reason that they know nothing outside movies. In the 1960s and 1970s, people like Pauline Kael, Dwight Macdonald, Stanley Kauffmann, Wilfrid Sheed, and other serious film critics took part in various symposia, or prescreening talks, were heard on the radio, and even appeared on television. Now this is extremely rare, and the quality of the current talk-show hosts leaves little room for hope.

Indeed, something alarming has happened: film criticism has found its democratic image in two sorry television duos: Siskel and Ebert and Lyons and Medved. Blame this on television rather than on movies, although the two are very much in the same bed. I mean, of course, television and movies, not Siskel and Ebert or Lyons and Medved. I had actually hoped that — similarly to what Dürrenmatt said about theater and film — television would relieve film of its worst deadbeats. But no such luck: televison directors go into movies; some of the same people write for both mediums. And since most television is aimed at second-rate minds, film criticism on television must follow suit. It is a frightening thought that to much of America the idea of the film critic is now Siskel or Ebert, the lightweight soul-searching of the one or the glib pontification of the other. Anything more than that would seem elitist and incomprehensible to most viewers.

A lot of this has to do with the state of our schools, both high and low, making it harder and harder to get an education. I have no transcripts of the pronouncements of our paired movie pundits, but here is a statement from

Woody Allen, who at the very least is their intellectual equal. It appears in a book-length interview with Allen by the Swedish filmmaker and critic Stig Björkman: "To me the most tragic, the most sad quality is if a person has profound feelings about life, about existence and love and the more deep aspects of life, and that person is not able to express it." True, but hardly less tragic is having all these profound feelings and expressing them as wretchedly as Allen does here. Aside from a pile of redundancies, note "most sad" for saddest, "more deep" for deeper, and the syntax in "the most sad quality is if." What does a fellow's grammar have to do with his filmmaking? A lot. I do not want people who speak that poorly writing my screenplays. Even if this was a transcribed oral interview, Allen was a stand-up comic, so he must be able to think on his feet; and he is an autodidact, so he cannot blame this verbicide on having gone to college.

But let us return to the state of criticism. In a democratic society, alas, anyone can purport to be a critic. Now, I have always maintained that a critic need not have seen every movie to come down the pike. That can be downright harmful. People who waste most of their days and nights on movies and more movies, as do so many film buffs who later become reviewers, have no time to find out much about other things, which skews their judgment of films. This holds for filmmakers, too. If Quentin Tarantino had not gotten most of his experience and education from working in a video store and consuming its contents, *Pulp Fiction* might have had a little more bearing on reality.

People for whom movies are the alpha and omega also do not get to know the other arts, from which, as mentioned earlier, film derives so much. Furthermore, history, philosophy, and psychology should not be neglected by the film critic. Foreign languages can be handy as well; it is good not to have to depend on inadequate subtitles. The importance of travel and knowledge of the world cannot be overestimated. Variety of experience, by all means, is useful, as is that element so often lacking in film critics, that very elitist and undemocratic element, brains.

Much also depends on attitude. When Stanley Kauffmann left his reviewing post at the *New Republic* to be succeeded by Pauline Kael, she changed the name of the column from "Film" to the more populist "Movies." When Kauffmann returned, the title went back to "Film." There is a real difference there. Wilfrid Sheed caught it well in a humorous but not unserious essay, "Kael vs. Sarris vs. Simon," reprinted in his collection *The Good Word*, from which I quote: "Simon's brief for insisting on 'films' instead of 'movies' reminds one of two monks chaffering over the word 'consubstantiation'—no mean issue in its day. Movies mean popcorn, double fea-

tures, and coming in in the middle: democracy. Film means, well, at least chewing quietly, no talking (a rule Mr. Simon has been known to break in person), the seriousness one brings to the other arts: aristocracy."

A bit farther on, Sheed describes Andrew Sarris's attack on me in the *New York Times*:

It seems, like most Simonology, to take off from Simon's Transylvanian accent, and the remoteness from American reality which that implies. Simon is, to be sure, not your typical American boy. He staggers under a formidable load of cultural baggage, gathered at a time and place (middle-century Central Europe) when and where it seemed possible to grasp *all* that Art was doing; to make, as Mr. Simon can, a good fist at criticizing music, painting, sculpture, theater, the works.

But as Sheed also points out, the three warring critics were often ideologically closer than anyone, themselves included, might have imagined. Just recently, Sarris and I agreed in print about the importance of *Nobody's Fool*; Pauline Kael, alas, is no longer sounding off — at least not publicly. Yet, I wonder whether she, Andrew, and I would not all agree with the Austrian man of letters Franz Blei, who, asked in 1913 to contribute to a book on film, replied: "How does man live? I consider showing this more valuable than the filmed monster births of an imagination that requires heaven and hell to express itself and to say nothing." And he went on: "One should film that which is nearest to us and yet so strange to us."

That, one might think, is precisely what film, the democratic art, would zero in on: the lives of our fellow human beings, about which we know so pitifully little. But no: Caliban does not wish to see in the mirror something that is not quite his own face yet disturbingly resembles it — thus offering him neither the joy of wallowing in narcissism nor the pleasure of total escape. And if films try to become too refined, then there is no dearth of reviewers to echo the message of Miss Kael in her penultimate review, of *Sleeping with the Enemy*, a rancid Julia Roberts vehicle, rightly excoriated by Kael. But then, near the end of the review appears a troubling statement: "A little tawdriness would have helped." Here, in her swan song, is the same Pauline who, twenty-seven years earlier, hoped that kitsch would be miraculously transformed into art.

That is the sort of advice we do not need, though we will keep getting it from the so-called Paulettes, disciples and imitators with whom Pauline has staffed countless movie reviewer jobs — I would almost say "peopled the isle with Calibans." But, for better or for worse, film remains the most affordable

of arts, excepting, perhaps, art museums. That is partly what makes it the most democratic of arts.

Yet consider that in 1994 Europe produced such films as *Colonel Chabert*, by Yves Angelo, based on Balzac's novel, from France; *An Unforgettable Summer*, by Lucian Pintilie, from Romania; Nanni Moretti's *Dear Diary* and Lina Wertmüller's *Ciao, Professore*, from Italy. All the United States offered as what might be considered an art film is the pretentious and dreadful *Vanya on 42nd Street*, which was shot by Louis Malle, a French director, unless one includes the remake of *Little Women*, by an Australian director.

Could the situation improve? Perhaps, if you who read this — the smarter, better educated, more aware part of the audience — demand something more. That would mean putting to good use your democratic citizen's right to abstain from the garbage with which the good capitalistic democrats or democratic capitalists from Hollywood shower you. That might put into them if not exactly the exalted fear of the Lord, at least the lowly but pervasive fear of financial loss.

Modern Democracy and the Novel

A. B. Yehoshua

As someone who is neither an American citizen nor a resident but an occasional visitor, I would like to begin by expressing my appreciation of the intellectual devotion of Americans to the theme of democracy. Although a state of democracy exists in my own country, Israel, as well as in other countries, it still seems that for us democracy is like wearing a suit of clothes after trying on various other styles, while for Americans it is more than a suit or a coat — it is the very skin of their body. That is because, if I am not mistaken, the United States is the only nation in the world whose national iden-

This essay was translated from the Hebrew by R. Dan Schlossberg and edited by Werner J. Dannhauser.

tity is almost genetically related to democracy. Its national independence was forged at birth within the world of democratic presuppositions.

Therefore, with a noteworthy perseverance, Americans reexamine their democratic nature the way other countries investigate the significance and limitations of their nationality or the origins of their language or religion. For other nations, democracy is only a form of government, relatively less harmful than others, which helps them maintain their national identity while they navigate the complexities of the modern world. Still fresh in the historical memory in nations such as Britain, Japan, Austria, and France are significant as well as prosperous eras in which democracy did not exist (as, for example, during the reign of Franz Josef over the Hapsburg empire). By contrast, democracy is the only undisputed trademark of the American heritage.

Other countries may despair of democracy during critical times, as when Hitler triumphed in the German election of 1933, or when Muslim fundamentalists won the Algerian elections a few years ago, or now, as Russia witnesses the chaos of its newly democratic country. (I also remember my own disappointment at the outcome of the 1996 elections in Israel.) At such times one can hear people say: "Democracy just doesn't suit my country. It is too dangerous." I can scarcely imagine an American saying such a thing, however. Casting doubt on or disclaiming democracy is like disclaiming the very fact of one's being American.

Thus, when I was asked to address the theme of modern democracy and the novel at an American university I smiled to myself. The very phrasing of this subject is so remarkably American that while studying this theme I found myself momentarily becoming somewhat American. It is most difficult to imagine Germans or French or Russians or Israelis formulating such a topic in such a way.

I

The question appropriate at this stage of my inquiry is whether democracy favors the art of the novel. As a novelist, I am primarily interested in this question and not its reverse: Can the novel be useful to the promotion of democracy? If I were to answer this question intuitively and off the cuff, my response would be either hesitant or skeptical. The proliferation and consolidation of *modern* democracy that we have witnessed in the last fifty years does not seem significantly favorable to the novel. (Incidentally, it may not favor the other arts either.) To make my point more clearly and perhaps somewhat coarsely, I propose the following. Let us assume, with the fin de siècle as well as the end of the millennium approaching, that we were to weed out our

bookshelves and get rid of all the old and dispensable books to make room for new ones. As a kind of spiritual provision accompanying us into the twenty-first century, however, we could keep the ten greatest and most important novels written in this century. Would these include even one written in the last fifty years? In my opinion, perhaps reflecting my personal taste but at the same time the preferences of many literary critics — which one can infer from contemporary literary research and its dominant interests — all ten would originate during the first half of this century.

If the choice were between, on the one hand, the novels of Thomas Mann, Proust, Joyce, Faulkner, Virginia Woolf, Kafka, Henry James, D. H. Lawrence, the less famous Hemingway, Fitzgerald, Bruno Schultz, Musil, Alfred Döblin, Agnon, and Celine, and, on the other hand, the novels of Saul Bellow, García Márquez, Sartre, Camus, Heinrich Böll, Günther Grass, Solzhenitsyn, and others, then the unequivocal choice would be to favor the first list. This is not simply a question of the classical aura that the earlier works may have acquired with the passage of time. In Elias Canetti's famous autobiography, *Die gerettete Zunge*, which describes the intellectual atmosphere and social circles of the 1920s and 1930s in central Europe, a great excitement is clearly felt among learned people all over Europe regarding the works of Joyce, Kafka, Faulkner, Proust, and so on, though these authors were as yet unknown to the wider reading public. This excitement was due to a unique feeling that something great and new was evolving in the art of the novel, a sensation one simply cannot find in the response to any contemporary novel.

I refer here only to the present century and exclude from my speculation the nineteenth century, whose works of genius remain to this day probably the greatest accomplishments ever achieved in the art of the novel. Moreover, I abstract from the possibility that there are better and worse times in this or that art, in order to face more starkly the relative weakness of the novel in the second half of this century. That weakness warrants an investigation of the art of the novel in relation to the consolidation of modern democracy. I shall claim that modern democracy — as we have experienced it in recent times — is not an especially fertile ground for the creation and cultivation of great novels of the type with which we have been familiar in the past.

II

At this point, someone may argue: "So what? Let us assume that you are right. What does it matter? Democracy is ten times more important than the

success or brilliance of this or that novel. All the great and wonderful novels written after World War I did not prevent World War II, which was even more devastating than the first. And if modern democracy does not necessarily produce great novels, what of it? The expansion of civil liberties and the effective supervision of government by the electorate are more important than all novels put together." That is certainly a valid response. As a novelist, however, and I emphasize the point again so as not to disguise my personal interest, I will not remain silent. I shall continue to ask whether there is something in the way in which contemporary democratic life is perceived or conducted that dilutes or weakens the greatest potentials of the novel and its development and leads to a certain discomfort with culture in general. Once again, I must be clear and precise on this point. I am not speaking of the novel and democracy in general but rather of the contemporary form of democracy and of novels written during this period. A considerable number of the great works authored at the beginning of this century were penned under a different type of democratic regime — a democracy neither as extensive nor as pervasive as the one we experience today.

These questions are especially important because, among the many art forms, such as poetry, drama, and short stories, one finds the novel the most accommodating to a democratic perspective and reflecting in its flexibility and open structure some basic democratic principles. Perhaps, one can add, somewhat boastfully, the novel, more than any other artistic form, has encouraged and supported the democratic revolution of modern times.

In the very first modern novel, *Don Quixote*, which was popular at the beginning of the seventeenth century, a time far from democratic, Cervantes tells a story that takes place in Spain, one of the countries in which democracy arrived frightfully late. This genre is already portentous, with unmistakable democratic signs. To begin with, there is the picaresque device of ranging freely from one place to another. This mobility is not merely geographic but social, generating a pluralistic sense of class. These characters from different classes and social circles all speak in their own various styles and from their own various perspectives; in this way, Cervantes creates a broad and captivating mosaic. Although the novel is propelled by Don Quixote's obsessive dream of re-creating the days of knighthood and chivalry, one finds that the contradiction between his dream and trivial or banal reality only seems to reinforce the strength of a reality that a democratic philosophy would respect and legitimate. In a democratic world, after all, there is no need to seek the truth in fantastical castles or persons of great virtue.

The language itself is also democratic in its inclusion of various vernaculars, all of which are legitimate, since all humans in this novel are essentially

and basically equal in their search for a nonexistent knighthood. In fact, the simple folk in the novel are more accommodating of and better able to deal with Don Quixote, that capricious and distressed knight, than are all the nobles or priests. This demonstrates once again a democratic value: The common sense of the people, with all their faults and limitations, will, for better and for worse, lead the way.

I refer to *Don Quixote* not only because it is the first modern novel but also because it is still the most famous in the world, and its translations are outnumbered only by those of the Bible. And if democratic values lie at the base of a novel that was written at a time when no one even dreamed of democracy, then I believe we can speak of a number of democratic values that are embedded in the whole genre of the novel. I will try to describe them according to six principles.

(1) The structure of the novel is open and liberal and in this way sensitive to social development and transition. From the start, the novel did not possess binding poetic rules. Rather, it was more of a container and an outlet for all those materials and means of expression that could not find their place in the more familiar forms of the other genres. Therefore, the novel essentially breathes with poetic liberty. This corresponds with a social and personal liberty greater than that which one finds in other literary genres, such as drama, poetry, and the short story. In these other forms the breaking of poetic rules involves a liberty gained by rebellion. For example, on the one hand, one can speak of a poem that does not rhyme, or a poem that is not metrical, or a drama with no conflict, and in this fashion acknowledge the rebellion and transition effected by the work upon the binding poetic norm. On the other hand, the open, liberal form that is *intrinsic* to the novel has not been achieved by breaking or rebelling against an earlier binding principle. The form itself is a primary and natural liberty.

(2) The novel is inclined to use different voices to tell the same story from differing perspectives. What is more, the truth is not imposed on the text by an omniscient author but emerges from the accumulation and integration of several points of view. In this way, it is a more democratic and a less dogmatic truth, a truth mediating among different voices. When I wrote my first novel, *The Lover*, in the 1970s, I adopted the Faulknerian technique found in *As I Lay Dying*, in which the story is guided by the alternating dialogues of a number of characters. At a certain point, people would ask me: "But who among the six protagonists is the leading protagonist of the novel?" Without blinking an eye, I would reply: "None of them." The novel's real protagonist is the space trapped in between the characters, a space in which one

can find one's thoughts, feelings, and actions. It seems to me that in this way I demonstrated to myself and others the true democratic character of the novel.

(3) The trivial and the commonplace can find legitimate expression in the novel more than, for example, in the short story. The latter continuously searches for a dramatic turn of events or climax of the plot that reveals the real face of the character and thus astounds us with our mistaken perception. The drama, which is more closely related to the short story than to the novel, is always compelled to present a clear conflict and then go on to provide an apt resolution. In the novel, by contrast, there is no obligation to dramatize or take the reader by surprise. It is fully legitimate and even basic to this genre for a continuous flow of smaller nuances to accumulate and lead to the conclusion. The novel speaks of evolution, not revolution. In Thomas Mann's wonderful novel *Buddenbrooks*, an intense flow of social and family transformations is described without the need for dramatic reversals of fortune, earthshaking revelations, or arresting climaxes. I do not claim that in the novel, as in life, there are no major turns of events or dramatic conclusions; rather, the duty of democratic reasoning is to find, in advance or in retrospect, all the early signs, the small traces and underlying currents, that with a slow and gradual ripening lead to an eruption of drama. The very same democracy that lends an attentive ear to the actions and dispositions of the "ordinary" man will not absolve him, for better or for worse, from the responsibility of dramas and reversals of fortune in his life and society; the novel does not have recourse to ambiguous terms such as fate or destiny. By the very nature of the genre, the novel can better fulfill its democratic duty of taking responsibility seriously than can any of the other genres of literature.

(4) Drama, short stories, and poetry are usually experienced in a relatively brief time; the individual is temporarily distracted from his personal life and involved solely, at times hypnotically, in the literary event. The novel, by contrast, must be read in a relatively greater length of time and includes "intermissions" during which the individual can participate in other daily routines. In this way, the integration of the reader's personal life with the experience conveyed by the novel is more consistent and the interaction a richer one. Therefore, one can conclude that reading a novel is a less passive experience than watching a play or reading a poem or short story and that in the reading of a novel there is significantly greater participation; hence, the relation of the author to the reader is more democratic.

(5) The democratic inclination of the novel also is manifested in its abil-

ity to accommodate a wide range of nonfictional materials, from philosophical extracts, to newspaper articles, to judiciary protocols, and so on. This ability already was evident in the nineteenth century in the lengthy historiographic additions by Tolstoy to *War and Peace* or, even earlier, in Laurence Sterne's *Tristram Shandy*, published in 1759. Joyce incorporated much nonliterary material into *Ulysses*. I see a democratic principle in this synthesis, because in this way the literary text undermines the hierarchy that places fiction above reality. A basic principle of democracy is attentiveness to the voices of reality, with each voice possessing a democratic status, that is, an equal right to be heard. Although the limitations of reality may often lead us to prefer one voice over another, we are still aware of the existence of the equal dignity of each voice. In literary writing we are given license to "ignore" the voices of reality in favor of the artistic selection of the author, who, for example, may at times compel us to accept a story about the Vietnam War diminutively narrated in the consciousness of an old man in a nursing home thinking about his grandson serving at the front. My point is that there is something undemocratic in literature that allows it to tell its story from an arbitrary and reduced perspective and to ignore other points of view. Literature seems to be based on the assumption that the democratic truth is not identical to the profound poetic truth. Therefore, some writers feel the need to incorporate documentary texts into their novels to compensate for and tone down the arbitrariness of their perspective so as not to widen the gap between literary truth and democratic truth.

(6) One of the democratic safeguards developed in recent years is a system of supervision over decision-making processes. It is not enough that the government be elected by the people and gain a mandate to act on its behalf; it must also continuously and openly demonstrate its decision-making policies. Democracy must give an account of itself not only at election time but at every moment of its existence. The same perspective can be applied to the novel more than to any other literary genre. That is because the novel possesses the capability, quantitatively as well as by virtue of tacit agreement between reader and author, to interrupt the flow of the story and expose the method or process of writing, the various alternatives available to the author or protagonist, the problems resulting from the execution of one of these alternatives, and so on. The novel possesses self-awareness and can lay bare its process of creation. Here one finds the fulfillment of a profound democratic principle: The reader can participate in policy making, can become a partner in the production of the work, and is no longer a passive subject who is hypnotized and bewitched by beautiful words.

III

I have now presented six illustrations of the democratic tendencies of the novel, and there well may be others, but it is time to revert to my initial inquiry: whether the consolidation and expansion of modern democracy in the last twenty or thirty years has favored the novel. Whenever I travel to different Western countries and ask about the latest novels, I sense no particular excitement when people speak about the current bestsellers. Especially noteworthy is the lack of eager anticipation of a major breakthrough. Although my knowledge of the inner workings of other arts, such as theater, painting, and music is limited, I have the feeling that in these areas as well, no dramatic revolutions are taking place.

As already stated, I do not wish to attribute the present static condition of the novel solely to the nature of modern democratic life; but I would like to underline how some contemporary democratic perceptions pose problems for the art of the novel. My feeling is — and at this point I am already indicating my closing argument — that if the novel, as the century nears its end, wants to take flight the way it did at the beginning of this century, it must throw off and even rebel against some fashionable democratic conventions and in this way improve its state as well as the state of democracy.

For the sake of manageability, I will once again limit myself to six considerations.

(1) Modern democracy's passion for heroes is declining. Not only do people no longer believe in heroes, but also they distrust them. To a certain extent, that is a favorable development, since heroes can, indeed, be dangerous. But because the controlling mechanisms of computerized bureaucracy and efficient data banks have become highly complex, the process of the decline of heroes has become pathological. The citizens who applaud and pin their hopes on a certain candidate already know that a few months after he or she is elected, they will be disappointed. Disillusion is built into election expectations. Modern literature is increasingly sustaining itself on antiheroes, who can be clearly distinguished from heroes, though I may be oversimplifying. On the one hand, the antihero encourages readers to identify with his or her hopes, feelings, and shortcomings, but despite their empathy, readers do not want to be in the antihero's place. On the other hand, the hero is more than someone with whom readers identify; rather, they want to fill the hero's shoes and go through the same process because it is valuable and meaningful to them. For instance, I would like to have experienced what

Pierre Bezhukov went through in *War and Peace*—his transformation from a decadent aristocrat whose servant dresses and undresses him into a man who independently endures the hardships of war to emerge solid and strong. Or I would like to have been Hans Castorp in Thomas Mann's *Magic Mountain*, who goes into seclusion for seven years, enters a state of deep impassivity, and from within this state experiences profound spirituality; or even Quentin in Faulkner's *The Sound and the Fury*, who struggles with the pain and emotion of incest in a very moving way despite the horror and suffering involved. Why? Because these people struggle with formidable and significant forces that make them great. But I would not want to be Herzog in Saul Bellow's novel of the same name, or Portnoy in Philip Roth's *Portnoy's Complaint*, although I can feel and identify with many of their experiences.

A literary hero draws me out of myself and lifts me up high, whereas the antihero causes me to withdraw into myself so that I may better contemplate my weaknesses and shortcomings. No doubt this is not an objective observation, and each reader must decide for himself or herself. It seems, however, that the hypercritical spirit of modern democracy seriously affects novelists, so that they do not risk trying to take flight with their heroes and instead prefer to devote themselves to discovering additional nuances in the foibles of humankind. Without the belief in their ability occasionally to create a hero, writers of novels will not be able to burn brightly again.

(2) I would like to introduce my second argument with the opening of an article written by Irving Howe, the wonderful American critic, who died a few years ago. The title of the article is "Mass Society and Postmodern Fiction."

> Raskolnikov is lying on his bed: feverish, hungry, despondent. The servant Nastasya has told him that the landlady plans to have him evicted. He has received a letter from his mother in which she writes that for the sake of money his sister Dounia is to marry an elderly man she does not love. And he has already visited the old pawnbroker and measured the possibility of murdering her.
>
> There seems no way out, no way but liquidation of the miserly hunchback, whose disappearance from the earth would cause no one any grief. Tempted by the notion that the strong, simply because they are strong, may impose their will upon the weak, Raskolnikov lies there, staring moodily at the ceiling. It must be done: so he tells himself and so he resolves.
>
> Suddenly—but here I diverge a little from the text—the doorbell rings. A letter. Raskolnikov tears it open:

Dear Sir,

It is my pleasure to inform you, on behalf of the Guggenheim Foundation, that you have been awarded a fellowship for the study of color imagery in Pushkin's poetry and its relation to the myths of the ancient Muscovites. If you will be kind enough to visit our offices, at Nevsky Prospect and Q Street, arrangements can be made for commencing your stipend immediately.

(signed) Raevsky

Trembling with joy, Raskolnikov sinks to his knees and bows his head in gratitude. The terrible deed he had contemplated can now be forgotten; he need no longer put his theories to the test; the way ahead, he tells himself, is clear.

But Dostoevsky: is the way now clear for him? May not Raskolnikov's salvation prove to be Dostoevsky's undoing? For Dostoevsky must now ask himself: how, if the old pawnbroker need no longer be destroyed, can Raskolnikov's pride be brought to a visible climax? The theme remains, for we may imagine that Raskolnikov will still be drawn to notions about the rights of superior individuals; but a new way of realizing this theme will now have to be found.

It is a common assumption of modern criticism that Dostoevsky's ultimate concern was not with presenting a picture of society, nor merely with showing us the difficulties faced by an impoverished young intellectual in czarist Russia. He was concerned with the question of what a human being, acting in the name of his freedom or disenchantment, may take upon himself. Yet we cannot help noticing that the social setting of his novel "happens" to fit quite exactly the requirements of this theme: it is the situation in which Raskolnikov finds himself that embodies the moral and metaphysical problems which, as we like to say, form Dostoevsky's deepest interest.

The sudden removal of Raskolnikov's poverty, as I have imagined it a moment ago, does not necessarily dissolve the temptation to test his will through killing another human being; but it does eliminate the immediate cause for committing the murder. Gliding from fellowship to fellowship, Raskolnikov may now end life as a sober professor of literature. Like the rest of us, he will occasionally notice in himself those dim urges and quavers that speak for hidden powers beyond the assuagement of reason. He may remember that once, unlikely as it has now come to seem, he was even tempted to murder an old woman. But again, like the rest of us, he will dismiss these feelings as unworthy of a civilized man.

The point Irving Howe makes is that the desired balance between the objective and spiritual despair of the heroes of yesteryears' novels (Raskolnikov's poverty and his superman theory), and the integration of these two, produces a type of persuasive and powerful authenticity that validates the actions and developments of the novel. This balance seems to have faded from the modern democratic world. Democratic society, especially the welfare state, generates the illusion that every problem is solvable by means of a social compact if only one knows the rules of the game. Therefore, if a student at Michigan State University or the University of Chicago goes hungry, he has only himself to blame because he simply did not know enough to approach the dean of students office and fill out the correct forms for requesting assistance. Therefore, too, his hunger could not possibly provide the basis for a state of disenchantment from which revolutionary ideas could grow. It follows that the contemporary novel must explain the distress driving its heroes' actions mostly by focusing on their psychological complexities rather than the problems resulting from a distorted social order, class discrimination, war, or oppression. Democracy gives us the promise or feeling (often imaginary) of a great liberty, of equal opportunity for all, and if the individual is hard pressed in an oppressive social predicament, then he or she is blamed for not having used the right channels or adequately persuaded others to change things. Thus, in the contemporary novel, cancerous diseases, mental handicaps, or traffic accidents are increasingly replacing poverty or war, the class struggle, or the social prohibitions of the nineteenth century and the beginning of this century as a means to provide some of the flesh and blood of an objective distress to the agonizing hero. Novels about troubles, however, will always be inferior to novels about problems.

(3) I am thus led to what seems to me the most important point — the increasing frailty of the moral dimension of the contemporary novel. Any work of prose or drama that deals with human relations also contains a measure of moral argument. I call it the "moral gene" found in every form of human relations, even those between a writer and his or her audience in an essay about democracy and the novel. It seems, however, that the modern novel has severely reduced its tendency to place moral issues at the forefront as the central focus of its story. Because of the expertise of modern psychology, which has provided us with efficient tools for understanding the human soul through and through, and which has led us to search for sources of disruption and affliction as far back as the mother's womb, novelists have lost or given up the ability to take a moral position. To understand means to forgive. Yet, democracy is continuously obligated to examine and evaluate every social and political move in order to define the moral value of either incum-

bents or candidates. One must prepare for the day when they will run in upcoming elections. What essentially has happened is that the entire role of moral judgment has been scooped up by the media, which daily erect drive-through field tribunals that shoot both right and left. I have nothing against journalistic rushes to judgment, which have recently been on the rise; modern democracy must ensure freedom of speech even at the price of whims and transgressions. Journalism, however, must not serve as an excuse for absolving literature from its moral duty. The tools of journalism are external and often superficial; they do not even approach the depths at which great literature may dwell. Instead of Harriet Beecher Stowe writing *Uncle Tom's Cabin*, if a television crew had been sent to do the story, no matter how capable it was, then I do not think the shock to American society would have been the same. That is because literature does not report on the agonies of Uncle Tom but turns the reader into Uncle Tom himself. A kind of paradoxical situation results.

In the very democracy that aspires to the participation and responsibility of everyone in the making of society, literature retreats from partaking in a more openly political fashion. Perhaps this situation arises because democracy has liberated politics from images of cruelty and evil but has replaced them with images of mediocrity, irreverence, and mudslinging, which in turn repel the writers of novels. And the democratic responsibility imposed on every person seems to have acquitted novelists of the necessity for political proaction that was once deemed respectful by many great authors of the past.

(4) At this point we can identify another negative association between democracy and the novel. The considerable importance modern democracy ascribes to the status of minorities, which evolves from the democratic principles of preserving minority rights and preventing the tyranny of the majority, has generated a wealth of literature. This corpus has been given rather unappealing labels, such as "minority literature," the literature of various ethnic groups, gender literature, and so on. Yet, despite its significant contribution to the empowerment and self-awareness of minority groups, the novel as a vanguard genre does not benefit in the long run. The democratic zeal of a group in its striving for autonomy and its excessive preoccupation with its own inner workings have disrupted the novel's potential for grand-scale integration, which is the very essence of great literature.

I will try to elaborate. In what I regard as the most important work written in this century, *The Sound and the Fury*, Faulkner's images of black Americans provide us, especially in chapter 4, with strong insights into the entire group without losing the group's vital relation to the world of white Ameri-

cans. The character of the old servant, Dilsey, becomes, without losing her African American uniqueness, a reliable narrator of what goes on in the center of the book's world. And the reader's solidarity with her, whether the reader is white or black, becomes an intimate experience of that world. Gender and ethnic zeal in the name of rigid democratic imperatives undermine the potential for the extensive human solidarity that a great novel needs to convey to the reader.

(5) My next argument concerns the excessive fear of critics that has recently been the plight of novelists. The politics of democracy loves to keep company with numerous experts so as to ensure constituents that their representatives are receiving only the best advice. Because politicians who run for election are not authorized by monarchs, nobles, or military or state authorities, they must secure their reputation by relying on highly accredited experts who have worked long and hard for their credentials. Although every field has experts who contradict one another, all experts know one thing — they must maintain safe margins for error in order to leave room for their own mistakes. Therefore, although we all have ample experience with critics who make crass or grave mistakes, as in the cases of the Vietnam War or the dissolution of the Soviet Union, experts are still able to create a feeling of inferiority among nonexperts, including novelists, who in the past were not afraid to take a comprehensive view of reality and interpret it either through the eyes of their heroes or an omniscient narrator.

The fall or deterioration of the comprehensive stance of authority, which novelists in the past had no qualms about adopting in their books, is one of the major losses inflicted on the democratic novel by modern experts. Thomas Mann, not many years ago, could permit the hero of *The Magic Mountain*, Hans Castorp, to lie awake for nights on end on the veranda of the Davos Sanitarium for tuberculosis patients and ponder detailed thoughts on spiritual and intellectual themes. Dostoevsky's Ivan Karamazov provides us with some brilliant orations on faith and religion. Without discrediting the increasing specialization in modern life, one concludes there is still room for the daring and grand integrations that the heroes of Saul Bellow often have performed. Certainly, not a few errors have been made, but at the same time one can find brilliant ideas that shed light on distant horizons about which not a single expert would even dare to think. The intellectual writer, whose moral pathos could identify deep-lying processes not even imagined by others, has retreated before the onslaught of experts so typical of modern democracy.

(6) My final point is more external to the novel, relating to the negative interaction between democracy and literature in general and the novel in

particular. It is the harm wrought by the democracy of numbers. At the base of the concept of democracy is a belief that the majority rules; not that the majority is right, but that it rules. Quantity does possess a qualitative force. If a great number of people think something, then that something is to be respected. Therefore, one cannot assume the democratic principle of the people's preference for one leader over another and at the same time make light of the people's desire to read this work instead of that one. The novel, far more than the short story, poetry, or even drama, must continuously vie for the public's taste, and, because of the aforementioned democratic principle, a literary hierarchy has evolved in which the quantitative success of books is based on sales that are publicly listed and accounted. This hierarchy influences not only the reader's awareness but also some writers and causes harm. In the United States, where the principle of numbers or quantity is the most powerful, this "democratic" evaluation has created a gap of disenchantment between the literature that tries to jockey for a higher position on the bestseller list and the literature that does not even attempt to enter this competition. In Europe and South America, there still exists a cultural imperative in support of the struggle against the democratic criterion that the voice of the people is the voice of God. Writers must feel that they possess an elitist destiny — even if their work ends up in a musty attic — in order to have something meaningful to say to the world. Yet, democracy continuously strives to erase elitist distinctions. How, then, will modern democracy give individuals the feeling they are both unique and special while at the same time maintaining their rights are always equal to those of everyone else?

IV

One can infer from all the "nays" I have presented what the "yeas" may be. It is quite simple. Novelists must take conscious and purposeful counteractions in order to overcome the obstacles that democratic life has placed along their path. I believe (and perhaps here I damage my reputation by being interpreted as naive) that bolder and better novels, novels that strive to depict not only what *is* but also what *should be*, can surely be of significance to the enhancement and betterment of democratic life.

Black-and-white reproduction of Komar and Melamid's America's Most Wanted
(photo: D. James Dee). Courtesy of Ronald Feldman Fine Arts, New York.

Museums and the Thirsting Millions

Arthur C. Danto

In Henry James's *The Golden Bowl*, one of the main characters is a wealthy art collector, Adam Verver, who accumulates artworks of the highest quality and in the greatest quantity, in order to stock a visionary museum in his own city — "American City," as James somewhat flatly calls it — to slake what he imagines is an immense thirst for beauty on the part of those countless workers through whose labor Verver has become a wealthy man. As if in fulfillment of that debt, he will set up a "museum of museums" — a house on a hill "from whose doors and windows, open to grateful, thirsty millions, the higher, the highest, knowledge, would shine out to bless the land."[1] The knowledge was in effect the knowledge of beauty, and Verver must have belonged to a generation that still resonated to the stirring thought that beauty and truth were identical. This meant, in Verver's mind,

that "release from the bondage of ugliness" meant release from the bondage of falsehood, and hence exposure to beauty was equivalent to a curriculum of knowledge.

I think it unlikely that Verver greatly analyzed the theory that drove him, although he was in a position to measure "the urgency of release from the bondage of ugliness," James tells us, for until Verver discovered the deep reality of artistic beauty, he had been "comparatively blind." At a certain moment, with the force of revelation, the discovery of perfection revealed to him that the desire for it had been present from the beginning, and this, too, was part of what he had been blind to, namely, his own aesthetic thirst. His "museum of museums" was to be a "receptacle of treasures sifted to positive sanctity." The people of American City were to be the beneficiaries of what it took time and struggle for him to discover. And, I think it fair to say, something like the Verver spirit is palpable in the great museums erected in America in *The Golden Bowl* years (it was published in 1904).

The Brooklyn Museum, opened to the public in 1897, is a good example of Verver's spirit. It was designed by the great New York architectural firm of James's time, McKim, Mead, and White, which was responsible for Columbia University in Morningside Heights and for many of the opulent structures of the city in that optimistic era. The Brooklyn was meant as a museum of museums in two senses. It was to be the largest structure of its kind in the world, hence the augmentative sense in which we speak of the "king of kings," and in the aggregative sense it was to be made up of several museums, each devoted to some department of knowledge. There was even to be a museum of philosophy, set on the highest point in Brooklyn, and though only the West Wing of the projected structure was erected, it transmits its meaning through the classical temple inserted into its facade, with its eight colossal columns.

There was something almost touching in the disparity between the architectural proclamation of grandeur and the limited extent of the fine arts holdings when the museum opened nearly a century ago. There is also something touching in the disparity between its vision and its incomplete state. The Brooklyn community clearly never rose to the tremendous vision embodied in this great architectural fragment. Its circulating exhibitions are visited by members of the Manhattan art world, its permanent holdings are of the highest scholarly significance, its public collections are on the agenda of the Brooklyn public schools, it is a valuable resource for the increasing population of artists who live in Brooklyn but who would prefer, all things considered, to live in Manhattan if they could afford it. The Brooklynites who are neither artists nor scholars and older than school age show no great

evidence of the thirst the high-minded Ververs of Brooklyn had in mind for a museum "worthy of her wealth, her position, her culture and her people."[2] Aside from the throngs of schoolchildren who sweep through like flocks of shore birds, its galleries are like the vast empty spaces those of a certain age are nostalgic for in the museums of their youth.

For the moment I want to leave aside the thirsting millions of the borough of Brooklyn — and of all the communities in the nation that possess largely unvisited museums erected in the spirit of the museum of museums — and reflect on what the Ververs of the nation must have supposed justified their beliefs in the value of a museum. Verver had certainly experienced art before he attained his revelation — before, in James's words, "he scaled his vertiginous peak." But he had not experienced it, as we might say, using an unfashionable word, existentially or transformatively. By this I mean he had not experienced it in such a way that it provided him with a vision of the world and of the meaning of living in the world. There are such experiences with art, none more compelling than the one Ruskin describes to his father in a letter of 1848. It took place in Turin, where Ruskin was distracting himself with copying a detail of Veronese's *Solomon and the Queen of Sheba* in the municipal gallery. He wrote the letter after hearing a sermon, preached in the Waldensian faith, and the juxtaposition of the sermon and the painting served to "unconvert" him.

> One day when I was working from the beautiful maid of honor in Veronese's picture, I was struck by the gorgeousness of life which the world seems constituted to develop, when it is made the best of. . . . Can it be possible that all this power and beauty is adverse to the honor of the Maker of it? Has God made faces beautiful and limbs strong, and created these strange, fiery, fantastic energies, and created the splendor of substance and the love of it, created gold and pearls, and crystal, and the sun that makes them gorgeous, and filled human fancy with all splendid thoughts; and given to the human touch its power of placing and brightening and perfecting, only that all these things may lead His creatures away from Him? And is this mighty Paul Veronese . . . a servant of the devil; and is the poor little wretch in a tidy black tie, to whom I have been listening this Sunday morning expounding Nothing with a twang — is he a servant of God?[3]

Ruskin underwent, through experiencing a great painting, a transformation of vision, and he acquired a philosophy of life. James has left us, so far as I can tell, no comparable episode for Adam Verver, though my sense is that it was probably equivalent in some way, even if it had most likely to do

with "the splendor of substance and the love of it—gold and pearls and crystal." Verver courted his second wife by taking her to Brighton to view a collection of damascene tiles. James does describe these: "The infinitely ancient, the immemorial amethystine blue of the glaze, scarcely more meant to be breathed upon, it would seem, than the cheek of royalty." Perhaps because Adam Verver is going to propose to a young and beautiful woman, he thought "perhaps for the first time in his life, of the quick mind alone, the process really itself, as fine as the perfection perceived and admired."[4] In any case, being struck by the gorgeousness of substance, Mr. Verver simultaneously saw the circumambient uglitude, which, I at least infer, he must have supposed to be irremediable or he would, given his vast energies, have found some way to change those conditions directly. Instead, he thinks of art as something that reveals and at the same time redeems the bleakness of ordinary life. He feels a certain bleakness even in his own widowed existence, for he would not otherwise risk so much in embarking on a second, dangerous marriage—unless he saw the beauty he would acquire as equivalent to what a great work of art would bring into his life.

These are not what one might call routine experiences with art or, in the case of Ruskin, routine museum experiences. Each has encountered works of art in some existential context that the art then throws in perspective, like a piece of philosophy read at just the right moment. It is difficult to know if any of the other works in Turin's Municipal Gallery, or the damascene tiles, would have done the trick at any other time. It is also worth observing that the experience did not especially make Verver and Ruskin better persons. Verver really did try to use the model of the artwork and of the museum as a model for human relationships, marrying his daughter off to what she describes as a *morceau de musée*, and turning his own ornamental wife into a sort of docent for the museum of museums. The museum is probably a very poor model for a happy life. And Ruskin's sad unconsummated marriage with the luscious Effie Gray suggests that the robust hedonism underwritten by Veronese did not dissolve his sexual inhibitions. Doubtless a pathologist would see significance in the fact that the "detail" that obsessed him was the flounce on the maid of honor's skirt. Notwithstanding that their lives fell short of the art that redeemed them, both men felt it imperative to extend to ordinary men and women the benefits of art—Verver through the museum of museums, Ruskin through his writings and his teaching of drawing at the Working Men's College in London. Both were aesthetic missionaries.

The possibility of such experiences as those described above justifies the production, maintenance, and exhibition of art, even if the possibility, for whatever reason, is unactualized for most persons. The experiences are un-

predictable, contingent on some antecedent state of mind, and the same works will not affect different persons in the same ways or even the same person on different occasions of experiencing them. This is why we go back and back to the great works: not because we see something new in them each time but because we expect them to help us see something new in ourselves.

Solomon and the Queen of Sheba is difficult to find in color reproduction because it is now, as a result of scholarship, believed to be mainly or altogether the work of Veronese's workshop. It does not figure as one of the mandatory Veronese's, and one wonders whether Ruskin, if he had known that, could have been transformed as he was. I know of no special condition an artwork must satisfy to catalyze the reaction: Few works have meant as much to me as the *Brillo Box* of Warhol, and I have spent a fair portion of my waking time in working out the implications of that experience. I would only say that art can mean very little to someone who has so far been, as was Adam Verver while he was amassing his great fortune, "blind" and numb to art, even if he or she has experienced it or even lived with it. And the museum itself is justified through the fact that, whatever else it does, it makes such experiences available. They have nothing to do with art history scholarship or with "art appreciation," whatever their virtues. And, in truth, the experiences can take place outside museums as well: I sometimes think my entire involvement with painting was abruptly determined when, as a soldier in the Italian campaign, I came across a reproduction of Picasso's Blue period masterpiece *La Vie*. I thought I would understand something profound if I understood that work, but I also know that I formed the resolution to make the pilgrimage to experience the painting itself, in Cleveland, whenever I returned to civilian life. Still, typically, it is in museums that most of us encounter the works that affect us in the way the Veronese affected Ruskin. At a press event not long ago, someone confessed to the curator of an exhibition of difficult photographs that he could not envision living with one of them, and her response seemed to me profound. She observed that it was after all wonderful that we have museums for work like that, work that demands too much of us to be able to contemplate having it confront us in our homes.

At the same time, for many, these experiences have made museums vulnerable to a kind of social criticism. Such experiences, or at least the kinds of objects that facilitate them, are not what the thirsting millions want. With this I return to the vast populations of Brooklyn for whom the museum is at best a childhood memory or at worst an architectural pile on Eastern Parkway of no particular significance to their life. A radical vision in the air these days, certainly in the United States, shares at least one premise with Adam Verver: The thirsting millions thirst for art. The art for which they thirst,

however, is not in principle that with which the museum has so far been able to provide them. What they seek is *an art of their own.*

In an exceptionally searching essay into what is called "community-based art," Michael Brenson writes:

> Modernist painting and sculpture will always offer an aesthetic experience of a profound and indispensable kind, but it is one that can now do very little to respond to the social and political challenges and traumas of American life. Its dialogues and reconciliations are essentially private and metaphorical, and they now have limited potential to speak to those citizens of multicultural America whose artistic traditions approach objects not as worlds in themselves but as instruments of performances and other rituals that take place outside institutions. . . . Certainly images whose homes are galleries and museums can do very little to respond to the present crisis of infrastructure in America.[5]

This essay appears in a volume that describes and celebrates a rather extraordinary exhibition in Chicago in 1993, called *Culture in Action*. A number of groups about as far removed in social distance from, let us say, the Art Institute of Chicago as it is possible to imagine were led by artists to create an "art of their own," which in its turn was about as far removed in artistic distance as could be imagined, with qualifications, from what that great and imposing structure houses as great and imposing art. Brenson, who had been the distinguished art critic for the *New York Times*, is spiritually at home in such institutions, and he writes, even in this essay, in ways regarding the art they contain that Adam Verver and John Ruskin would recognize and endorse:

> A great painting is an extraordinary concentration and orchestration of artistic, philosophical, religious, psychological, social, and political impulses and information. The greater the artist, the more each color, line, and gesture becomes both a current and a river of thought and feeling. Great paintings condense moments, reconcile polarities, sustain faith in the inexhaustible potential of the creative act. As a result they become emblems, inevitably, of possibility and power. . . .
>
> To audiences who love painting, the experiences this kind of concentration and coherence offers can be not only profound and poetic but also ecstatic, even mystical. Spirit is incarnated in matter. . . . Not only does an invisible spiritual world seem to exist, but it seems accessible, within the reach of anyone who can recognize the life of spirit in matter.
>
> Painting points toward the promise of healing.

This is a fairly exalted characterization of the art of the museum, and there is hardly any scale by which it can be rendered commensurable with "an art of their own" of the kind to which *Culture in Action* dedicated itself. Probably the most controversial work was *We Got It!*, a candy bar produced by members of the Bakery, Confectionery, and Tobacco Workers' International Union of America, Local No. 552, and described in the text as "the Candy of their Dreams." There is, as I say, no scale that would have this work at one location and Veronese's *Solomon and the Queen of Sheba* at another. A response to this statement, one which I regard as dangerous but which has to be faced, is an analogy that renders all art compatible through relativization: Veronese is to the group represented by Verver and Ruskin — and by Brenson in one of his aspects — what *We Got It!* is to the group represented by the workers of Local 552. Just as the candy bar is "an art of their own" for the unionists, *Solomon and the Queen of Sheba* is an art of their own for the well-off white males such as Brenson, for whom painting is an emblem of possibility as well as power. This has the instant consequence of tribalizing the museum. It is valid for the group for whom the objects in it constitute an "art of their own" — and this leaves out that vast population of Brooklyn thirsting, according to the premises of this position, for an art of their own.

Because of the issues it raises, it seems to me that *Culture in Action* was a landmark exhibition. It crystallized so many of the issues that divide us into factions today that it will, I hope, be discussed until those issues are dissolved, whenever that will be. Some of them focus on the museum, inevitably, and it is on these I will make a few comments. I have been involved in these issues in various ways, and so in part I am speaking out of my own experience.

(1) *Public Art.* There has always been a certain kind of public art in America, namely, commemorative monuments, but in relatively recent times the Verver spirit, recognizing that the public would not go to museums, has sought to take museums to the public by putting artwork in public spaces. There the public could respond in the same way — aesthetically — as it would to works in a museum. This strategy was subtly architectural, in that it created a museum without walls by colonizing spaces in the name of a museum, ostensibly for the benefit of the public. The public itself had no say in the choice of art, which was determined by what I term the curatoriat — art experts who know, as the public in general does not, how to discern what is good. There is no question that this can be read as a play for power on the part of the curatoriat, and it emerged as such in one of the great artistic dramas of our time, the conflict over Richard Serra's *Tilted Arc* in Federal Plaza in New York. I am fairly proud that I argued for the sculpture's removal in

my column in *The Nation*, a position I doubt could have been argued by any art publication in America. I remember Tony Korner, the publisher of *Art-Forum*, saying that a great many there agreed with me but it was not possible for the magazine to say as much.

The art world drew its wagons in a protective circle at the hearings over the matter, but the piece was removed, and the ugly emptiness of Federal Plaza was restored to the public for its own unexalted uses. In my view, that controversy did more than any single event to reveal the power component in museum reality to the larger public. Well, temples have always been emblems of power, but in a way disguised by the spirituality of their practices and their claims. As long as the museums were represented as temples to truth-through-beauty, the realities of power were invisible.

(2) *The Public's Art.* There are two ways to address this issue. One is to give the public greater say in the art with which it must live in extramuseal spaces. This should not present inordinate difficulties and is an area in which participatory democracy would play a role. The public to be involved with the artwork should participate in the decisions that affect their aesthetic life. Christo engages the relevant public all the time; indeed, the decision-making process is part of the work he does, which is also ephemeral — an important point, since later generations are not stuck with it. This decision is still, however, based on the idea of the museum, that is, for the duration of the art, the extramuseal space is a detached museum precinct, the responses are museum responses, and the public has had input primarily as a consultative body, in effect, experts on the subject of their own wishes, preferences, and desires. The response of some California landowners to Christo's *Running Fence*, which was achieved partly through their allowing it to be achieved, compares in poetry and intensity to Ruskin's response to Veronese for those who have seen Christo's work in the Meisels' film. I will return to the idea of participatory aesthetics.

Before considering the alternative — to create nonmuseal art by transforming the public into its own artist — one should recognize that once the public has been admitted to the decision-making processes of the museum, both museum and public must determine where, if anywhere, a line can be drawn as to what may and may not be exhibited. In the United States, the public has been greatly exercised over art with sexual content and the concomitant issues of censorship. In Canada, there was a tremendous outcry recently over the acquisition of art of the most critically esteemed order — Barnett Newman's *Voice of Fire* and Mark Rothko's *Number 16*. It would appear that the issue of censorship could be avoided by tribalizing the mu-

seum; in effect, "they" determine what "their" art should be, and this deci-
sion is not made by the portion of the public who defines their identity with
their feet, that is, by staying out of the museum.

But the burden of taxation falls on all theys alike. This is not a problem
for a museum supported out of the deep pockets of the Ververs of the com-
munity, although donors may have to wrestle with their conscience over al-
locating dollars to art rather than other good causes. In contrast, a show like
Culture in Action received major support from the National Endowment for
the Arts, not to mention a page-long list of tax-exempt organizations. I have
no idea what it cost the taxpayers to produce the candy bars. The latter
did not make much money, for all the effort made to sell them to the candy-
hungry population of Chicago, and they tasted not one bit better for being
art. Yet, the candy could not have been made as art had the candy-making
plant not existed, which the confectioners were allowed to use for the time
it took to produce *We Got It!* Of course, Richard Serra was not obliged to set
up a steel-rolling mill to get the immense plates of weathering steel required
for *Tilted Arc*, but that is by the way.

Contemporary art is distinguished from perhaps all art made since 1400
by the fact that its primary ambitions are not aesthetic. Its primary mode of
relationship is not to viewers as viewers but to other aspects of the persons
to whom the art is addressed. Hence, the primary domain of such art is not
the museum at all, and certainly not public spaces constituted as museums
by virtue of being occupied by artworks that are primarily aesthetic and that
do address persons primarily as viewers. In an essay in *ArtForum* in 1992, I
wrote as follows: "What we see today is an art which seeks a more immedi-
ate contact with people than the museum makes possible . . . and the mu-
seum in turn is striving to accommodate the immense pressures that are im-
posed upon it from within art and from outside art. So we are witnessing, as
I see it, a triple transformation — in the making of art, in the institutions of
art, in the audience for art."[6] This passage was quoted as an enabling text in
Culture in Action, which did not surprise me, in part because my thought was
in some measure inspired by the previous endeavor of the chief mover of the
exhibition, Mary Jane Jacob. She is an independent curator of immense en-
ergy and social vision, and she mounted an exhibition of site-specific art at
Spoleto-USA that I found remarkable.

Extramuseal art ranges from certain genres not easily regarded as be-
longing to museums, such as performance art, through art (*We Got It!* is a
signal example) addressed to a particular community, whether defined along
racial, economic, religious, sexual, ethnic, or national lines, or along such

other lines as may come to identify communities. The notorious Whitney Biennial of 1993 was an anthology of extramuseal art suddenly given exhibition space, and the Whitney thereby acknowledged the trend I had in mind in the 1992 article. As ready as I was to support such art, I hated seeing it in the museum, but that shows my politically retrograde nature. The outcome of an art of their own is almost certainly a museum of their own — a special-interest museum, typified by the Jewish Museum in New York in its return to tribalism, or by the National Museum of Women in the Arts in Washington, where the experience of the art is connected to the way individuals identify with the community whose art it is, which splits the audience into those whose art it is and the others.[7] (The claim that "the" museum is already tribalized rests on the claim that it is just like museums-of-their-own for various theys — splitting the audience between the white male, etc., etc., on one side, and the disempowered, the marginal, etc., etc., on the other.)

(3) *But Is It Art?* Part of what makes community-based art possible, at least of the sort exemplified by *We Got It!*, are certain theories articulated in the late 1960s at the earliest, though an argument can be made that the ground was laid in 1915, when Marcel Duchamp advanced his first readymades. The most radical statement of the enfranchising theories is that of Joseph Beuys, for whom not only anything can be a work of art but also, even more radically, everyone is an artist (which, of course, is different from anyone can be an artist). The two theses are connected. If art is narrowly understood in terms, say, of painting or sculpture, then the latter thesis is that everyone is a painter or a sculptor, and this is as false on the face of it as everyone is a musician or a mathematician.

No doubt a psychological thesis is available according to which everyone can learn to draw or model up to a certain point, usually rather short of the point at which painting or sculpture as art begin. Similarly, perhaps everyone can dance or make music of some sort, but certainly short of the point at which these become art. I can detect no room for such invidious gradations in the Beuysian enfranchisement. It is art if it is art; otherwise, it is not art. There may be no special mark by which we can tell *We Got It!* from other candy bars, but certainly not the criteria by which candy bars themselves are graded into better and worse — by taste, size, ingredients, and so on. *We Got It!* may fall short of these on all such criteria and still be art, while they are merely candy bars. A candy bar that is a work of art need not be an especially good candy bar. It just has to be a candy bar produced with the intention that it be art. One can still eat it: Its edibility is consistent with its being art.

It is worth observing that the first in a series of what are called "multiples" by Beuys consisted of a piece of chocolate mounted on a piece of plain paper. It is rather ironic that a certain sense of "quality" derives from connoisseurship and the dynamics of the secondary market, such that someone might advertise one of Beuys's chocolates as of "especially high quality." This could mean, among other things, that the corners are sharp and the edges clean, which has nothing, one would think, to do with the spirit of the multiple as art. It would be like asking a high price for Duchamp's snow shovel on the grounds that "they don't make shovels like that anymore" (i.e., on the grounds of its workmanship and the thickness of its metal).

It is easy to see that "quality" has nothing to do with being art under Beuysian considerations, and it is in these terms that "quality" was questioned in a famous, controversial piece by Brenson in the *New York Times*: "Is Quality an Idea Whose Time Has Gone?" It is worth emphasizing that the irrelevance of the concept of quality is not as such a mark of "an art of their own." Women's art, thinking not of the fine arts as done by women but the art traditionally practiced by women (quilts are an obvious case) that was long excluded from museums of fine art, was clearly subject to assessment by reference to quality. Because of iconoclast prohibitions, Jews and Muslims did not produce painting and sculpture, but there can be little doubt that what they did produce as art was marked by the applicability of quality. Even the work of Beuys, "the most prophetic voice," according to Brenson, for *Culture in Action*, is sometimes better than at other times, and by criteria that the repudiation of the idea of quality threw into question.

I think there would be consensus on which of Beuys's works were best and why, and what makes them good when they are good. Indeed, Beuys's work provides experiences of the same order as those provided by the damascene tiles or Veronese's *Solomon and the Queen of Sheba*. In 1970, for example, Beuys put on a performance (he used the term "action") called *Celtic (Kinloch Rannoch) Scottish Symphony* at the Edinburgh College of Art. There is a photographic record of him, in his characteristic felt hat and hunter's vest, standing in a large bleak room, or kneeling on its paint-encrusted floor, surrounded by some electronic equipment. Here is a description of part of his performance:

His actions are reduced to a minimum: he scribbles on a board and pushes it around the floor with a stick in a forty-minute circuit of Christiansen [i.e., the pianist], shows films by himself (not entirely successful as the editing destroys the rhythm), and of Rannoch Moor drifting slowly past

the camera at about 3mph. He spends something over an hour and a half taking bits of gelatin off the walls and putting them on a tray which he empties over his head in a convulsive movement. Finally he stands still for forty minutes.

Thus told it sounds like nothing, in fact it is electrifying. And I am not speaking for myself alone: everyone who sat through the performance was converted, although everyone, needless to say, had a different explanation.[8]

I draw attention to the word "conversion," which echoes Ruskin's "unconversion." And I think everyone who reads the description wishes they had been there to experience it for themselves. There is sometimes a tendency to think about Beuys as if he were someone influenced by Beuys's ideas. But he was an astonishing artist with a compelling style and could have amazing effects on people.

It can be argued that the members of the marginalized communities that produced art to which value was relevant had internalized the values of the dominant but essentially alien artistic culture and that Beuys, for all that he was a prophet, remained contaminated by the institutions that formed him. True community-based art is subject to criteria, but they are not of the kind that apply to the dominant artistic culture, enshrined as it is in museums and their satellite institutions.

But it is not my aim here to protract the argument. It is possible to suppose that the kind of art the museum defines has had its day and that we have lived into a revolution in the concept of art as remarkable as the revolution with which that concept emerged, around 1400, and from which the museum as an institution exactly suited to art of that kind developed. I have argued, in a number of places, that the end of art has come, meaning that the narrative generated by that concept has come to its internally projected end. When art changes, the museum may fall away as the fundamental aesthetic institution, and the norm may become exhibitions of the sort exemplified by *Culture in Action*, in which art and life are far more closely intertwined than the conventions of the museum allow. Or the museum may itself become aesthetically marginalized as it becomes tribalized to what might still remain the dominant artistic culture, understood now as the province of certain sexual, economic, and racial types. That would certainly take a lot of pressure off the museum, but at something of a price.

Before speaking of that, let me take up the "But is it art?" question, with reference particularly to such works as *We Got It!* Artwork may not meet

"museum of museums" criteria, but, to the degree that we allow the possibility of conceptual revolutions in art, that need not count for a lot. What we can say is that there has to be some extrahistorical concept of art in order for conceptual revolutions to occur, which is the province of the philosophy of art, an area in which I and others have taken some steps. It is quite plausible that *We Got It!* qualifies as art according to a philosophical definition that no one so much as surmised had to be given before relatively recent times. It may not meet a number of criteria that have prevailed for some centuries, but there also may be a lot missing from work canonized by those criteria.

(4) *The Museum and the Public.* In saying that the museum is limited in what it is able to do for multicultural America, I tend to think the museum is a bit undersold. I do not believe the experiences communicated by Ruskin to his father, or by James through Adam Verver, or by the witness to Beuys's action in Edinburgh in 1970, are quite as restricted by class, gender, race, and the like, as the theses of multiculturalism make out. One needs, of course, some knowledge to ground those experiences, and it must be conveyed to people if they are to have those experiences. That knowledge is of a different order altogether from art appreciation of the sort transmitted by docents or art historians, and it has little to do with learning to paint or sculpt. It belongs to philosophy and to religion, to the vehicles through which the meaning of life is transmitted to people in their dimension as human beings.

To return to Adam Verver's conception of the thirsting millions, in my view, we are all thirsting for meaning: the kind of meaning that religion was capable of providing, or philosophy, or finally art. These, in the tremendous vision of Hegel, are the three (and only three) moments of what he terms Absolute Spirit. It was the perception of artworks as fulcrums of meaning that inspired the temple-like architecture of the great museums of James's time, and it was their affinity with religion and philosophy that was sensed as conveying knowledge. That is, art was construed as a fount rather than merely an object of knowledge. I think other expectations must have replaced it, reflected in other architectures, such as the Beaubourg masterpiece of Rogers and Peano in Paris. These other expectations, whatever they may be, are probably good and valid reasons for making, supporting, and experiencing art, but perhaps the museum is more and more an obstacle to be gotten round, predicated as it is on the possibility of the kind of meaning I have sought to illustrate. My own sense is that these expectations are dependent on that kind of meaning, and hence on the museum as dedicated to making it available.

The museum has sought to be responsive to so many other matters that it is a tribute to Verver's intuition — there is something for which the millions thirst — that its galleries are still hung with paintings, and its cases filled with marvelous objects of the kind for which he negotiated with his intended betrothed in Brighton a century ago.

(5) *Art and Democracy*. The emigré artists Vitaly Komar and Alexander Melamid in one sense lost their subject when the Soviet Union dissolved, for until then they were able to exploit the remarkable comic potential of socialist realist art, mocking the mock heroics of Lenin and Stalin from the relative safety of the New York art scene, where they were appreciated for their wit as much as for their predicament. Their true genius revealed itself when, artistic freedom being restored in their native land, they took as their subject the concept of the market, embraced by former apparatchiks with the same unquestioning conviction of their ancestors' acceptance of Christian orthodoxy. With the support of *The Nation*, they decided to emulate market research in order to find in the United States what they termed on the cover of the March 14, 1994, issue "a people's art." In focus groups and polls, randomly selected American households were asked to respond to a set of questions regarding aesthetic preferences. The results are certified as statistically accurate "within a margin of error of $+/-$ 3.2 percent at a 95 percent confidence level." The sample was stratified according to state, and gender quotas were observed. The answers constitute a singularly interesting piece of aesthetic sociology. Blue, for example, is by far America's favorite color (44 percent) and is most appealing to people in the central states between ages forty and forty-nine, conservative white males, making $30,000 to $40,000 — and who do not go to museums at all. The appeal of blue falls off as the level of education increases, but black is increasingly appealing as income drops: People making less than $20,000 are three times as likely to prefer black as those with incomes over $75,000, who are three times more likely to prefer green than those making less than $20,000. On the basis of this massive amount of data, Komar and Melamid produced what they title *America's Most Wanted* (see p. 56), a painting with as many of the preferred qualities as could be incorporated into a single canvas.[9]

Komar and Melamid's painting, executed in a modified Hudson River style and perhaps something more than 44 percent blue, shows a riverbank with George Washington, a typical American family group in outdoor clothing, and some animals, including a hippopotamus. There is a more saturated blue, but less of it, in *Russia's Most Wanted* (with Jesus rather than George Washington), and we will have to see what *China's Most Wanted* will look like when the data are in. "Most wanted," as an expression, has a use in American

English in connection with the list of criminals to whose apprehension the FBI assigns the highest priority: not the wish list of the National Gallery. But in any case, the "second most wanted" painting would not be, say, Gainsborough's *Blue Boy* or the *Mona Lisa* but the painting by Komar and Melamid incorporating the second most highly prized aesthetic qualities. In fact, *America's Most Wanted* only belongs on a list that includes paintings by Komar and Melamid based on similar data elsewhere. As a painting, it has no place in the art world at all.

What does have a place in the art world is the performance piece by Komar and Melamid: the opinion poll, the painting, the publicity, and so on. *That* work is probably a masterpiece. *That* work is about people's art without itself being people's art at all.

What is striking about *America's Most Wanted* is that I cannot imagine anyone really wanting it as a painting, other than as part of the performances of which it is a part. There may or may not be a parable of political philosophy in this, but the painting that is supposed to reflect the integrated aesthetic utility curves of Everyone in fact reflects the artistic utility curve of no one at all. The only condition under which I could imagine wanting the painting would be to find it at a flea market or a thrift shop and purchase it as an emblem of dissociated painterly expression, made by no one for no one. It fails as art because it fails to embody a meaning to which people can connect, and it does that in part because it is, as Nietzsche said about Zarathustra, a work for everyone and for no one. By contrast, *We Got It!* is artistically dense and rich, although were someone to put the question in a poll whether one would prefer an artwork made of paint to one made of chocolate, it is altogether predictable how the choice would fall — even if, as demonstrated in the work of Beuys or of Janine Antoni, a young American artist in whose famous work, *Gnaw*, a six-hundred-pound block of gnawed chocolate played a central role, chocolate brings into art so many connotations of comfort and pleasure that only a prejudice in favor of inedibility and against ephemerality can explain why marble and bronze were used as sculptural materials instead.

We Got It!, by contrast with *America's Most Wanted*, is at least an artwork for someone, namely, the confectionists of Local 552, and it carries meanings not ordinarily carried by chocolate bars, such as those having to do with autonomy and the kind of self-management that was so widely discussed as an ideological ideal in former Yugoslavia. Beuys's chocolate rises to a level of near universality as, to a degree, that of Janine Antoni does. Had Warhol painted — perhaps in fact he did — Hershey's chocolate bars, he would have expressed the consciousness of the culture as he did with soup cans, trading stamps, screen idols, disasters. The genius of Pop lay in its recognition of the

power of the icons of popular culture. They touch the meanings that define our lives, and it is because of the sheer externality of *America's Most Wanted* to what makes life meaningful that it fails as art. But its failure is its great inadvertent contribution to our understanding of why art matters for our lives. It may also tell us something we do not want to know about democracy as well. The great value of the democratic form of life may very well be that it does not express the personal values of those who live it but enables them to express those values in other ways.

Architecture and Democracy, Democracy and Architecture

Carroll William Westfall

God is faithful, and he will not let you be tested beyond your strength, but with the testing he will also provide the way out so that you may be able to endure it.

—I Cor. 10:13.

"The maxim held sacred by every free people: Obey the Laws" declares the lintel inscription of the Greek Revival courthouse serving Fluvanna County, Virginia, since 1830. The courthouse exemplifies the classical character favored in houses and public buildings during the early years of the American republic because it explicitly evoked the image of ancient Greece and Rome. But, as with the form of the new polity this classicism served, a visitor from antiquity would have been struck more by the differ-

I acknowledge the time made available for preparing this paper by the Center for Advanced Study at the University of Virginia through a Sesquicentennial Fellowship. The comments of several people have led to improvements in this final version: Father Allan B. Johnson-Taylor, Dean Bruce Abbey, Dean Steve Hurtt, Professor Charles R. Mack, Allan

ences than by the similarities this building bore to the ones he or she had known.

Despite the differences, this building recalls four points connecting us with our ancient forebears: In the founding of America, we considered ancient Greece to be the origin of the democracy we were establishing; we sought an American architecture in the architecture of Greek and Roman antiquity and its legacy; we saw a link between political and architectural forms that was not coincidental or optional but substantial, necessary, and consequential; and both political and architectural forms were in some way extracted from, or based on, nature. At the heart of these four points is the reciprocity between architectural and political form, a reciprocity that is reinforcing and synergistic. Doing well in one ensured the success of the other.

Today, the reciprocity of the political and the architectural no longer resonates within us. While we share the belief with antiquity and with our nation's founders that democracy is the best form of government, we embrace an architecture that was invented as an antithesis to the architecture that served both antiquity and the founders. Of course, times have changed. Ours is not an ancient regime. Indeed, in our modern polity we seek to bring all the people who live under our laws into the legislative process. And we recognize that our success in attaining justice requires that all people remain free to participate and that they participate as equals. These are principles on which our republic was founded, but such continuity in the political realm is lacking in the current architectural dogma, which supports an architecture fundamentally opposed to the founding ideals. In our political life we may still embrace the maxim held sacred by every free people, but in architecture we do not obey the laws. As Ada Louise Huxtable recently observed, "today, everyone [practicing architecture] is free to follow a personal path and muse. . . . There are no longer any rules; it hardly matters what philosophy drives the design or what vocabulary is being used."[1]

The votaries of professional architectural orthodoxy have deemed the modernist doctrine that rejects the rule of tradition and law in architecture to be the basis of the architecture of democracy. But this modernist claim is

Brangman, and the organizers of and participants in the Symposium on Science, Reason, and Modern Democracy. Also useful was the robust discussion following its presentation in a number of places: the universities of Virginia, Maryland, Notre Dame, and South Carolina, the Massachusetts Institute of Technology, and Andrews University. The present text owes a great deal to the insightful editing of Claudine Hof, whose assistance I hereby acknowledge.

John Hartwell Cocke, Fluvanna County Courthouse, Palmyra, Virginia, 1830 (photo: author).
This rural courthouse is built of brick, stone, and wood, the same materials used since the earliest
colonial period in Virginia. Its form and interior disposition reflect two influences: the State
Capitol Building in Richmond, which was designed by Cocke's friend Thomas Jefferson almost
fifty years earlier and was based on the form of a Roman temple, and the new interest in Cocke's
time in Greek architectural models.

wrong. Classicism is the architecture of democracy. By classicism I mean an explicit classicism, one that legibly incorporates traditional conventions and paradigms into current examples, one that operates within the laws appropriate to that art, and one that demands evaluation against all practice that has preceded it. This rich and complex architecture, whether ancient or modern, is supported on a tripod whose legs are the formal, the tectonic, and the civil. Each entails the other, but since each has a different task to perform, each can bear scrutiny independent of the others.

Formally, classical architecture revels in its good looks, but it does not propose that a marble Corinthian capital is simply a well-executed union of beam and support and is interchangeable with a welded steel joint.

In the tectonic sense, classicism understands that architecture is imitation within the art of building, and therefore the role of fiction in architectural form is to reveal the truth of construction.[2]

In the civil realm, classicism does not accept the equality of all buildings irrespective of purpose and does not subordinate larger civil purposes to immediate functional uses. In a civil architecture, a building always contributes to a larger whole that includes the landscape and all the other components a polity needs to support and promote the public life. A building is analogous to a citizen who recognizes that the best means of promoting private goals is through their magnification in the public realm. Buildings serve regimes

Allan Greenberg, The News Building, Athens, Georgia, 1988–92 (photo: Tim Buchman).
The building serves as the editorial offices, printing plant, and distribution center for three
newspapers and two magazines. Modern materials are used throughout, with curtain walls
made of brick, metal, glass, and precast concrete. The temple front is also of precast concrete, and
inside is a dramatic two-story polychromatic public lobby leading to executive and editorial offices,
an art gallery, conference rooms, and an auditorium.

first and foremost, and because this is so, architecture is linked with forms of government. This one leg of the classical tripod, the civil one, is the only one to be discussed here.

What follows shares a common ground with modernists in two premises. One is that we now know that modern democracy is the best form of government. It is the form that best promotes what the citizen wants and needs to live a full life. In classicism, the attributes of such a life are justice, goodness, truth, and beauty, and the city is the instrument used to reach those ends. This claim derives from the fact that city, or *urbs*, is the name historically given to the locus where the political life of a democracy is lived. From that premise the argument is made here that classicism is the architecture most adept at building cities whose chief intent is to assist citizens in their pursuit, when the objects of their pursuit are justice, goodness, truth, and beauty. This is not a formal issue.

The second premise, likewise shared with modernists, is that good buildings, or the best possible buildings, represent a pursuit in architectural form of the best possible synthesis of the formal, physical, and functional ends appropriate to architecture. Contrary to modernists, however, I argue that the best buildings result from the freest, best informed, and broadest civil inquiry, an inquiry conducted within the traditions and laws appropriate to architecture. This is a formal issue. Buildings that are explicitly and first of all civil buildings will look different from those that are not. They will not look

like modernist buildings but like classical buildings or those that have always put civil values above other values. Later in this essay it will be shown that modernist buildings attempt to consign the tradition of civil buildings to the past and replace them with buildings that look different. If the principal value of a building is its civil value, then it must appear to belong to the tradition of buildings that have served that value in the past. Otherwise, there can be no open, public discussion about how well it reaches its civil purpose. Only within the formal conventions of traditional, civil architecture can one find a parallel to and partner in the other practices of free inquiry that seek freedom and equality in a democratic regime.

Both architecture and democracy have their origins in ancient Greece. The Greeks invented the polis, or the willing assemblage of a people into a partnership that seeks to organize its affairs with a view to assuring the common good. The city has ever since been the community that transforms private ends into public actions and that uses public actions as means of reaching private ends. This was a disciplined community, a regime or a way of life under law, that depended on the participation of its members for its effectiveness.[3] Aristotle's reflections on the Greeks' experience with this new way of living together emphasized the cumulative, accretive nature of a city, which is composed of families that perpetuate the race, as well as of markets, settlements, or villages that assure sustenance (*Politics*, I, i). These lesser associations all require governing, but because a city seeks to secure a higher good than a market, namely, the good and noble life for its members, it requires a higher form of governing.

During the sixth and fifth centuries before Christ, the Greeks used several different forms of political organization for their cities. Democracy was only one of these, but many accepted it despite its shortcomings as the one offering the best approach to achieving the justice they sought from a regime. During the same period the Greeks also perfected the conventions that would become canonized as classical architecture.

This was no mere coincidence. Both a self-conscious political regime, of which the democratic regime was perhaps the best available form, and the newly conventionalized examples of the highest art (*arche-tecton*) were extracted from nature through imitation. For the Greeks, and within the tradition we inherit from them, the term "nature" refers to that order, truth, beauty, and goodness that we can know as a goal on the horizon of our strivings. It is something always before us, always beckoning, usually visible, but always beyond the point our actual actions will carry us. The best city pursues justice by seeking the common advantage of all. Its citizens place their intellect in charge of their passions and join as unequal members into a union

that provides each member with an improvement he or she would not have apart from the group.[4] In doing this, the city seeks to be a whole harmonious body, and in being such a whole, it imitates the order of nature.

The ancient philosophers tell us that such an imitation of nature was supposed to be the goal and aspiration of any Greek city no matter the political form of its regime. When done well, this imitation qualified any regime as just and devoted to goodness, truth, and beauty. And so, too, with buildings that serve regimes. The most successful buildings most closely imitated nature, the origin of the qualities the regime sought. The same architecture would therefore serve any regime. There was no special link between democracy and architecture. The link, instead, was between the justice of the regime and the beauty of its buildings.

It is commonly accepted as axiomatic that because the Athenians' regime was democratic, it was good; and because it produced the most beautiful buildings, its precedent established classical architecture as the architecture of democracy. But a closer look at the Athens that built the Acropolis we love reveals injustices we should not countenance. To finance those buildings, Pericles stole money belonging to the Delian League's defense fund and thereby exacerbated the Peloponnesian War. Those same Athenians pursued an unapologetic policy of self-interest during the Peloponnesian War, as when they justified the slaughter of the people of Melos by appealing to the right of the stronger.[5] And perhaps most interesting for Americans today, the buildings on the Acropolis were temples erected to the gods and not simply civic buildings serving the offices and magistracies of a democratic regime.

Indeed, the only admirable buildings built in Greece when democracy flourished were the products not of a democratic impulse but of piety.[6] They were religious as well as civic public buildings, since the political and religious then were intimately intertwined. And because they were religious, they were built both very well and conservatively. They imitated nature by comprising a knowable range of parts. Each part took a conventional form embodying the accumulation of traditional knowledge about the kind of part it was. And architects arranged all the parts in an intelligible and orderly pattern. The form of the parts and the patterns of their assemblage approximated the normative paradigm for both parts and patterns. In this way architecture portrayed the enduring qualities of nature. The buildings were examples of great architecture because religious piety demanded that inherited tradition strictly regulate the design of their architectural elements; thus, their assemblage into whole buildings exemplified accepted paradigms. That is, they were great buildings because they were conservative, not rashly

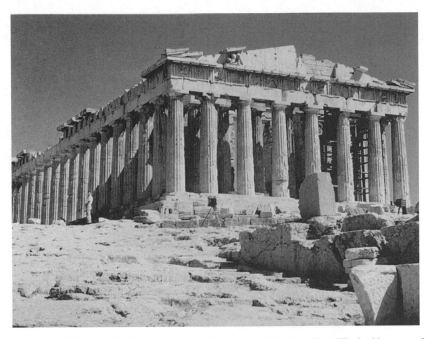

Callicrates and Ictinus, Parthenon, Athens, 446–438 B.C. *(photo: author). The building served as a shrine for the principal deity of Athens. It is built from marble and embodies the experience gained since the Greeks began constructing this kind of building in this kind of material in the seventh century* B.C.

innovative, and obeyed the rules extracted from nature and transmitted as traditional knowledge.

But this conservative architecture also was innovative. To invest it with the best, latest understanding of the traditional knowledge it embodied, architects had to reinterpret the traditional forms and paradigms each time they used them. Each building was therefore both a unique design and an example of a readily identifiable type of civic architecture made from recognizable parts.

In this way, the buildings were as constant and as changeable as the lives of the citizens involved in the city's democratic but unstable life. In producing them, the people relied on the dynamic interplay of their views to propagate and improve their version of freedom and equality. They therefore embody the result of pious skepticism in that they treat tradition with pious regard and challenge that tradition with new information and sharpened inquiry, finding thereby the best fit between the guidance of the past and the exigencies of the present. This interplay between tradition and innovation, between the unreachable horizon and the world in which people lived, aspired to produce beauty in buildings and justice in the regime, and it did so

by ceaselessly making modifications to both near and distant traditions. Here, democracy and architecture benefited from their public nature, which exposed them to open scrutiny. Such lively discourse staved off the sterility that accompanied the withdrawal into elitism and privatism that would occur in Hellenism and again in modernism.

Yet, we cannot forget that the buildings serving these democracies were temples paid for by looting their allies' resources and that their sponsors had slaughtered an entire people for no good reason. They hardly provide a worthy model for a connection between architecture and democracy in our modern understanding of it. But the disjunction between the Greeks' sense of integrity and ours hardly sanctions the present antimony between the basis of our polity and the foundation of our architecture.

Whereas the Greeks produced an abundance of political literature and a paucity of strictly civil buildings, the Romans did the opposite with little political theory but an abundant production of civil buildings and words about them. The best guide, because he knew what he was talking about and had the good luck to have his written work survive, is Vitruvius: "The work of the architect consists in the complementary tasks of building and explaining."[7] The explanation by this conservative architect of the Augustan period, along with the large literature surrounding his treatise and the vast, ruined remains of the Roman world, open for us a knowledge of the differences between building and architecture and about how to build well to facilitate living well.

Roman theory and practice touched a wider realm of building activity than had Periclean Athens. The buildings of Hellenic Greece that embraced architecture were homes of the gods; the purely civic buildings were, in contrast, makeshift. Secular construction suggested the constant adaptation to change characteristic of democratic cities rather than the preservation of pious traditions reserved for honoring the gods with temples and religious ceremonies. This marked contrast between the aspiration to the highest harmony on the Acropolis and a responsiveness to the changing circumstances in the agora and its residential surroundings revealed something of the Greeks' civic ambitions. They understood that the best possible life is lived within the tension between ethical aspirations and their frustrations at the hands of the ever-changing pathos of life as actually lived.[8]

The next period, that of Hellenism, stabilized regimes and inhibited the ways citizens could express their character through acting within the political community. Cities now began to produce strictly civic buildings capable of taking a proud place next to the buildings serving religion. Rome followed the Hellenistic, not the Hellenic, model.

The ancients categorized buildings hierarchically, and their architects, such as Vitruvius, also distinguished building from architecture.[9] Building (*aedificatio*), a necessary but lesser thing than architecture (*architectura*), must satisfy the conditions of commodity (*utilitas*), firmness (*firmitas*), and delight (*venustas*). These prerequisites are authoritative for building, for making material serve useful purposes, and they operate as joinery for the formal and tectonic legs of architecture's classical tripod. They provide all that is needed for a building to serve any particular secondary function, such as providing market space or dwellings for the unenfranchised. But these buildings cannot accommodate the more important purposes fulfilled in the precincts of religion and law or in the houses of those vested with civil authority. Architecture, not mere building, is needed for the civil buildings serving these purposes, and thus these buildings answer to a higher calling than mere building with its three criteria. Architecture's three criteria may be summarized in the terms *symmetria*, *eurythmia*, and *decor*. *Symmetria* refers to the quantities or numerical, proportionate character of a building's parts and the pattern of their assembly, and *eurythmia* extends to their qualities. Finally, *decor* orders the propriety of the parts and patterns. The rules governing this propriety are established in a political realm external to the practice of the art of architecture. At this intersection between the art of architecture and the political regime it serves, the political realm exerts an authority back into the formal and tectonic aspects of building.

The three criteria of building (commodity, firmness, delight) are absolutely essential for any building; the three criteria of architecture (*symmetria*, *eurythmia*, *decor*) are necessary in any important civic, religious, or residential building, the only kinds Vitruvius discusses at any length. These higher criteria for architecture are the same ones that are authoritative in a political regime seeking concord and justice, and they govern the conduct of individuals who seek to live well by exhibiting good character.

This is classical doctrine, a doctrine of imitation to which anthropomorphism is central. The arts imitate the order of nature; the actions of good men transpire in accordance with that order; the regime is a forum within which man's character may be revealed and exercised through his actions. Man's character, represented formally by his physical makeup, is an analogue to nature's harmonious order. Thus, the good city is the good man writ large; it facilitates man's aspiration to do good; and the best buildings are those that present the physical, intellectual harmonies of the well-formed man and the just and noble citizen in clear architectural form.

But note that this is a purely formal doctrine. It does not make moral judgments, or depend on them, except insofar as the arts arise from order

and not from chaos to embody the proportionate harmonies of the cosmos. That is, this doctrine lacks the reciprocal relationship between the good, the true, and the beautiful and the origin of those moral qualities in the author of the universe. To find this modern sense of the moral, we must move beyond pagan morality and examine the moral order of the Christian universe.

Christianity absorbed and transformed paganism. Like paganism, Christianity has anthropomorphism at its core. Christian doctrine fulfills the covenant God made with the Hebrews, who had learned that God made man "in our image, after our likeness" (Gen. 1:26). Christian doctrine sees God as the author of the universe of nature, Christ as God incarnate, God as the Holy Spirit in the Church, and the Church as the vessel provided for the redemption of mankind in a moral universe.

In transforming paganism, Christianity also transformed the interlocked political and architectural theory and practice it inherited. Most important, it expanded citizenship. As St. Paul explains, the citizenship of the City of God embraces all souls irrespective of their tribal or national affiliation and is indifferent to their political status in secular regimes: "For in one Spirit we are all baptized into one body — Jews or Greeks, slaves or free — and we were all made to drink of one Spirit" (I Cor. 12:13).

Christianity also transformed the physical legacy of the pagan world. No new architecture arose to provide Christianity's buildings, which would be revolutionary rather than transformational. Instead, Christianity's architects transformed the traditional conventions and paradigms of pagan architecture.[10] The city remained, but to it was added a meta-city, the City of God, the Church. As St. Augustine observed, the city of man is here to serve the heavenly city and "while it sojourns on earth, calls citizens out of all nations" to participate "in the perfectly ordered and harmonious enjoyment of God and of one another in God."[11] Within the City of God, which is resident within the city of man, Christians could enjoy perfect equality and freedom under the law of Christ.[12]

A half millennium of devastation ensued before men turned their attention to rebuilding the city of man to protect and nurture the City of God. Once under way, the rebuilding took two different but complementary forms.[13] One form given the reconstructed city was that of the monastery, a precinct closed to the secular world. Its form could provide a model for the city of man, and its citizens, the monks, could provide a model for how Christians should live in the world. The other model appeared in cities that sought order in secular affairs through adaptations of ancient Roman law. Some medieval cities perpetuated the tradition of top-down authority found in their imperial past, which favored the claims of church and empire. Oth-

ers sought to gain independence and ensure their freedom by asserting a bottom-up authority that would undermine the top-down pretensions of church and state. Officials trained in ancient law, literature, and rhetoric and working for Italian republics took the offensive against imperial and papal powers. In response, the pope, emperor, and lesser princes hired their own humanists to respond.

By the fifteenth century, the learned classes in both republican and princely strongholds had recovered and successfully employed the intellectual tools that had given classical thinking its biting edge. They restored the ancient habit of posing skeptical challenges to accepted conventions and traditional authority in order to elucidate modern political and architectural purposes.[14]

Leon Battista Alberti, the Florentine humanist, priest, and architect who served republicans and princes alike, zealously argued and adroitly illustrated how tradition mandated that different places have different political regimes and that the buildings of different regimes have different forms. Although differing from place to place, the buildings making up the physical fabric of cities would have in common the satisfaction of the criteria not only for mere building but also for architecture, which criteria he had recovered from Vitruvius and recast for modern use. The result was the modern classical doctrine that the architectural character of a place depends on the character of its regime and architectural concerns should encompass not only individual buildings but also the entire city. Building and architecture now embraced the entire range of activities occurring in cities. In imitation of nature, buildings and whole cities would satisfy the criteria of *symmetria* and *eurythmia*, while the criterion of *decor* would mandate that some buildings stand out and dominate others. This hierarchic disposition insisted that sacred buildings were always superior to profane ones and that public buildings outranked private ones. But because all buildings, from highest to meanest, were members of a body called the city, it became possible to compare one building with another and one city with another and thereby learn the purpose and relative beauty of each building and each city.[15]

Alberti established a modern theory of civil architecture. From his time on, at least until the advent of modernism, it was generally accepted that a building was a member of a whole urban body, which housed a regime that it served.

These cities were moral entities, cities of man serving the City of God, the latter itself being the presence of Christ in each citizen.[16] This fifteenth-century doctrine of the city as an ethical entity, as a proportionate harmony between man and God and among city, citizen, and building, unraveled

rather quickly under the pressure of the Reformation and the expansion of national ambitions. By the end of the sixteenth century, cities had become rhetorical devices working to legitimate the claims of particular regimes, and this they have remained in some places up to the present day.

Under this regimen, the princes of the Catholic regimes in Europe would not tolerate dissent, be they the pope in the imperial Vatican, the king of Spain in his residence modeled on the Temple and palace of Solomon, or the king of France at Versailles, built to trump the Spanish king and the pope. The dull but grandiose architecture of increasingly autocratic princely courts supplanted the lively practice and theory of late medieval and early Renaissance statecraft and architecture. In the absence of open debate and skeptical challenges, no matter how pious, architectural form could no longer contest the moral content of the regime that built it.[17] The result was an architectural rigidity and eventual gigantism housing hollow institutions.

It is human nature to bridle in situations that forbid dissent. When institutions are closed to challenge, the result is revolution, and *the* product of the revolution that unfolded in France was modernism. But earlier, a different way to contend with the rival claims of past and present had begun to unfold. In England, the ultimate fruit of Henry VIII's revolt against the Church of Rome and the ongoing English battle against absolutist popes and monarchs was transformation rather than revolution. This squaring of the present with the past was the legacy inherited and acted upon by the American colonists when their own overweening top-down authorities sought to deprive them of their ancient rights and liberties.

The American founders protected their legacy by transforming it, and the product was a modern democracy and an architecture to serve it. Like the ancient Greeks long before them, the founders posed challenges to old conventions and traditional authority, always retaining the transformed old for comparison against the new. And always their intent was the same: to produce an imitation of nature embodying a clearer understanding of nature's order.[18]

Fundamental to the new regime were the freedom and equality that had become self-evident truths. These derived from the very same ideas of natural right that the Christian doctrine of the equality of souls made possible. Freedom and equality are possible because some higher authority makes them available to men. In St. Paul's case, that authority is God in the person of the Holy Spirit. In the case of Jefferson and secular America, it is "nature or nature's God" and reason's capacity to convert power into lawful authority. The one is transformed in becoming the other, but with this important difference: The authority cited as providing the endowment of freedom and

equality in America is a lesser authority than the ones claimed by either Aristotle or the Church, and it therefore has correspondingly lesser goals. The state now seeks only to guarantee the rights and liberties of its members. It does not seek to do what Aristotle said the good city must do, namely, absorb the individual into a body within which he loses his liberty as he perfects his character or virtue.[19] Nor does it take up the Church's task of connecting man to God and thus to eternal grace.

As a result, all authoritative institutions in the American polity are secular. Ours is not a top-down theocracy but a bottom-up democracy. The good the regime can do depends not on governance descending from on high but on the aspirations of individual citizens working within secular political institutions.

In the civil realm of our regime, a central question has been with us from the beginning and remains open: In our aspiration for a just political community and for cities illuminating the love of justice and promoting the search for goodness, truth, and beauty, can the Church, or a church, be excluded? The First Amendment, which builds a wall between the institutions of church and state, says "yes." But in aspiring to live justly and nobly, is it enough to depend on the guidance of secular knowledge and the goodwill of citizens?

We know the problems the First Amendment is meant to solve: Throughout history architects and patrons have built buildings as moral entities in cities that men intended to be hosts of the City of God, and in so doing both the Church and the state built cities we admire and still attempt to emulate; but they also silenced, burned, exiled, or otherwise excluded and punished those whose beliefs threatened the sacred moral order. Such cities were hardly centers of open public discourse based on freedom and equality.

The American regime is not attempting to build the City of God on earth. But do we recognize that to build the good city of man we must acknowledge the central role of the City of God in the city of man? Can we build good cities only when we confront the relationship between those two cities, between the horizon we aspire to reach and the limits of the steps we take toward it, between the immeasurable proportionate harmony of nature and our limited calibration of its dimensions? Today's cities show that we are no longer animated by these questions. Now architects work with the belief that there is no connection between the good and the beautiful, and they build primarily for private individuals, for corporations, and for other bodies, such as universities. They and their clients avoid issues touching on church-state relations by taking the position that they are supposed to be on the secular, civic side of an unbreachable wall. This barrier sets the state

apart from the church, and within that secular world architects claim that their contribution to the city lies in their support of purely secular ends. These include efficiency, fair trading, and fair-mindedness, the ends of the settlement, not the city; of the market and nothing more; of the concerns of building that never reach the level of architecture. Is it any wonder, then, that what we build is not the city that aspires to justice, goodness, truth, and beauty but a lesser thing that for some is an efficient center of production yielding the good life and for others a life fraught by what we call the urban crisis?

In the current state of affairs, two choices present themselves. One is represented by "the maxim held sacred by every free people: OBEY THE LAWS" and the other by the slogan "the architect 'is free to follow a personal path and muse.'" The path most chosen now is quite unlike the one taken in the early days of the republic. Architecture remains the most public of the arts and the one that most directly serves the regime and depends on the political realm for its existence, but today it spurns any special relationship between political and architectural form. Those responsible for building forsake the primacy of the obligation to build good cities. The building of buildings is vouchsafed to those who respond to private, "artistic," intuitive understandings and imperatives beyond the reach of public understanding. And architecture is no longer a means parallel to the political life that people use to fulfill the nature of man. The purpose of architecture has been revolutionized because pious skepticism was banished by the same princes who quashed and frustrated democratic and republican forms in favor of unquestioned acceptance of whatever their higher authority, be it religious or secular, promulgated as authoritative. In such a climate buildings and cities became demonstrations of the legitimacy of that authority. Architecture came to serve regimes, not truth, even though the purpose of all states, as Machiavelli explained, was merely to survive, not to provide a means for citizens to live justly and well.

Revolution was supposed to negate the world of hollow, authoritative gigantism and renew mankind by canceling the past, with its traditions of intolerance and rigidity. The revolutionary regimes have collapsed, but the revolutionary habits survive into the present. Whether serving reactionaries or revolutionaries, the intention of the regimes erected on the foundations of those revolutions was to eradicate all connections between the present and any past that did not support current claims to legitimacy.[20] The past is a history to be used rather than a tradition that teaches. This holds for both the nineteenth-century eclectics and the twentieth-century modernists. The modernists appear different only because they claim to be unique and

because they seek to make a clean sweep of an ugly and unjust past that culminated in the cataclysm of World War I. But they, too, like their immediate predecessors, sought to launch history into a new world unconnected with recent and distant traditions.[21]

The current hegemonic international modernism (and its flaccid postmodernist incarnation) is based on those revolutionary foundations and on the technological and sociological rationalism of Gropius, LeCorbusier, Mies van der Rohe, Mendelsohn, and others who in the interwar years propounded a sleek, new, efficient manner of building. Technologically engaged and politically indifferent, international modernism has served sponsors ranging from Russian Bolshevists to Italian fascists and from European union syndicates to urban renewal agencies in America. The munitions factories of both sides involved in World War II were products of modernism. So, too, were the postwar buildings serving the bureaucracies of corporate capitalism and of governments, whether they were liberal, democratic, or totalitarian. Over the last fifty years, modernist architecture has reached its fullest potential as a nihilistic art serving morally impassive regimes with no ambitions beyond those found in the settlement. It is an apathetic, irreverent, and thus amoral idiom.

Ironically, the moral amnesia sanctioning this architecture derives directly from Adolf Hitler's firm embrace of modernism. The Nazis, like the modernist communists and socialists they fought, dismissed the City of God and looked only to dominating the city of man. Driven by an unparalleled evil, they took full authority over the regime's subjects in order to bring their vision of the ideal future state into being, pushing into the abyss whatever stood in their way.

Modernist architecture played a key role in securing Nazi aims.[22] Hitler and his party leaders were not indifferent to the ways architecture could serve them, but they often exercised only loose and disorganized control over many of the architectural aspects of their various enterprises. For factories, military installations, and death camps, the sleek, efficient, astylar (and therefore antitraditional) modernism amenable to the Bauhaus served their nihilistic purposes. A *Volk* style was used for the villages, towns, and governing centers in the east that were to be reclaimed from the Slavs for the Aryans. But for the centers in which the regime would display for itself and for others its claim to legitimate status within the imperatives of world history, the Nazis were very attentive to how architecture could serve them. In this setting, only the best possible classical dress would suffice.

Theirs was not a modern, traditional classicism but a mere modernist classicism. Under modernism, style was no longer the result of building well

but was instead a means of representing the claims of those responsible for the building. During the Nazi era, the political ramifications of a stylistic choice for a lesser building could be ignored, and such other considerations as economic efficiency or the predilection of the architect could be allowed to decide the issue. Modernism's newest forms spoke about efficiency and industry; its vernacular, Germanic, traditional forms would evoke the medieval past on which rested the regime's claims to the lands in the east; its exercises in classicism would link the regime with world history. In this context, its new astylar, antitraditional forms could evoke terror, while its vernacular and classical forms could inspire allegiance and attract followers. Hitler's choice of architectural styles and adamant conviction that architecture played an important part in representing the ends of a regime reveal that he understood the difference between rape and seduction.

Hitler made these choices because he recognized classical architecture as the only kind that could link the moral and the aesthetic. He found classical architecture no less useful than had the prerevolutionary popes and absolutist monarchs. But he was not simply their successor. For them, the alternative to ancient classicism was a different form of classicism, a contemporary iteration of it, a modern classicism, the most recent and best current result of a pious skepticism enacted in public. Similarly, the alternative to their statecraft was a different form of diplomacy seeking to build a different form of the good city or to build the same good city by different means. In Hitler's perverse world, things were quite otherwise. When he used classicism it was because he knew it could cast a powerful spell, and it could still do this because the new astylar modernism had not purged it from the world. Indeed, because astylar modernism was linked with revolution, classicism was seen as its opposite and therefore connected to a time when architectural forms intended to establish a moral state within the traditions of history, not merely an efficient one aimed at a future justice. Had classicism's meaning in architecture not still been current, Hitler's neoclassicism would have been an ineffective choice as the clothing for his evil regime.

Other regimes at this time used the legacy of antiquity for their public and private buildings. Americans have done so throughout the history of the republic. The revolution that gave birth to the nation had sought to reform the errors of traditional authorities. The new nation was founded on the recognition that since it is impossible to change the nature of man, government can seek only to protect the freedom, equality, and dignity with which nature endows all people. The Americans retained the habits of pious skepticism, whereas the French revolutionaries degenerated into impious skeptics seeking to impose their current understanding on the past, the present, and

the future. Their legacy is the hubris of modernism, both political and architectural, including that of the Nazis. By contrast, in America, a modern classicism in both politics and architecture was built into the regime's political foundation. So long as the arts of governing and building developed together in service to and as complements to one another, they were legitimate successors of the arts of Aristotle, Vitruvius, St. Paul, and Alberti. In America, classicism is an ongoing tradition; in France and its epigone, neoclassicism is the moniker given the buildings built to legitimate the regime.

Compare Hitler's Berlin and Roosevelt's Washington. Berlin was to be rebuilt using forms imported and imposed with minimal respect for the existing city. Architects built at a scale meant to overawe those who would see and use the city and its buildings, an order meant to make unmistakable the absolute authority of its Führer to the *demos*. And the materials were to be supplied by the labor of slaves who would work themselves to death.[23]

The coeval rebuilding of Washington embodies unbroken traditions of classicism in architecture.[24] The 1902 McMillan Commission guided the projects that sought to modernize a plan formulated a century earlier by architect Pierre Charles L'Enfant, President George Washington, and Secretary of State Thomas Jefferson. The twentieth-century designers would improve, not cancel or annul, the city's, and the nation's, legacy. The 1790 and the 1902 schemes underscore the institutions that allow the people, the *demos* of a representative republic, to govern itself. The public political process mirrored this commitment to self-government: Because implementation required the careful deliberation of issues by the duly constituted authorities, the most portentous changes would happen slowly and only after a public airing.[25] And the accelerated pace of building during the 1930s was meant to put people to work and to make them self-sufficient within the most open economy available within current circumstances.

Whatever might be said about the achievement or talent of individual architects (who was the better architect, Arthur Brown or Albert Speer?), and leaving aside the neglect of the intermixture and rich, compact variety of land uses characteristic of great cities but lacking in all urban schemes of this period, in what way do Berlin and Washington differ in their use of architecture to embody political intent? The key distinction is this: Hitler sought to present a beautiful face on a vacuous, insidious regime, a regime any morally healthy individual can recognize as evil, a regime any sane observer can see was at odds with the architectural costume intended to legitimate it. Washington achieved a resonance between classical architectural form and the aspiration for justice sought through the democratic activities of free and equal individuals.

Hitler's architects were good at what they did. But their classicism presents empty exercises in the formal aspects of architecture that were, or would have been, tectonically sound. And so were their counterparts in Washington, and in London, Paris, and Rome for that matter. The formal and the tectonic legs of the tripod are enough to support mere building but not enough to support architecture. The formal deals with visual content within the laws of architectural form, and the tectonic connects construction and architectural form to the physical world outside architecture. The civil leg is the one reaching outside the internal workings of architecture to engage the public realm, the civil purpose, and the standards of ethical and moral conduct guiding the regime the buildings serve. When the civil leg is not a support for architecture, building is merely that — building. Building is adequately guided by the criteria of commodity, firmness, and delight, but when the civil leg is lacking, it does not become architecture, and the choice of classical expression is arbitrary, capricious, and inconsequential. In short, the result is modernist. If classical forms are used, it is a modernist classicism, a mere neoclassicism, a formalism unguided by the superior ethical claims of a beauty embodying justice and with no more claim to satisfying the ancient criterion of *decor*, reached through *symmetria* and *eurythmia*, than its astylar, antitraditional counterpart.

Hitler's choice of classical forms so thoroughly undermined classicism that he legitimated astylar, antitraditional modernism simply because its forms were not classical. He could do this so effectively only because modernism had not been successful in providing an amoral architecture as an alternative to what it saw as an immoral architecture. And he, in his turn, did this so well that it is now difficult, whether in building or in explaining (to paraphrase Vitruvius), to grasp the difference between neoclassicism and modern classicism, or to understand the distinction between modernism's version of classicism (a mere style) and an ongoing tradition of classicism, between architecture as a representation of itself and architecture as a continuing enrichment of a tradition arising out of pious skepticism, the imitation of nature, and anthropomorphism.

In the paradox that sees the victor conquered by the vanquished, we allow Hitler's example to divert us from the path that produced the uniquely American city. America once demanded that its polity hold authority over the beauty of architecture, and in a complementary manner it insisted that only beautiful buildings and cities could serve and illuminate the polity. In our haste to show we indeed are the enemies of fascism, we have both embraced the antitraditional modernism the Nazis relegated to second place and rejected its opposite: a classical architecture that in America is capable

of simultaneously invoking and criticizing all architecture that originates in ancient Greece.

Even those who develop architectural orthodoxy—in universities, in professional organizations, in the media — see all classicism as neoclassicism, as a now obsolete style acceptable only for satisfying blind contextualism or sentimentalism or stodgy alumni. But otherwise it impedes the forward march of history. They think that modernism, not modern classicism, is the only appropriate architecture for our liberal democracy.

For three-quarters of a century we have been rejecting traditional conventions and paradigms as the point of departure for designing new buildings and for assessing our achievement and thereby we have been alienating ourselves from others across time and across town. We have built more in the last fifty years in this country than was built in America up to that time. The result is incomprehensible buildings, uninhabitable cities, and increasingly disrupted rural areas.

When people of goodwill standing outside architecture's orthodoxy take stock of all this experience with modernism, they find that they know this for certain: As a people, we are unhappy with its products. Still, the purely private architecture justified by the declaration that whatever architects do must be good since architects have done it never seems to gainsay current private judgments; therefore, there is no opportunity for civil discourse to assess the modernists' declaration.[26] Practices that confuse freedom by promoting "a personal path and muse" and argue that it "hardly matters what philosophy drives the design or what vocabulary is being used" fall short of the democratic goal and deny "the maxim held sacred by every free people: OBEY THE LAWS."

It must become the task of fair-minded people of goodwill to reclaim architecture for civil life and allow it to display the beauty of our civic intentions. We will always fall short of our goals, but we can always narrow the gap. Faith in our polity and a pious skepticism in facing tradition should sustain us, as it did our forebears in classical antiquity and in our own republic. If we choose to use it well, then architecture can guide and sustain our informed political intentions. It captures and crystallizes what we consider most dear in democracy, holding the hope of a treasured common good in the tensile strength of well-joined timbers. Yet, our cities today, the core of our common political consciousness, are collapsing under neglect and apathy. It is worth our effort to redeem them and ourselves. It is hardly an option to fear demise or consider despair. To paraphrase St. Paul, we know that we will not be tested beyond our strength, but with the testing we will be provided with the way out, so that we may be able to endure it.

Serious Music

John Rockwell

Our century has been marked by a deep pessimism, at least in its cultural commentary. This is a pessimism born of a long history, to be sure, from Plato's fretting about the proper role of artistic expression in a well-ordered republic; to all manner of puritanical repression, be it Catholic or Protestant or Marxist; to Spenglerian despair at the decline of universal civilized standards, also known as "the West"; to neoconservative nostalgia for a cultural world that can never be and probably never was.

In our century, with its wars and holocausts and plagues, the disgruntlement of our cultural commentators has grown gloomier and gloomier, capped in music by Theodor Adorno's doom-laden dismissals of nearly all modern-day composers and musical genres that most people might reasonably be expected to like. What I propose to offer here is a statement

couched in a more optimistic, not to say Pollyanna, mode. As such, it partakes of an alternate — perhaps more American, perhaps more democratic — manner of looking at the modern world. My view no doubt descends from the 1960s: not the radical-activist 1960s or the drug-addled/elevated 1960s, but the 1960s that echoed and amplified the affirmations of Whitman and the leftist populists of the 1930s.

It is also a view, I would argue, based on a typically American pragmatism: a refusal to be bound by theory when theory contradicts evident reality. I want to write about music, serious music, as it is perceived and practiced by composers, performers, and intelligent listeners today — not as it has been traditionally perceived or didactically ordained. While I concede that contemporary classical music may be suffering under modern democratic values, particularly in the United States, I also argue that a redefinition of hierarchy, an opening of the upper chambers of the pantheon to include the best examples of musical styles heretofore denied admission even to the lower portals, may offer new hope for our cultural and even our democratic future, particularly in the United States.

In the division of musics first proposed by the editors of this volume, Stanley Crouch was accorded the "jazz" territory, Greil Marcus the "pop," and I the "classical." Such confinement makes me uncomfortable. It reflects received divisions, not tangible realities. It does not conform to the way I listen to and think about music, or to the way most people I know relate to music, or to the actuality of modern American democratic culture.

As a onetime academic cultural historian, a longtime music critic, a briefly fledged arts administrator, and now as an arts editor — as well as an American pragmatist — I find it useful in sorting out analytical conundrums to check in just occasionally with things as they are, as opposed to how they maybe once were or how we might more or less realistically wish them to be. I began *All American Music* with the sentence: "This is a book about new American music as it really is," and that ideal underlies my thinking about music to this day.

In discussing music in the United States, it is imperative to recognize and value the tastes and concerns of actual people — composers and performers and listeners. Many of the more interesting classical composers today combine genres with an effortless, organic naturalness that transcends the cruder kinds of classical "crossover" — one thinks of William Bolcom's exuberant stylistic collages, or the obvious yet still subtle influence of rock on the early music of Philip Glass. Among listeners, most people I know have lots of different kinds of music in their CD collection and cross casually over musical borders considered inviolable by the marketeers or our sterner academic

monitors of taste. Perhaps the operative word is "casually"; perhaps this is an openness born of indifference. But I would like to think it is something more, a true catholicity of taste reflecting musical curiosity and the harbinger of a new set of critical standards.

In the United States today, there remain a remarkable number of people who are passionate about music. Yes, home musical performance, of the sort practiced in central European middle-class living rooms a century ago, may have declined. But people are still singing and making music, across all genres, in large numbers, even if the guitar or the synthesizer has replaced the piano as the instrument of choice. And we hear music, live and electronically, in greater numbers than ever before. Of course, the majority of people in any society are casual about their musical tastes; 'twas ever so, despite laments that classics on the radio during "drive time" trivialize the musical experience. But from my observation, deep musical commitment can everywhere be found as well.

With eclectic stylistic passions comes a desire to become ever more expert. Classical snobs — jazz snobs, too — think of commercial pop music as a wasteland, devoid of standards. I myself know of no field in which devotees are more opinionated, more expert, more outright elitist in defense of their tastes than rock 'n' roll. Of course, one can be compulsively impassioned about, say, collecting bottle caps, and that does not transform that idiosyncratic passion into art. Still, an enthusiastic, expert response to art is more valuable than bland tolerance or nitpicking dismissiveness. Expertise encourages the cultivation of personal standards within a particular genre. The notion among neoconservatives that they alone possess the key to universal standards is poppycock, the product of a closed mind and closed ears.

Most value hierarchies of music, with an elite at the top and a cruder kind of music lower down, were crafted consciously or unconsciously as rationales for a political, social, and religious order. The king ruled, but he did so as a humble servant of God's plan. For reasons of feudal gentrification or social display or (rarely) personal taste, he cultivated a certain style of court music. Gradually, that style and its institutional showcases (private salon, opera house, orchestra, the actual instruments) were dispensed through the aristocracy to the bourgeoisie and became the model for the middle-class — and even proletarian, in the Soviet system — theaters, museums, and classical music itself of the nineteenth and twentieth centuries.

Although commentators like Tocqueville recognized the incongruity of a too-easy association between inherited aristocracy and spiritual aristocracy, the notion of hierarchy persisted. It persists to this day, above all in a cen-

tralized country like France, even if France and the rest of the countries in Western Europe have evolved into democracies at least theoretically as representative as our own. Still, the United States remains the epitome of democracy and its consequences, however one chooses to judge those consequences. This country lacked a monarchical-aristocratic tradition; it was created to confound such traditions. Thus, despite our post-Tory, cravenly Anglophilic upper and intellectual classes, the United States, with its polyglot immigrant cultures, has lacked the consensual taste and will to impose a centrally directed, didactically informed cultural policy on the unwashed. The result has been a pronounced lack of the *grands travaux* for which we so envy the French. At the same time, we have also missed out on a sometimes deadening, self-congratulatory, all-powerful arts bureaucracy that stifles innovation with clubby consensus and the threat of largesse withheld.

What we have instead, many have argued, is a fulfillment of Tocqueville's direst predictions: demotic desolation, with mass taste, whipped along by overpowering commercial interests, nearly obliterating high art, especially the creation and propagation of new classical music that cannot or will not immediately find favor on the open market. One result of this pervasive (pessimistic) view has been the erection of Hadrian's Walls within the worlds of academia and not-for-profit arts institutions, behind which the civilized minority can huddle in the nervous satisfaction that, although there may be seething hordes of Picts on the other side, they can rest assured in their own cultural superiority.

I am against walls but for ladders. Not so much ladders as ways over walls but ladders as metaphors of hierarchy. To believe in serious music within a democracy is by no means to abandon hierarchy and adopt some perverse notion of anarchic leveling, whereby all achievement is deemed equal, and all opinion deemed equally valid. Serious music means music capable of plumbing the deepest thoughts and feelings of those responsive to it. It usually means music with a history, however brief, and music with an evolved technique. It means music about which creators and performers care deeply and which has awakened a passionate and articulate response.

The trick, as an analyst of and participant in the world of music, is to adjust one's precise sense of hierarchy as the real world outside — that is, music itself — fluidly evolves. Standards probably become pedantic and repressive as soon as they announce themselves, but they certainly become so when they slip, sometimes suddenly and embarrassingly, out of sync with reality. What is cruel about the process of maturation is that just as one begins to sort out one's values, becomes "wise," one runs the risk of irrelevance. The solu-

tion is not to chase, just as ludicrously, after every contemporary fashion. One must, in the case of music, listen hard to what composers of all kinds are up to and adjust one's taste — refashion one's hierarchies — accordingly.

This process can be observed, sometimes positively but often negatively, throughout the history of classical music. Composers (or, more commonly, their eager admirers) start out championing the new (i.e., themselves) over the old and wind up defending the old (i.e., themselves) over the still newer. The sonata form evolved through compositional practice, however articulate; it was codified by pedagogues and became a set of rules that simultaneously instructed and distorted the creative energies of younger composers. In the twentieth century, a classic example of innovation mutating into repression was Paul Hindemith, who moved from his sensational expressionist operas of the 1920s (most shockingly, *Sancta Susanna*, about a nun's sexual gratification with a crucifix) to stuffy pedantry at Yale in the 1940s and 1950s, still resented by so many of his students.

Closer to today is the still-controversial genre of musical minimalism, as practiced by Terry Riley, Steve Reich, Philip Glass, and John Adams. By now, thirty years after the original works of Riley, Reich, and Glass appeared, their reputations have sorted themselves out, however preliminarily: Riley the California eccentric; Reich the old master, taken semiseriously by the old guard; and Glass the commercial sellout, this generation's Kurt Weill. But the initial controversy, with the minimalist works of the 1960s arrogantly dismissed or even more arrogantly ignored by the various musical establishments of the time (American symphonic, folk-operatic, Germanic serialist, or even Francophilic neoclassic), recalled similar schisms in the past, such as the transitions from Renaissance polyphony to early baroque monody around 1600, from high baroque to rococo around 1750, from classical to romantic around 1805, or from romantic to modernist around 1910. In all cases, the new was widely rejected at first because it failed to be the old. A hierarchy, once established as a guide to canonical excellence, became a barrier, a wall, against the new. And since the new, for better or worse, was already there, clamoring in its green body paint to be heard, the old hierarchy's rejection rendered the hierarchy itself as outmoded as Hadrian's Wall today.

In our modern democratic culture, the applicability of hierarchies, be they hopelessly outmoded or reasonably reflective of reality, must extend far beyond conventional notions of classical music. For "serious music" and "classical music" as traditionally conceived are no longer the same. Values remain, but the music to which they can and must be applied has long since transcended traditional classical music history. And those who insist that the

classical tradition, and especially its European modernist strain in this century, represents the only true musical seriousness have long since consigned themselves to irrelevance.

Of course, hardly anyone in the postmodern age argues that dogma anymore, at least in public. Conservatives have no trouble espousing an elitist mindset while simultaneously conceding an enthusiasm for jazz and even for pop standards and country music (rock and rap are beyond the pale, or wall). Paul Griffiths, in trumpeting the continued relevance of serialism in the *New York Times* in 1997, went so far as to argue that its break with tonality had been a catalyst for our current postmodernist interest in world music (and I suppose he must have meant, in popular music as well). This may be true, but it was hardly the position argued by serialist pedagogues just a few minutes ago.

Classical music and the industry and critical apparatus that surround it often unthinkingly assume the link between serious and classical, and even the exclusive equation of those two adjectives. It is true that the old dies hard: The very persistence of business and social and pedagogic structures in a particular genre reinforces that genre's isolation. Hindustani classical music was based securely on the caste system. When, a generation or two ago, Bismillah Khan began to play classical ragas on the shehnai, or Indian oboe — a lower-class instrument — it was considered shocking and unsuitable. Now he is an undisputed master. At the center of Western classical pedagogy, the Juilliard School in New York, it may take a generation or two for the didactic conservatism built into a learning process that prides itself on craft and tradition to accept new ideas. By that time, still newer ideas will have arisen that will make the grudging acceptance of the old by the older look, well, old-fashioned.

Just as the division between the serious and classical makes less and less sense these days, so does the separation of high, not-for-profit (or state-supported) art and commercial art. This is a delicate issue, given the combined aristocratic and Marxist disdain, not to say hatred, for music that succeeds in the marketplace. Defenders of the classical tradition have accepted, albeit with a considerable degree of patronization (snobbish or racist or both), some noncommercial popular styles (contemporary jazz, now far from topping the charts and fast on the way to becoming a codified performing tradition; folk music; and even safely dead Broadway musical theater). Intellectuals still tend to favor contemporary popular music with self-conscious artistic pretensions, which in turn means favoring pomposity or the inept yearning for classical status that dogged the worst English art rock of the 1970s. There is always the risk of making all "lesser" musics seem like

anthropological offshoots from the high canon. But beyond such unthinking disdain, a denial of any possible artistic integrity for commercial music has been a tenet of modernist elitism, headed by Adorno; even that stout Germanophobe Virgil Thomson proclaimed that no music that made money could be of value.

In the 1960s it was perhaps too easy to believe that the schlock commercial imperatives — the imperatives that for Adorno defined any and all popular music — were the province of an outmoded, prerock pop epitomized by the ditzy novelty songs of the early 1950s. Now, after decades of co-optation by the record and concert businesses, after the rise of successive waves of glitter and punk and alternative rock to combat the supposed corruption of the previous generations, the complexities of the relation between music and commerce seem considerably more subtle.

Yes, much commercial music, if not "bad" — an adjective that carries with it a perhaps irrelevant moral connotation — is certainly mediocre, generic, and formulaic (with regard to what sells, not self-expression). But any genre of music beholden to imperatives that do not speak to a composer's inner voice, such as the dutiful attempt to mimic a superior's style in an academic music department, can be similarly lifeless.

Quality still manages to emerge with heartening frequency, as anyone with the slightest openness to what can truly be called "contemporary music" can hear at every turn. It is just that quality can spring from a far wider range of institutional and financial sources than adherents of a linear tradition of classical music are likely to believe. The real enemy is deadening institutional inertia, not commerce. Overbearing institutions can stifle creativity even as they seek to foster it, be they commercial or non-profit: rock promoters, record companies, museums, opera theaters, or universities.

Not-for-profit institutions must still keep a nervous eye on the bottom line. The Metropolitan Opera cannot sustain productions that consistently draw below, say, 80 percent of capacity. It can throw in the occasional loss leader for prestige and hope for the eventual evolution of its subscribers' tastes. But essentially its administrators are slaves to its seating capacity and to the conservative public their predecessors spent so many decades cultivating.

Commercial institutions operate on a rationale perhaps not all that different. For them, the need to make a profit is a given, and with that need comes the unspoken desire to tailor their products to some form of mass taste. When entrepreneurs or corporate executives speak of cultivating innovative young bands or film directors, they do so mostly in the expecta-

tion that a few of them will turn out to be next year's Nirvana or Quentin Tarantino.

But young innovators have found it possible to work on their own, reducing their scale in pursuit of their freedom. Corporations may hope to draw upon the independent rock and film and software innovators, but those scenes sprang into being prior to any attempted exploitation. The comparatively low cost of making a record or a new piece of computer software has encouraged a wider range of experimentation and risk-taking in those arenas than in major Hollywood film studios. Yet, the dinosaur-like immobility of the majors has fostered independent filmmakers — "small, mobile, intelligent units," in the English rock guitarist Robert Fripp's lovely phrase.

If the prejudice against commerce in capitalist democracies remains a mighty wall against a reconsideration of seriousness, so, too, does the seemingly inherent prejudice against a lack of technique (or, perhaps better, of recognizable or acceptable technique). This is an issue that transcends democracy or capitalism or any other aspect of the modern age. Practitioners of a highly evolved craft have a lot invested in its mastery. They find it difficult to accept the validity of a similarly hard-won, similarly arcane alien craft, let alone of a self-consciously primitive style. Technique becomes codified, and codification erects bulwarks against threatening innovation.

It is easy to be suspicious of brilliant one-shots, the host of (mostly American) musical originals who come up with one clever idea, or who operate in one vernacular idiom, and never grow much beyond it. Their lack of technique constricts their inspiration. The crudity of Glenn Branca's guitar-based "symphonies" is but one case in point; the sheer reliance of so many popular composers on the song form is another. Yet, music history presents a panoply of styles that begin simple, evolve (often very quickly) into complexity, and then provoke reactions back to simplicity (Renaissance to baroque, baroque to rococo). Branca may well evolve his own technical responses to his current limitations. And even if those responses are adjudged crude by arbiters of current technical standards, they may be perceived as far-reaching by future pedants, most of whose time will be spent dismissing future forms of unexpected innovation.

We live today in a time of jet travel and instant electronic communication, and in a postcolonial (or at least overtly postcolonial) age in which cavalier dismissals of world art forms different from our own have been replaced by a sometimes idolatrous admiration. Just as Debussy was profoundly influenced by Javanese gamelan music a century ago, and modern painters and sculptors were affected by African masks, so now Western composers and

listeners readily respond to the most exotic of musical styles. Technical mastery must no longer mean traditional Western musicianship, academic musical analysis, or even musical literacy.

Perhaps the problem lies not in strictly musical technique but in our overly elaborate modes of analysis. Perhaps folk and popular songs are best heard not as isolated short forms but as parts of a mosaic that transcends any individual creator, with single songs filling in a vast web of layered musical and cultural cross-references, as Greil Marcus has shown so bracingly with "The Coo Coo Bird." A faith in the power of literary metaphor, rather than in our present-day neo-baroque (or is it neo-late-Renaissance?) formalistic musical parsing, is one alternative to conventional technical mastery.

Another alternative is the electronic studio, or even a personal computer. This is not to say that the mastery of such equipment does not demand its own forms of (rapidly evolving) technique. But electronics have freed the creation and performance of music from the years of repetitive practice that older, mechanical instruments demand — as the career and writings of Brian Eno have so suggestively shown. The trouble with canonical rigidity and technical mastery of any sort is unwarranted pride, a belief that your tradition and your technique are *the* canon and technique, and a quick readiness to condemn others as inept — as falling short by high-art standards — if they fall short by your standards. That they might be masters of other techniques to which you are deafened by your own training does not, almost by definition, cross your mind.

For young composers, a reconsideration of the nature and value of technique might encourage nascent values by fostering greater tolerance of alien traditions, greater openness to new sounds and new ideas, greater willingness to communicate with someone beyond one's teachers and peers. For critics and academics, such a reconsideration might mean resisting value formation easily mistakable as maturity and actually amounting to little more than ossification. For arts administrators, it could mean devising programs that honor traditions yet suggest cross-connections.

Innovative art is made by individuals, not institutions, whether commercial or noncommercial, complex or crudely folkish. In classical music, the minimalists evolved defiantly outside the normal spawning ground for composers (i.e., academia), drawing their support instead from fellow "downtown" artists, primarily painters and dancers. In the electronic mass arts of popular music, film, television, computer software, and CD-ROMs, young innovators have found their own way, a way superior both to the elaborately cultivated, publicly subsidized system in France and to American efforts by

the likes of Dreamworks SKG and Microsoft to encourage young musicians, filmmakers, and computer wizards in the hope of making billions.

Maybe that is where we should leave it: by recognizing that in a capitalist democracy most art must appeal to at least some people and must seek idioms which allow it to do just that. Those with more refined, or perhaps old-fashioned or hermetic, tastes can seek satisfaction in mediums that readily preserve the past — recordings, museums, books, normal classical concerts. More venturesome listeners can seek out what interests them within larger borders, rejecting blatant commercial calculation as righteously as bland lack of imagination in more conventionally "serious" genres.

A libertarian notion of cultural democracy, as opposed to New Deal statism, would prevail, and small-scale innovation would be prized, even if the absence of large-scale challenges to conventional taste, not to speak of a nationwide cultural consensus, might be missed. Maybe that is what some might call Midcult — a simultaneous rejection of a moralistically fervent, esthetically obtuse, all-out defense of "excellence," as espoused by Allan Bloom or Samuel Lipman, and an indiscriminate embrace of everything offered up by our vital, messy, gaudy culture.

But to accept such a position, whether it be called Midcult or common-sensical, seems insufficient: It lacks intellectual resolution. Furthermore, to separate the older "high" arts from the younger mass arts denies both their best chance for healthy growth. The high arts lose vitality, while American demotic culture, writhing and heaving with mindless bestial energy, is cut loose from refining guidance.

Any effort at reconciliation involves the question of what might be called hierarchical correlation. There are standards everywhere underfoot; the trick is to relate standards in seemingly incompatible systems, from rock to string quartets, from MS-DOS to Apple. I myself have spent a good deal of time fretting over such questions, with no sterling record of success. In *All American Music*, I sought to present the multiplicity of American composition by juxtaposing twenty living composers ranging from Ernst Krenek to the Talking Heads. Some readers enjoyed the act of juxtaposition itself; others complained about my failure to provide explicit analytical tools for a comparison of Elliott Carter and Eddie Palmieri. I believed, and believe, that the mere act of discussing such composers with equal seriousness becomes part of a self-fulfilling process. But others wanted more.

As for the future, posterity has a way of sorting things out; musicians lead, audiences and analysts follow, and old prejudices are pushed aside by new enthusiasms, which then become rigidified into standards that need to be

overthrown. What seems muddled to us now will seem clear later (perhaps falsely, as any analytical categorization must be to some extent). What great German symphonies were composed between Schumann and Brahms? Could not and did not commentators then have lamented the "death" of the symphony, at a time (the nineteenth century) we now regard as a shining continuum of bourgeois composition? In fact, musical creation was bubbling away outside German-speaking lands, in Italy and Bohemia and Russia (not to speak of India and the Far East), and outside conventional symphonic forms, in concertos and operas. Just as musical creation is bubbling away now outside conventional Western classical centers (and within them, too, to be sure) and in genres seemingly far removed from conventional classical music. The trick, as ever, is to be as aware as possible of the fullest possible range of music to which one can apply standards. Which is every kind of music.

The answer to the question of hierarchical correlation is that there is no answer, or perhaps that there is no (proper) question. In a democracy, it is individuals who must make choices. Groups of individuals can build majorities, and majorities, in the long run, can shape posterity. But in the short run, culture and cultural taste are issues of individual responsibility and, beyond that, of individual persuasiveness of advocacy, through whatever medium (composition, performance, criticism, programming, general civilized behavior). All tastes are not equal. But superiority must be continually challenged and defended; it is not a right conferred by birth or degree or position.

Creative taste is a process of vigorous yet delicately subtle evolution. Crude if unformed, pedantic if overdeveloped, taste must be tended gently, allowed to grow as healthily, strongly, and beautifully as possible. That means, to return for a final time to pragmatism, listening as well as thinking, allowing new sounds and new ideas to refashion hierarchical standards that one might have thought (hoped?) with age and experience would take on some aura of permanence. Democracy is a societal vision designed to favor the individual. But it is not so much a system as a struggle; it is up to the individual to create a self, and a society, worthy of the democratic ideal.

Blues to Be Constitutional

Stanley Crouch

Blue Rebellion Breakdown

I write not as a scholar of the Constitution but as a student of the human soul, which is what any writer with the ambition to capture the whys and wherefores of our lives must be. Before I have finished, I hope to have examined the metaphor of the Constitution as it applies to a number of things in our society, and I hope also to have looked at a few of the elements that not so much threaten the democratic institutions of this country as they tend to lessen the morale necessary to work at the heroic expansion of this democracy into the unlit back streets and thickets of our civilization. I have chosen to be that ambitious. And in the process of expressing my ambition, I may kick off another version of the good number of pitched intellectual battles I

have had with people we continue to describe mistakenly by their color, since no one has ever seen anyone who is actually white or black, red or yellow, however close a few here or there might be. That level of imprecise identification in such a technologically advanced society is one of the ironies of our time and our place in the history of America and of the world.

As a writer, I find it ironic that I began working on these ideas in public at Harvard University in 1992. The afternoon address was given on the thirty-seventh anniversary of the death of Charlie Parker, whose consciousness was swallowed by the grim reaper in Manhattan's Fifth Avenue Stanhope Hotel on March 12, 1955. It was nearly ten years after the performance of *Koko*—a harmonic skull-cracker built on the chords of *Cherokee*—had announced Parker's ability to extend our expectations of jazz improvisation. Legend lays it down that the virtuoso Kansas City alto saxophonist died while laughing at an act on a television variety show, an electronic update of the minstrel and vaudeville tradition Parker had so poorly fought against throughout his career. A statistic of his own excesses, the innovative genius had been nursed round the clock not by a Jewish princess but by a Jewish baroness, who had driven North African ambulances during World War II and had so scandalized her Rothschild family that, so continues the legend, she was paid off to badly drive her Bentley and enthusiastically host her Negro jam sessions out of sight and out of earshot.

Parker is a man I have come to know quite well since I began working on his biography in 1982. But Parker is most important to what I have to say because he represents both the achievement and the myth of jazz as well as the trouble we Americans have deciding whether we will aspire to the heroic individuality symbolized by Abraham Lincoln and Martin Luther King, Jr., or sink down into the anarchic individuality represented by Billy the Kid and the various bad boys our society has had crushes on for over a century. However great his talent surely was, Parker was celebrated as much in the half-light and the darkness of the night world for his antics, his irresponsible behavior, his ability to embody what Rimbaud called "the love of sacrilege." He was a giant of a bluesman and a jazz improviser of astounding gifts, but his position in the world and in this overview has much to do with praise he received for being an outlaw, a praise that speaks directly to a number of our dilemmas.

Since our actual preparation for becoming a democratic society was outside the law, dumping tea in Boston Harbor while disguised as Indians and fomenting rebellion, since our moral assaults on the limitations of our democracy were expressed in the illegal actions of the abolitionists who worked the Underground Railroad and foreshadowed the sorts of activities that

people of conscience would later replicate when spiriting Jews beyond the death camp clutches of the Nazis, it is not hard to understand why we have such a high position in our pantheon for the bad boy. We love riotous outsiders as much as we once loved the eloquence we no longer hear from our politicians. And in our straining against the constraints of modern civilization, we, like Baudelaire and Rimbaud, have a love of symbolic violence.

That symbolic violence has two sides, one rooted in a democratic assertion and expression of the culture's vitality, a breaking away from European convention in pursuit of a social vision that eventually allowed for recognition and success beyond the limitations of family line and class. The other is a set of appetites focused on the exotic, bedeviled by a nostalgia for the mud, given to a love of sensationalism that completely hollows out a pretentious vulgarity. From the moment Americans joyously dumped that tea into Boston Harbor, we were in the process of rebelling against what was then a traditional denial of the colonized underdog's access to dialogue. But that Indian disguise also exhibited perhaps the first burst of what would evolve into the love of the ethnic mask as witnessed in burnt-cork stage presentations and the cinematic symbol of Al Jolson's jazz singer moving from Eastern European provincialism into the Negro rhythmic bustle of American popular art.

Since the rise of American nationalism, which took off at an express tempo following the War of 1812, our art has as frequently reflected disdain as celebration. We love to make fun of the rules and to prick those who think themselves superior for all the wrong reasons, especially since our democracy tells us that the little David of the common man can knock down the Goliath of wealth, unfairness, and privilege. We believe the smart money can always be wrong. In the first third of the nineteenth century, the Yankee Brother Jonathan and the backwoodsman Davey Crockett often outwitted the stuffed shirt, as would the burnt-cork minstrel show figures who stood in for the rural whites endangered by the con men of the big city. Our art tends to pull for the underestimated and the outsider, perhaps because so many of us originate in groups and classes that were once outside the grand shindig of American civilization, noses pressed against the ballroom's huge windows. We have great faith in the possibility of the upset. There is no American who does not understand well the statement "They said it couldn't be done, but we did it."

That dictum is basic to our national character and underlies the virtues of our society as much as it does the vulgar volleys against convention we presently find so worrisome in popular art. What we are now witnessing is a distorted version of our own understanding of the battle between the old and

the new that is basic to an improvisational society such as ours, in which policy is invented to redress previous shortcomings or to express attitudinal shifts. Central to being an American is the belief that limitations will not necessarily last very long, primarily because we have seen so many changes take place in everything from technology to the ongoing adjustments of policy. It is part of our history, from Eli Whitney, Thomas Edison, Henry Ford, and the Wright brothers in the machinery of modern life, to Abraham Lincoln, Martin Luther King, and Sandra Day O'Connor in political influence and high national office.

But a tendency in our contemporary popular art is to extend identification with the outsider to a love of the scandalizing bad boy. This love has evolved in our century from the silver-screen gangster to MTV gangsta rap, introducing a few other kinds of bad boys along the way. We have moved swiftly from the cardboard goody-goody to Cagney, to Bogart, to Edgar G. Robinson, motorcycled forward to Brando and James Dean, hopped the racial fence to play out sadomasochistic rituals with Miles Davis, Malcolm X, and now Spike Lee, not to mention all the adolescent rock 'n' roll intoxication our society guzzles to the point of hangovers from Prince or Madonna or Public Enemy. As Gregory Peck says, "The audience loves the bad guy because he will come up with a surprise."

Those surprises were first seen in our century in slapstick, in the many variations on the pie in the face of the society snob. That harmless disdain for smugness and pretension made us laugh when the superficially bad boy and comic figure, from Chaplin's Afro-balletic tramp to Eddie Murphy's *Beverly Hills Cop*, unleashed chaos at the pompous gathering. But Peck's observation says much about the dark glamour that surrounds the worst of rock and the lowest of rap; the canonization of antisocial posturing and the obnoxious appropriation of the racial stereotype have been basic to rock criticism at least since the elevation of the Rolling Stones and Jimi Hendrix. As rock critic Gregory Sandow says, "It's all about the love of the outlaw. The outlaw is going against everything you want to fight in the society, he's doing all the things you would like to do and being the way you would like to be. He's beyond the pale of convention, and if he's black, it's even better."

Sandow's observation is corroborated when one reads the bulk of rock writers on the subject of rap, they who were so quick to shout down racists or fume about Jesse Helms and the 2 Live Crew obscenity trial but who are almost always willing to indulge their own appetites for contemporary coon shows, for the brute glamour of this racial replay — and affirmation — of "the love of sacrilege," of the extensions of Jolson's statement "You ain't heard nothing yet." For these writers, and perhaps for the bulk of white rap

fans, the surliest rap recordings and videos function as experiences some-
where between viewing the natives boiling the middle class in a pot of pro-
fanity and the thrill of gawking at a killer shark in an audio aquarium. For
Negro rap fans, we see another version of the love of the noble savage, the
woolly-headed person from the street who cannot be assimilated, who is safe
from our American version of the temptation of the West.

All those tendencies clearly express our young people's dissatisfaction
with the shortcomings of our culture, but a dissatisfaction had on the cheap.
In the world of the prematurely cynical, the bad boy reigns, for he represents
retreat into pouting anarchy. Of course, the nature of capitalism means that
anything can become a career, even one that earns millions or television
time or tenure selling defeatist visions, playing on or cultivating appetites for
ersatz savagery, trumpeting segregation and substandard levels of scholar-
ship on the campuses of our best universities. At the lowest and highest lev-
els, say, from Louis Farrakhan or from some professor of "victim studies,"
we hear all the carping about the meaninglessness of American democracy,
of the tainted moral character of the men who attended the Constitutional
Convention and whipped the tragically optimistic fundamentals of our so-
cial contract into championship form.

Behind that carping, when what we discover is not merely opportunistic,
we learn something quite distinct about the maudlin as it relates to the cyni-
cal. We come to understand that unearned cynicism, much more frequently
than not, is no more than a brittle version of sentimentality. It is a failure of
morale, a cowardly removal from the engagement that comes of under-
standing the elemental shortcomings of human existence as well as did the
founding fathers of this country. Those given to no more than carping are
unprepared to address the tragic optimism at the center of the metaphor that
is the Constitution. They know nothing of heroic engagement, the engage-
ment that would not allow one to misunderstand the singing of "We Shall
Overcome" in the town square of Prague as Dubček stood on a balcony look-
ing into the faces of those from whom he had been exiled by the Communist
Party. It is an engagement that would not allow one to miss the meaning of
the Red Chinese troops having to destroy a crudely built Statue of Liberty
with even cruder means when the night was filled with the familiar violence
of totalitarianism in Tiananmen Square. That engagement would recognize
that the very success of our struggle to extend democracy has inspired the
world, and much of that extending has been the result of the efforts of people
at war with the social limitations that were so severely imposed upon Negro
Americans.

One cannot speak of Negro culture in this country without speaking of

the blues. The blues, which I shall soon discuss in detail, have much to do with the vision of the Constitution, primarily because you play the blues to rid yourself of the blues, just as the nature of our democracy allows us to remove the blues of government by using the government. The blues is a music about human will and human frailty, just as the brilliance of the Constitution is that it recognizes grand human possibility with the same clarity that it does human frailty, which is why I say it has a tragic base. Just as the blues assumes that any man or any woman can be unfaithful, the Constitution assumes that nothing is innately good, that nothing is lasting — nothing, that is, other than the perpetual danger of abused power. One might even say that the document looks upon power as essentially a dangerous thing that must never be allowed to go the way it would were it handled by the worst among us, many of whom remain unrecognized until given the chance to push their ideas on the world. The very idea of the amendment brings into government the process of social redemption through policy. By redemption, I mean that the Constitution recognizes there may be times in the future when what we now think of as hard fact may be no more than a nationally accepted prejudice, one strong enough to influence and infect policy. So you use the government to rid yourself of the blues of government.

The Constitution is also a blues document because it takes a hard-swinging position against the sentimentality residing in the idea of a divine right of kings. Sentimentality is excess, as is any conception of an inheritance connected to a sense of the chosen people. The Constitution moves against that overstatement with the same sort of definition Jesus had when his striking down the idea of a chosen people prefigured what we now think of as democracy, an open forum for entry that has nothing to do with any aspect of one's identity other than one's humanity. I must make clear that I am not talking so much about religion here as about the idea that the availability of universal salvation is a precursor of the idea of universal access to fairness that underlies our democratic contract. Universal salvation means that no one's identity is static, that one need only repent and be born anew. That is what I meant earlier about social redemption: Every policy structured to correct previous shortcomings in the national sensibility that have led to prejudicial doctrines or unfair treatment is a form of government repentance. Once again, the government is used to rid the blues of government.

Yet, the Constitution, like the blues singer willing publicly to take apart his own shortcomings, perceives human beings as neither demons nor angels but some mysterious combination of both. That is why the revelations of scandal and abuse that rise and fall throughout our history, including our deeply human susceptibility to hypocrisy and corruption, prove the accuracy

of the Constitution. Every time we learn of something unfair that has happened to a so-called minority group, or even a majority group like American women, we perceive anew how well the framers prepared us to face the tar and feathers our ideals are periodically dipped in — even if those framers might have been willing to tar-brush some ideals themselves! Every time there is a scandal or we learn another terrible thing about some president or some hanky-panky in government contracts, we see more clearly the importance of freedom of the press and of accountability for public figures. Ask Boss Tweed, ask Richard Nixon; both were felled by the press. The framers of this blues document could see it all, and they knew that for a society to sustain any vitality it had to be able to arrive at decisions through discourse that could stand up to the present or lighten the burdens wrought by the lowest aspects of the past.

In essence, then, the Constitution is a document that functions like the blues-based music of jazz: It values improvisation, the freedom to constantly reinterpret the meanings of our documents. It casts a cold eye on human beings and on the laws they make; it assumes that evil will not forever be allowed to stand. And the fact that a good number of young Negro musicians are leading the movement that is revitalizing jazz suggests a strong future for this country. I find this true because of what it takes for young Negroes to break free of all the trends that overtake them, perhaps even more comprehensively than the rest of American youth. I find this true because Afro-American culture is essentially oral, and any oral culture is in danger of being dictated to by whomever has command of the microphone.

There is a large dream in the world of jazz, and that dream is much richer than anything one will encounter in the ethnic sentimentality of Afrocentric propaganda. What those young jazz musicians symbolize is a freedom from the taste making of mass media and a vision that has much more to do with aesthetic satisfaction than with the gold-rush culture of popular entertainment, by which I mean that the clichés of adolescent narcissism replace the pickaxe, some pans, and a burro in the quest for gold. These are young Americans who have not been suckers for the identity achieved through unearned cynical rebellion; they seek individuality through affirmation, which puts them at war with the silly attire and hairdos that descend directly from the rebel-without-a-cause vision of youth that Hollywood began selling adolescent Americans nearly forty years ago, when the antihero started to emerge. Less in awe of youth than of quality, those who would be jazz musicians would also *be* adults, not just shriek for adult privileges, then cry foul when the responsibilities are passed out. They have a healthy respect for the men and women who laid down an astonishing tradition. In their wit, their

good grooming, their disdain for drugs, and their command of the down home and the ambitious, they suggest that although America may presently be down on one knee, the champ is about to rise and begin taking names.

But to convey a true appreciation of the direction these young musicians are taking, I provide a longish discussion of what the blues and jazz traditions offer us in the way of democratic metaphors, or aesthetic actions closely related to the way in which our very society is organized.

Blues to Be There: Transition Riff on the Big Feeling

I am quite sure that jazz is the highest American musical form because it is the most comprehensive, possessing an epic frame of emotional and intellectual reference, sensual clarity, and spiritual radiance. But if it were not for the blues, there would be no jazz as we know it, for blues first broke most clearly with the light and maudlin nature of popular music. Blues came up from this land around the turn of the century. We all know that blues seeped out of the Negro, but we should be aware that it also called backward into the central units of the national experience with such accuracy that it came to form the emotional basis of the most indelible secular American music. That is why it had such importance — not because it took wing on the breath, voice, and fingers of an embattled ethnic group, but because the feelings of the form came to magnetize everything from slavery to war to exploration to Indian fighting to natural disaster, from the woes of the soul lost in unhappy love to the mysteries, terrors, and celebrations of the life that stretched north from the backwoods to the steel and concrete monuments of the big city. Blues became, therefore, the aesthetic hymn of the culture, the twentieth-century music that spoke of and to modern experience in a way that nothing of European or Third World origin ever has.

In a number of ways, the blues singer became the sound and the repository of the nation's myth and the nation's sense of tragic recognition. It was probably this sense of tragic recognition, given its pulsation by the dance rhythms of the music, that provided blues with the charisma that influenced so many other styles, from jazz to Tin Pan Alley to rock. In the music of the blues, the listener was rescued from the sentimentality that so often threatens the soul of this culture, either overdoing the trivial or coating the significant with a hardening and disfiguring syrup. Surely, the Negroes who first came to hear the blues were not at all looking for anything sentimental, since the heritage of the work song and the spiritual had already brought them cheek to jowl with the burdens of experience, expectation, and fantasy. In the sweat- and ache-laden work song, the demanding duties of hard labor

were met with rhythm, and that rhythm, which never failed to flex its pulse in the church, was the underlying factor that brought together the listeners, that allowed for physical responses in the dance halls and the juke joints where blues emerged as the music of folk professionals. Blues all night in guitar keys, the development of a common source of images, a midnight-hour atmosphere of everyday people out to rhythmically scratch their own — and someone else's — itching, sensual essences.

Yet, there was always, as with any art given to the lyrical, a spiritual essence that referred as much to the desire for transcendence as it did to any particular tale of love and loss or love and celebration. In both cases, what was sometimes rightfully considered lewd could also constitute a sense of romantic completeness that was expressed with equal authority by men and women, that fact itself a motion toward women's liberation and the recognition of libidinous lore that transcended gender conventions. In fact, the first popular blues singers who rose to professional status were women such as Bessie Smith. And with the evolution of the blues singer into the jazz musician, an art came forward that was based in the rocky ground and the swamp mud of elemental experience while rising toward the stars with the intellectual determination of a sequoia. It was also symbolic, as had been the erotic wholeness basic to blues, of American democracy.

The Democratic Swing of American Life

In 1938, the great German novelist Thomas Mann, who had fled Nazism in his homeland, delivered a lecture from one end of America to another that was published as a small volume under the title *The Coming Victory of Democracy*. It is only sixty-five pages in length, and a few aspects of it are now outdated, but the overall sense of the world and the observations Mann provides about democracy connect very strongly to the processes and the implications of jazz, which brings a fresh confluence of directness and nuance not only to the making of music but also to the body of critical thought its very existence has challenged in vital ways that are peculiarly American.

The vision of jazz performance and the most fundamental aspects of its aesthetic are quite close to Mann's description of democratic thought: "We must define democracy as that form of government and of society which is inspired above every other with the feeling and consciousness of the dignity of man." The demands on and the respect for the individual in the jazz band put democracy into aesthetic action. Each performer must bring technical skill, imagination, and the ability to create a coherent statement through improvised interplay with the rest of the musicians. That interplay takes its di-

rection from the melodic, harmonic, rhythmic, and timbral elements of the piece being performed, and each player must have a remarkably strong sense of what constitutes the *making* of music as opposed to the *rendering* of music, which is what performers of European concert music do. The improvising jazz musician must work right in the heat and the pressure of the moment, giving form and order in a mobile environment, where choices must be constantly assessed and reacted to in one way or another. The success of jazz is a victory for democracy, and a symbol of the aesthetic dignity, which is finally spiritual, that performers can achieve and express as they go about inventing music and meeting the challenges of the moment.

Those challenges are so substantial that their literal and symbolic meanings are many, saying extraordinary things about our collective past as well as the dangers and the potential of the present. In fact, improvisational skill is such an imposing gift that the marvelously original Albert Murray has written in *The Hero and the Blues*: "Improvisation is the ultimate human (i.e., heroic) endowment." The very history of America's development bears this out, as does much of the history that preceded it. But perhaps no society so significant has emerged over the last five centuries that has made improvisation so basic to its sensibility. Even the conflict between Cortés and the Aztecs, for all its horrific dimensions, pivoted on the element of improvisation. As the French writer and critic Tzvetan Todorov observes in his startling *The Conquest of America*:

> It is remarkable to see Cortés not only constantly practicing the art of adaption and improvisation, but also being aware of it and claiming it as the very principle of conduct: "I shall always take care to add whatever seems to me most fitting, for the great size and diversity of the lands which are being discovered each day and the many new secrets which we have learned from the discoveries make it necessary that for new circumstances there be new considerations and decisions; should it appear in anything I now say or might say to your Majesty that I contradict what I have said in the past, Your Highness may be assured that it is because a new fact elicits a new opinion."

That quote sounds more than a little like an attitude foreshadowing the constitutional vision of amendments mentioned earlier, and it is also similar in tone and content to the way jazz musicians have explained how different nights, different moods, and different fellow musicians can bring about drastically dissimilar versions of the same song. Part of the emotion of jazz results from the excitement and the satisfaction of making the most of the present, or what the technocrats now call "real time." Todorov follows that

quote with an idea basic to the conception of improvising jazz: "Concern for coherence has yielded to concern for the truth of each particular action."

In jazz, however, *comprehension* of each particular action, the artistic truth of it, will bring from the better and more inspired players reactions resulting in overall coherence. And it is the achievement of coherence in the present that is the great performing contribution jazz has made to the art of this century.

1.

Just as American democracy, however periodically flawed in intent and realization, is a political, cultural, economic, and social rejection of the automated limitations of class and caste, jazz is an art in which improvisation declares an aesthetic rejection of the preconceptions that stifle individual and collective invention. But the very history of African Americans has always been dominated by a symbolic war against the social and artistic assembly line, especially since stereotypes are actually forms of intellectual and emotional automation. In fact, slavery was a forerunner of the nation's social compartmentalization, especially the sort upheld by the pieties of stereotypes. Those stereotypes maintained that certain people came off an assembly line in nature and one need not assume them capable of the endless possibilities of human revelation. They had a natural place, which was inferior, and they were sometimes to be pitied and guided, sometimes feared and controlled, but they were never to be considered more than predictable primitives who functioned best in subservient positions.

The aesthetic revelation in the present that is so central to jazz improvisation repudiated such attitudes and rejected what Charlie Parker called "stereotyped changes." But long before the emergence of Parker, the level of virtuoso craftsmanship that evolved in the improvising world of jazz redefined both instrumental sound and technique in an ensemble in which this idiomatic American music met all the criteria demanded of musical artistry. Even virtuosity took on a new meaning, a meaning steeped in unprecedented liberation. And it was no coincidence that this frontier of artistry came from Afro-Americans and eventually spoke to and for all. As this writer pointed out in an essay entitled "Body and Soul":

Given the attempts to depersonalize human beings on the plantation, or reduce them to the simplicity of animals, it is understandable that a belief in the dignity of the Negro and the joyous importance of the individual resulted in what is probably the century's most radical assault on Western

musical convention. Jazzmen supplied a new perspective on time, a sense of how freedom and discipline could coexist within the demands of ensemble improvisation, where the moment was bulldogged, tied, and given shape. As with the Italian artists of the Renaissance, their art was collective and focused by a common body of themes, but for jazzmen, the human imagination in motion was the measure of all things.

The degree of freedom introduced into Western music by black Americans has touched some of the few truly good jazz writers deeply and has inspired in them ideas of substantial significance in twentieth-century aesthetics. Getting beyond the noble savage school that shapes the thinking of too many jazz critics of whatever hue or background, Martin Williams points out in his largely superb *The Jazz Tradition* that there has never been a music in the Western world that allowed for so much improvisation on the part of so many. Williams raises telling issues. He articulates the depth and meaning of this improvisational freedom quite clearly:

> In all its styles, jazz involves some degree of collective ensemble improvisation, and in this it differs from Western music even at those times in its history when improvisation was required. The high degree of individuality, together with the mutual respect and cooperation required in a jazz ensemble carry with them philosophical implications that are so exciting and far-reaching that one almost hesitates to contemplate them. It is as if jazz were saying to us that not only is far greater individuality possible to man than he has so far allowed himself, but that such individuality, far from being a threat to a cooperative social structure, can actually enhance society.

Williams also makes an observation that helps clarify the human *wholeness* jazz proposes through its bold performance conventions:

> The Greeks, as José Ortega y Gasset has pointed out, made the mistake of assuming that since man is the unique thinking animal (or so they concluded him to be), his thinking function is his superior function. Man is at his best when he thinks. And traditionally, Western man has accepted this view of himself. But to a jazz musician, thought and feeling, reflection and emotion, come together uniquely, and resolve in that act of doing.

This is best described by Mann's phrase "a new and modern relationship between mind and life" from *The Coming Victory of Democracy*. That new relationship in this context demands a cooperation between the brain

and the body that is perhaps fresh to Western art, since the levels of perception, conception, and execution take place at such express velocities that they go far beyond what even the most sophisticated information about the consciousness is presently capable of assessing. These musicians hear what is played by their fellow performers, are inspired to inventions of their own, hold their places in the forms of the songs, and send tasks to their muscles that must be executed so swiftly that all functions of mind and body come together with intimidating speed. In the process, a bold and unprecedented radiance is brought to the performing ensemble. The music of jazz uniquely proves out Mann's dictum that "to come close to art means to come close to life, and if an appreciation of the dignity of man is the moral definition of democracy, then its psychological definition arises out of its determination to reconcile and combine knowledge and art, mind and life, thought and deed."

2.

Though the skills that make for jazz are the result of a musical evolution that probably began the moment African slaves started reordering music they heard from and were taught by the slave masters, this writer would again say that it is a dangerous simplification to hear jazz primarily as a music protesting the social conditions of Afro-Americans, even if its seminal inventors were often subjected to social limitations based on race. That reduces the monumental human achievement of a sustained artistic vision that allows for the expression of every passion, from delicate affection to snarling rage at the very demons of life at large, those tragic elements that no amount of money, power, or social inclusion will hold at bay. If social problems in and of themselves were the only things that provoked the creation of great art, then a century as bloody as ours would have inspired far more original and profound aesthetic achievement than it has. No, the miracle of this improvisational art is that the techniques with which Africans arrived in the Americas evolved into *aesthetic conceptions* that reinvented every kind of American music they came in contact with, from folk to religious music to dance tunes, and finally came together for jazz, in which all those aspects of American musical expression were brought together for a fresh synthesis.

That fresh synthesis was the product of a down-home aristocracy of men and women whose origins cut across class and caste, who might or might not have been able to read music, might or might not have used conventional technique, but who all had in common the ability to make musical sense during the act of playing. In no way did their rising to artistic prominence from

the bottom, middle, or top of the social strata on the steam of their own individual talents and wills conflict with the collective concerns of the music. By doing so, they actually enhanced our understanding of the music's democratic richness, proving through their work what Mann meant when he said, "real democracy, as we understand it, can never dispense with aristocratic attributes — if the word 'aristocratic' is used, not in the sense of birth or any sort of privilege, but in a spiritual sense." A jazz musician would probably say *soul*, knowing that those who possess the deepest spiritual connection to the music can come from anywhere, and enough of them have done so to affirm the merit system of aesthetic expression. The whole point of democracy itself is that a society is best off and most in touch with the vital when it eliminates all irrational restrictions on talent, dedication, and skill.

No matter what your class or sex or religion or race or shape or height, if you can cut the mustard, then you should be up there playing or singing or having your compositions performed. You should, in fact, after all the practice and the discipline necessary to push your art into the air as a professional, be taking on the ultimate democratic challenge, which means bringing into the aesthetic arena the fundamentals of constitutional discourse, checks and balances, policy, and the amendments in which you symbolically use government to rid yourself of the blues of government. When that challenge is met, children, we hear the lucidity rising into the air that is the bittersweet truth of the blues to be there — what Hernando Cortés predicted, what the framers put together, and what we, and our descendants, as all-American children of the Constitution, will continue to reinterpret until the end of our time in the quicksand of history.

The Old, Weird America

Greil Marcus

SMITH: *I don't think you can say that folk culture was doing such and such, and that in popular culture these things became disseminated—although I used to think that was the case. I now believe that the dissemination of music affects the quality. As you increase the critical audience of any music, the quality goes up.*

COHEN: Doesn't it also go down because it has to appeal to a more divergent range of people?

SMITH: *I don't think they're that divergent. There isn't that much difference between one person and another.*

—JOHN COHEN, "A Rare Interview with Harry Smith," *Sing Out!*

"The old, weird America" is a phrase I twisted out of a phrase Kenneth Rexroth invented. He was trying to describe the country he thought lay behind Carl Sandburg's work; he came up with "the old free America."

When I first ran across those words, they almost made me dizzy. "The old free America"—the words, the idea, seemed all but natural, coded in the inevitable betrayals that stem from the infinite idealism of American democracy. I don't hear irony in those words. But while I respond helplessly to them, I also recoil—because those words cast all Americans out of their own history.

They cut Americans off from any need to measure themselves against the idealism—the utopianism—Americans have inherited. By fixing the true America, the free America, in the past, those words excuse the betrayals of those Americans who might hear them. There's an alluring, nearly irre-

sistible pull in the phrase — at least there is for me — and I almost took it to name the ground I hope to map out in the following pages, but instead I only stole the cadence. "The old, weird America": That will have to do for the territory that opens up out of Harry Smith's 1952 *Anthology of American Folk Music*, the founding document of the folk revival of the late 1950s and early 1960s, and thus a cornerstone of the music that has been made since, and of the culture that has been made since.

I can best begin to frame that territory with a long quotation from a book called *American Studies*— not a textbook, but a first novel published in 1994 by Mark Merlis. In a dreamy passage that echoes back and forth from the present to the seventeenth century, the narrator, a man in his sixties, is remembering an English professor with whom he once studied, a man named Tom Slater. Slater is transparently based on F. O. Matthiessen — the great Harvard scholar, author of the pioneering *American Renaissance* (1941), once a communist, and secretly a homosexual. In the Red Scare of the late 1940s, Matthiessen could hear the hounds baying at his door; in 1950, he killed himself. In the Harvard English department, debate over who might have been to blame went on for decades. Mark Merlis's narrator thinks back to the same year. Tom Slater has been driven from the university. "He sits in his living room and realizes that he hasn't read anything in weeks, he hasn't written anything," the narrator says, re-creating the time, imagining the scene: "He will never teach again. Everything he sank his energy into for thirty chaste years is gone."

> The seminar above all, that famous seminar of his, that he first had the audacity to call "American Studies"— nowadays that means dissertations on "Gilligan's Island." But that wasn't what Tom meant at all. He never meant to study America, the whole shebang, in all its imbecile complexity. For him there were, perhaps, three hundred Americans in as many years. They dwelt together in a tiny village, Cambridge/Concord/Manahatta, Puritans and Transcendentalists exchanging good mornings, and Walt Whitman peeping in the windows. A little Peyton Place of the mind, small enough that Tom could know every byway and every scandal. I am not certain that Tom, in his life, ever uttered words like "Idaho" or "Utah." Not unless there was a strike there.
>
> He had made a little country of his own. In those first few years during and after the second war, America was what we talked about in Tom's overheated seminar room. Every week someone came into the room with a chance notion or an off reading destined to become holy writ for the generation that came after. As Jefferson thought it would take a millen-

nium to settle the continent, so we thought it would take forever just to cut a few paths through the forest primeval of nineteenth-century letters. Now it's used up, all of it, from Massachusetts Bay to Calaveras County. But while it lasted: even I was excited some days, though I hadn't quite done all the reading and was there only because this was the life Tom had laid out for me. Even I felt, with Tom and his real students, like a conquistador, staking my claim on the imagined America that lived in that little room where it was so hot my glasses fogged up.

There was the real exile, maybe, when they shut the door of that seminar room in his face, cast Tom out from the land that wasn't just his birthright but to which he had given birth and a name.[1]

An imaginary home and a real exile — those might be the borders of the imagined America in Harry Smith's *Anthology of American Folk Music*, and it is no accident that the *Anthology* was issued in 1952, at about the same time Mark Merlis's real and fictional incident takes place. The *Anthology* was a collection of eighty-four songs on six LPs in three boxes, each with the same cover art, a mystical depiction of the harmonious interaction of the fundamental elements: earth, air, fire, and water.[2] There was, remembers artist Bruce Conner, who encountered the *Anthology* in the early 1950s in the Wichita Public Library, "a confrontation with another culture, or another view of the world, that might include arcane, or unknown, or unfamiliar views of the world, hidden within those words, melodies, and harmonies — it was like field recordings, from the Amazon, or Africa, but it's here, in the United States! It's not conspicuous, but it's there. In Kansas, this was fascinating. I was sure *something* was going on in the country besides Wichita mind control."[3]

As a document carrying such faraway suggestions, the *Anthology of American Folk Music* was a profound rebuke to what, in the 1950s, was known not as America but as Americanism. That meant the consumer society, as advertised on TV; it meant vigilance against all enemies of such a society, and a determination never to appear as one; it meant what Norman Mailer, in words that could have been those of many other people in the 1950s, described as the state of the republic: the coexistence of the fear "of instant death by atomic war" and the fear of "a slow death by conformity with every creative instinct stifled."[4] This was boilerplate, no matter how true; a dead language the instant it was spoken. The *Anthology* was a mystery — an insistence that against every assurance to the contrary, America was itself a mystery.

As a mystery, though, the *Anthology* was disguised as a textbook; it was an

occult document disguised as an academic treatise on stylistic shifts within an archaic musicology. This was in Harry Smith's grain. A polymath and an autodidact, he was also a trickster. A westerner, he was born in 1923, in Portland, Oregon, and grew up in and around Seattle; he died in 1991 in New York City, where he was known as "the Paracelsus of the Chelsea Hotel." His parents were theosophists; his grandfather was a leading Mason. "I once discovered in the attic of our house all of those illuminated documents with hands with eyes in them, all kinds of Masonic deals that belonged to my grandfather," Smith said in 1965. "My father said I shouldn't have seen them, and he burned them up immediately." But, Smith said, on his twelfth birthday his father presented him with a complete blacksmith's shop and commanded that he turn lead into gold. "He had me build all these things like models of the first Bell phone, the original electric light bulb, and perform all sorts of historical experiments," Smith said; the *Anthology of American Folk Music* was the most complete historical experiment he ever devised.[5]

A turning point in Smith's life came in the early 1940s, when he left the University of Washington, where he was studying anthropology, and traveled to the San Francisco Bay Area. There he entered bohemian circles: He met artists, communists, folksingers, and folklorists. Writing of that time and that milieu in *Utopia and Dissent: Art, Poetry, and Politics in California*, Richard Cándida Smith could be describing the auras of Smith's *Anthology*: "The avant-garde on the West Coast had a preference for cosmological-theosophical over psychological-sociological understandings of art and the individual's relationship to larger forces. The sacred, which need not involve a personalized deity, was valued over the profane.... Historical 'facts' served hierarchy, while tradition was liberating because it grew from a voluntary personal response to the repertory of the past."[6]

I like that phrase, "the repertory of the past." Smith might have as well. But while his response to the past was nothing if not personal — he drew on his own vast collection of 78s to assemble his *Anthology*—I think the response he meant to elicit was less voluntary than instinctive, or magical. I didn't use the word *auras* lightly; the *Anthology* was a spell-casting work. It was prepared as a sort of gnostic ritual. In the scared and satisfied reactionary freeze of the postwar period, it meant to distinguish those who responded from those who didn't, to distinguish those who responded to themselves.

Smith's definition of "American folk music" would have satisfied no one else. He ignored all field recordings, Library of Congress archives, anything with the scent of purity on it. He restricted himself to the commonly held music of traditional and marginalized American cultures as it was com-

mercially recorded between 1927, when, as he wrote, "electronic recording made possible accurate music reproduction," and 1932, "when the Depression halted folk music sales."[7] Those years comprised the high point of a time when northern record companies suddenly realized there were specialized markets throughout the American South for gospel music, blues, Cajun airs, ballads handed down over generations; as a commercial proposition, those years were a window opening onto a seemingly infinite past, a present altogether abstracted from history, and a future more dependent on fate than on will.

Dressed up like a good pedagogue, and arming his selected old discs with complex, cross-referenced discographies and bibliographies, neatly attaching story-songs to the historical events (the made-up historical events, sometimes) from which they derived, noting changes in approaches to voicing, instrumentation, tunings, and the like, Smith divided his eighty-four choices into three categories, his three boxed sets of two LPs each: "Ballads," "Social Music," and "Songs." Within his five-year span, he paid no attention to chronology as he sequenced the numbers; for all his painstaking annotation, he never identified a performer by race, happily sowing a confusion that in a few cases persists to this day.

Very carefully, Smith constructed internal narratives and orchestrated continuities. He moved tunes about homicide into those about suicide. Or he placed a performance so that it would echo a line or a melody in a preceding number — so that the repeated line might deepen its powers of suggestion, or the doubled melody intensify the actors on its stage. Linking one performance to another, he ultimately linked each to all.

Out of such arrangements, Smith made a world — or a town. Call it "Smithville." In this town, Dick Justice's "Henry Lee," the story of a murder witnessed by a talking bird, is as suffused with religious awe as the Reverend J. M. Gates's "Must Be Born Again." In this place, Bascom Lamar Lunsford's "I Wish I Was a Mole in the Ground" is more otherworldly — less at home in this world — than the Memphis Sanctified Singers' "He Got Better Things for You."

Smith opened "Ballads" with progressively spookier renditions of the sort of English and Scots murder tales that since the late eighteenth century had found a more lasting home in the mountain isolation of the southern Appalachians than in the British Isles. With the air over his town growing heavier, he moved to numbers about homegrown murders. A fiddler, who as both a singer and a musician sounds at least as old as the story he is telling, describes how in 1808, in North Carolina, a pregnant woman named Naomi Wise was killed by her lover. Cole Younger goes down after the James

Gang's 1876 bank robbery in Northfield, Minnesota. President Garfield falls to an office seeker in 1881, and President McKinley to an anarchist twenty years after that. In 1894 one man kills another over a crap game in West Virginia; in 1895 Stagger Lee shoots Billy Lyons in a St. Louis bar; four years later, in the same neighborhood, Frankie shoots her lover Albert. Then murder is superseded by disaster: the *Titanic* sinks, trains are wrecked, farms fail, the boll weevil dethrones King Cotton. "Ballads" ends with "Got the Farmland Blues," by the Carolina Tar Heels, which really is a *farmland* blues. "I woke up this morning," sings Clarence Ashley, "between one and two. . . ."

Though in most cases traced to historical incidents, these ballads are not historical dramas. What they dramatize is action; regret; sardonicism; fear; acceptance; isolation; the wish for mastery running up against forces no one can understand, let alone master. After this, "Social Music" is a respite, at first almost tiresome. A dance is under way, fiddlers play reels and stomps, there is drinking and merriment, and then — then God, in the person of the Reverend J. M. Gates, asking, like a man making the cruelest joke last as long as he can, "Oh! Death Where Is Thy Sting?" Chanting against a chorus that seems constantly on the verge of breaking up into pieces, Gates is utterly implacable, fearsome. His voice is harsh, deep, impatient with the weaknesses of the spirit and the flesh: impatient with human nature. Suddenly you're trapped. The party wasn't supposed to end this way, but now, in a church that changes shape with each new performance, the party is just starting. It's as if, now, the whole community has to pay for the solitary crimes of the first two LPs, and as if everyone knows that this is fitting and proper, that this is right. But by the time "Social Music" ends, it's not only the shape of the church but also God's face itself that has changed. Against all odds, it is smiling. The Reverend F. W. Moore celebrates "Fifty Miles of Elbow Room." The Reverend D. C. Rice and His Sanctified Congregation take their place in a great army. "I'm on the Battlefield for My Lord," they sing, and they make you want to join them. The pleasures of the dance, the wallow in drink, now seem very distant, and worthless. In their place is a great spirit of freedom: the freedom of knowing exactly who you are, and why you are here.

I

You leave "Social Music" in the arms of certain knowledge. Instantly, on "Songs," you're ripped from those arms and cast into a charnel house that bears a disturbing resemblance to everyday life: to wishes and fears, difficulties and satisfactions that are, you know, as ordinary as dirt but also, in the

voices of the men who are now singing, the work of demons — demons like your neighbors, your family, your lovers, yourself. The first side of "Songs" is a panorama of the uncanny. It's not that here nothing is as it seems; as Buell Kazee negotiates "East Virginia" and Rabbit Brown meanders through "James Alley Blues," as Dock Boggs takes his place in the limbo of "Sugar Baby," it's as if nothing that seems even is. The streets of Smithville have been rolled up, and now the town is an amusement park, offering that quintessential American experience, the ultimate, permanent test of the New Man that Tocqueville found as he traversed the American democracy: Step right up, Ladies and Gentlemen! Enter the New Sensorium of Old-Time Music, and feel the ground pulled right out from under your feet!

The *Anthology*'s two albums of "Songs" continue on from this first side, maintaining a startling level of power, on through suites of songs about loneliness, prison, death, labor — passion and exuberance bursting through even tunes beginning on a chain gang or in the midst of deadly labor strife. The whole long story is brought to a close when it is lifted out of itself, with the freest song imaginable, Henry "Ragtime Texas" Thomas's "Fishing Blues," played on panpipes, an instrument that blocks all possibility of tracing the historical origins of this song or that — the high, lilting, piercing sound of the panpipes goes back to the end of the Paleolithic. This sound is older than any surviving language, and so might be the message of this song from a traveler who crisscrossed the South from the end of the nineteenth century into the 1940s, a message he repeats over and over, as if it holds all the secrets of the universe: "Here's a little something I would like to relate / Any fish bite if you got good bait."

There is an almost absolute liberation in "Fishing Blues" — a liberation that is impossible not to feel, and easy to understand. Yet there is a liberation just as absolute brooding on that first side of "Songs," breathing through Dock Boggs's nihilism, Bascom Lamar Lunsford's pantheism, the ghost dance of Rabbit Brown. This liberation — or this absolute — is not easy to comprehend, but for just that reason, it is here, in Smith's most explosive collage of scavenged old records, that the *Anthology* finds its center, or its axis; it is here that Smithville begins to shade into Hawthorneville, Melvilleburg, Poetown.

In "Smith's Memory Theater," an essay on the *Anthology of American Folk Music*, the ethnomusicologist Robert Cantwell is writing about one of the songs in this sequence, but he might be writing about almost any of them, or all of them. "Listen to 'I Wish I Was a Mole in the Ground' again and again," he says. "Learn to play the banjo and sing it yourself over and over again, study every printed version, give up your career and maybe your fam-

ily, and you will not fathom it."[8] What he says is not that different from what Bob Dylan was saying about folk music in 1965 and 1966, when people were asking him whether he wasn't betraying himself and his audience by trading music made with a wooden guitar for the electrified music of rock 'n' roll — trading, they meant, the timeless values of "the folk" for the spoils of Babylon. "All the authorities who write about what it is and what it should be," Dylan said, "when they say keep things simple, [that it] should be easily understood — folk music is the only music where it isn't simple. It's never been simple. It's weird . . . I've never written anything hard to understand, not in my head anyway, and nothing as far out as some of the old songs":[9]

> I have to think of all this as traditional music. Traditional music is based on hexagrams. It comes about from legends, Bibles, plagues, and it revolves around vegetables and death. There's nobody that's going to kill traditional music. All those songs about roses growing out of people's brains and lovers who are really geese and swans that turn into angels — they're not going to die. It's all those paranoid people who think that someone's going to come and take away their toilet paper — *they're* going to die. Songs like "Which Side Are You On?" and "I Love You Porgy" — they're not folk-music songs; they're political songs. They're *already* dead.
>
> Obviously, death is not very universally accepted. I mean, you'd think that the traditional-music people could gather from their songs that mystery is a fact, a traditional fact . . . traditional music is too unreal to die. It doesn't need to be protected. Nobody's going to hurt it. In that music is the only true, valid death you can feel today off a record player.[10]

Bob Dylan could have been talking about the first side of Harry Smith's "Songs"; despite radical differences in pitch and style, one quality that unites the singers here is that *they* sound as if they're already dead. In moments, it's as if they're lining out a crucial but unspoken premise of the old southern religion: Only the dead can be born again.

No performance captures this sensation more completely than the first number on this magical side, Clarence Ashley's 1929 Columbia recording of "The Coo Coo Bird." There is no more commonplace song in the Appalachians: the song has been sung for so long, by so many, in so many different places, as to come to seem, to some folklorists, virtually automatic, a musicological version of the instinctive act, like breathing — and therefore meaningless.[11] As Ashley sings and plays the song, he pays in full every claim Dylan makes about traditional music, and also the claims of the uniquely plain-spoken argument the South African musicologist Peter van der Merwe makes about the sort of Appalachians who appear all across the *Anthology*

of American Folk Music: Ashley, Lunsford, Kazee, Boggs, Uncle Dave Macon, and so many more. In *Origins of the Popular Style: The Antecedents of Twentieth-Century Popular Music*, van der Merwe writes:

> When middle-class America first discovered these mountain folk, there was a tendency to present their ways as even more primitive and archaic than they actually were. Nonsense was talked of their "Elizabethan speech," as though they had been preserved unaltered since the sixteenth century. As an inevitable reaction, it is now fashionable to point to urban influences on this isolated rural culture, just as it is fashionable to make similar observations about British country people. Taking all such reservations into account, I still believe the biggest danger lies in *under*estimating the strangeness of these cultures.[12]

Clarence Ashley was born in 1895 in Bristol, Tennessee; from the age of fifteen or sixteen, he traveled with medicine shows ("I was always crazy about the show business"); by the 1920s, he was a professional itinerant musician, playing in string bands, at fairs, on the streets, to miners as they picked up their money or their scrip; he died in 1967. In 1929, he was in his mid-thirties; he sounded 17, or 117, or as if he'd died 17 or 117 years before. His performance made one thing clear: however old the singer was, he wasn't as old as the song.

"The Coo Coo Bird," like many of the numbers on the *Anthology*, was a "folk-lyric" song. That meant it was made up of verbal fragments with no direct relationship to one another, drawn from a floating pool of thousands of disconnected verses, couplets, pieces of eight. Harry Smith guessed the folk-lyric form came together somewhere between 1850 and 1875.[13] Whenever it happened, it wasn't until enough fragments were abroad in the land to reach a kind of critical mass — when there were enough fragments, passing back and forth between blacks and whites as common coin, to sustain an almost infinite repertory of performances, enough fragments to generate more fragments. But just as it is a mistake to underestimate the strangeness of the cultures that spoke through these fragments ("When I leave here, just hang crêpe on your door / I won't be dead, just won't be here no more"; "I wish I was a mole in the ground / Like a mole in the ground, I'd root that mountain down"), it is also a mistake to imagine that when people spoke through these fragments, they were not speaking — for themselves, as contingent individuals. What appears to be a singer's random assemblage of fragments may be a sermon delivered by the singer's subconscious. It may be a heretic's way of saying what could never be said out loud.

Ashley's singing — high, a voice edgy with the energy of musing, of want-

ing, of not getting, of expecting to get it all tomorrow — rises and falls, dips and wavers, playing off the rhythm his banjo makes like a tide eddying up to a bank again and again. There's a willful irascibility in his voice, a nihilistic disdain for the consequences of any action the singer might take, or not take. The banjo could be from another song, or another world. The music seems to have been found in the middle of some greater song; it is inexorable. The opening and closing flourishes seem false, because the figures in the music make no progress, go from no place to any other; this sound was here before the singer started, and it will be here when he's gone.

In this context, the most apparently commonplace folk-lyric fragment in Ashley's "Coo Coo Bird" — the verse seemingly most unburdened by any shard of meaning — cannot be meaningless. "Gonna build me / Log cabin / On a mountain / So high / So I can / See Willie / When he goes / On by" — it sounds like a children's ditty only until you begin to realize the verse is made in order to refuse to answer any of the questions it makes you ask. Who is Willie? Why does the singer want to watch him? Why must he put aside his life and embark on a grand endeavor (in versions of "The Cuckoo" closer to its original, British form, the log cabin is a castle) just to accomplish this ordinary act? The verse can only communicate as a secret everyone already knows, or as an allusion to a body of knowledge everyone knows can no longer be recovered, and Ashley only makes things worse by singing as if whatever it is he's singing about is the most obvious thing in the world. The performance doesn't seem like a jumble of fragments. Rather, there is a theme: displacement, homelessness. "We Americans are all cuckoos," Oliver Wendell Holmes said in 1872. "We make our homes in the nests of other birds."[14] This is the starting point.

More than seven hundred years ago, the English sang that the cuckoo heralded the coming of summer — and yet the bird was hated. Its cry (the male's cry) was reviled down through the centuries as oppressive, repetitious, maniacally boring, a cry to drive you crazy, a cry that was already crazy.

The cuckoo — the true, "parasitic" cuckoo, which despite Holmes's choice of it for national bird is not found in the United States — lays its eggs in the nests of other birds. It is a kind of scavenger in reverse: Violating the natural order of things, it is by its own nature an outsider, a creature that cannot belong. Depositing its orphans, abandoning its progeny to be raised by others, to grow up as impostors in another's home — as America filled itself up with slaves, indentured servants, convicts, hustlers, adventurers, the ambitious and the greedy, the fleeing and the hated, who took or were given new, impostors' names — the cuckoo becomes the other, and sees all other creatures

as other. When the cuckoo egg hatches, the newborn drives out any other nestlings, or destroys any other eggs, as new Americans drove out or exterminated the Indians. As a creature alienated from its own nature, the cuckoo serves as the specter of the alienation of each from all.

If this is the theme of the song, then rather than the antinarrative many find in folk-lyric performances, what is present in Clarence Ashley's performance — the axis on which Harry Smith's *Anthology* seems to turn, or maybe the proud anthem of Smithville, sung every night at sundown — is a master narrative: a master narrative of American willfulness and fatedness, a narrative implied but altogether missing, replaced instead by hints and gestures, code words and winks, a whole music of secret handshakes. The song seems to assume a shared history among its listeners, to take in the countless volumes of what does not need to be said, and yet as Ashley sings the song it is almost a dare. That's how it feels; but who, or what, is being dared, or why, is completely unclear. "Oh, the coo coo / she's a pretty bird / And she warbles, as she flies," Ashley begins. "And it never / Hollers coo coo / Till the fourth day / Of July." It is usual to dismiss this as not even a metaphor, as merely a rhyme. But that is only because, as a metaphor, this verse can be understood but never explained; because it can be felt, but not figured out; because it can place the listener, pull the listener's feet right out from under, but cannot itself be placed. It is not an argument; it is a riddle.

Imagine that in 1929 this was a riddle Clarence Ashley took pleasure presenting before the country. Part of the charge in the music on the Smith *Anthology* — its reach across time, carrying with it such individualistic flair, such collective intensity — comes from the fact that, for the first time, people from isolated, scorned, forgotten, disdained communities and cultures had the chance to speak to one another, and to the nation at large. A great uproar of old/new voices was heard, as happens only occasionally in democratic cultures — but always, when it does, with a sense of explosion, of energies repressed for generations bursting out all at once — and this uproar was not a cacophony; one of the great gifts of the *Anthology of American Folk Music* is that it recreates this uproar as a conversation. Yet if the years 1927–32 contained a democratic event, its spirit was democratic in a way that socialists and communists — the people who, from the 1920s to the 1950s, perhaps more than others took up the cause of American folk music, and through mastery of its facts claimed ownership of knowledge of the American soul — could never accept. That is, save for the performances Smith collected on "Social Music" (and by no means all of those), the music on his *Anthology* was not exactly made by "the folk." It was made by willful, ornery, displaced, ambitious individuals (almost all of them men, because it was men and not

women who were permitted to exhibit such traits in public): contingent individuals who were trying to use the resources of their communities to stand out from those communities.

These were people who had summoned the nerve to attend auditions held by scouts from northern record companies, or who had formed bands and tried to get their fellow men and women, people just like them, to pay attention to them as if they were not quite just like them. These were people who, if only for a moment, looked beyond the farms and mines to which they were almost certainly chained. The stories they would later tell of journeying to New York to record are almost all the same; they contained the same question. *How*, one singer after another would recall asking himself — as the singers spoke in the 1960s, when folk fans had tracked down Harry Smith's survivors, Ashley, Boggs, Mississippi John Hurt, so many more — how, they remembered asking themselves, as they had arrived in New York City in the 1920s like tourists from some foreign land, *how* could they keep hold of their pride, speak their piece as if they knew their neighbors would hear, but also as if they knew the country itself might actually acknowledge their existence, myself, Clarence Ashley, yes, but also everyone I know, and those I don't know, my ancestors, and those I'll leave behind?

It is this spirit — the pride of knowledge to pass on, which is also a fear for the disappearance of that knowledge, and of its proper language — that makes a whole of the *Anthology of American Folk Music*. It is this suspicion that there is, somewhere, a smaller, perfectly, absolutely metaphorical America — an arena of rights and obligations, freedoms and restraints, speech and silence — that makes kin of Mark Merlis's Tom Slater, or real life's F. O. Matthiessen, Harry Smith, and all those he brought together.

II

What is Smithville? It is a small town whose black and white citizens are not distinguishable by race. There are no masters, and no slaves. The prison population is large, and most are part of it at one time or another. While some may escape justice, they do not remain among their fellow citizens; executions take place in public. There are, after all, an inordinate number of murders here — crimes of passion, of insanity, of absurdity — and also suicides. There is a lot of humor, most of it cruel: as the citizens love to sing, "Roosevelt's in the White House, he's doing his best / McKinley's in the graveyard, he's taking his rest." There is a constant war between the messengers of God and ghosts and demons, dancers and drinkers, and, for all anyone knows, between God's messengers and God himself — no one has

ever seen him, but then no one has ever seen a cuckoo, either. The town seems simultaneously a seamless web of connections and an anarchy of separations: Who could ever shake hands with Dock Boggs, who sounds as if his bones are coming through his skin every time he opens his mouth? And yet who can turn away from the dissatisfaction in his voice, the adamant refusal ever to be satisfied with the things of this world or the promises of the next?

This is Smithville. Here is a mystical body of the republic, a kind of public secret, a declaration of what sort of secret wishes and fears lie behind any public act, a declaration of a weird but queerly recognizable America within the America of the exercise of institutional majoritarian power. Here, the cadence of Clarence Ashley's banjo is both counterpoint and contradiction to any law; here everyone calls upon the will and everyone believes in fate. It is a democracy of manners — a democracy, finally, of how people carry themselves, of how they appear in public, to others. God reigns, but his rule can be refused. His gaze cannot be escaped; his hand, maybe. You can deal: You can trade a probably real exile for a probably imaginary homecoming. Or you can take yourself out of the game and wait for a death God will ignore; then you, like so many others, already dead but still speaking, will take your place in the bend of a note in "The Coo Coo Bird." It's limbo, but it's not bad; on the fourth day of July you get to holler.

Suiting Everyone: Fashion and Democracy

Anne Hollander

Fashion in dress means continual change in what looks right on the body—it is based on an ideal of contingency in satisfactory appearance. This ideal, along with fashion itself, came into existence only in Europe, somewhere between the twelfth and fourteenth century, a period that can arguably be called "modern." Fashion thus preceded modern democracy by many centuries and developed in very nondemocratic political contexts; but from the beginning it demonstrated, I would argue, some of the desires underlying the ideal of democracy that would later come into being.

To make such demonstrations, I would further argue, was and is the imaginative function of fashion. It is a mode of illustration that permits collective thoughts and wishes to be expressed without language, in terms of visual form only. This means that its social or political or sexual expressions can

flourish in advance of ideas that require verbal articulation, consensus, and action. Thus, fashion's alleged *reflection* of political or cultural movements is often not a reflection but a prophecy. Moreover, fashion can permit a form of wordless disagreement with the overtly stated opinions of its wearers — people can say one thing and wear another, and both can be the truth, although only one is in language. The invention of fashion made this sort of expression possible in clothing, and I would therefore conclude that fashion is what really turned dress into an art. Without fashion, dress is a craft. With it, dress is an art, more specifically a modern art — personal and imaginative, competitive and subversive, as the modern democratic West believes the arts should be.

Judging from art during the long period before fashion started, European clothes were very different and were perceived very differently from the way they were designed and perceived when fashion was in full swing. Beginning with first-century Roman reliefs, moving on to sixth-century Byzantine mosaics and still further on to eleventh-century Romanesque sculpture, it is easy to observe how the simple shapes of garments helped artists create a unifying and beautifying order among persons. Whatever the style and medium, the two sexes and all ages are shown to be harmonized by their clothes. The mode of draping garments in art conforms to a single ideal of stable beauty for men, women, and children's clothed bodies, as if to show both the belief that peace prevails and the desire that nothing be changed. Only small details distinguish the sexes and classes, and high rank is plainly shown only by additional ornament. All garments have clearly minimal and similar form — basic tunics, basic cloaks, basic veils — and interesting aesthetic complexity is provided only by the artist's rendering of everyone at once, not by the individual clothing of anyone.

In French courtly illuminations, German engravings, or Italian panels from the fifteenth century, however, one can see not only a great difference between the sexes and among individuals but also great inventiveness in the actual form of the garments. The scheme for clothing offers a strong impression of instability, even irrationality — long, pointed toes for shoes or high, stiff hats for heads, or the body tightly confined by tailoring at certain places and swamped in sweeping drapery at others. Artists were careful to emphasize these phenomena as individual expressive elements, demonstrating both the separateness of each person and the general unaccountability of human wish. Harmony was nevertheless still shown to prevail. The style and medium gave obvious coherence to disparate expressions, so that one mode plainly applied to all vagaries. The whole picture would show both how fashion works to unite and individuate at once and how its extremes should be

taken as temporary examples, just the way extreme emotional states are only fleeting examples of a civilized individual temperament.

Fashion and the arts that mirror it have produced this sort of effect down to our present time at about the same rate. The question cannot be avoided: What made it start? Only general answers are possible. Transforming dress from an immemorial custom into an immediate poetic form seems to have begun as a part of the changes occurring in other arts — courtly love, with its codification of amorous feeling and behavior; new modes for lyric verse, including romances about old times; the use of light and form to create a new lifelikeness for emotional and physical individuality in visual art.

All this went with the rise of towns, of rich ducal courts in competition and strife with one other, of international trade and pilgrimage. Once in motion, however, fashion in dress continued to move, together with other visual manifestations, in a sort of forward-flowing dialectical dance — looseness following tightness, carelessness following rigidity, complexity following simplicity, each change seeming to comment on what preceded it in one way or another.

Changes in fashion were always fairly quick, and pictures can be dated within five years, even back then; what has increased is the number of people who can play its game at once. The point is the constant flux in overall effect; and here is where the principle behind it comes in, as something that could already seem like a broad and deep background to eventual democratic ideals. To begin with, the constant change in bodily form through fashion reveals a need to illustrate the normal emotional shifts in human life, as well as differences of personality, the waywardness of sexuality, the provisional character of beauty. Behind this lies a desire to acknowledge (visually and bodily) a sense that life is an uncertain single trajectory leading to certain death, awareness of which makes vividly urgent the specific phrasing of life, both individual and communal.

This urgency puts a value on the power to control changes in circumstance, and, especially if that is impossible, on the freedom to express changes in feeling, including the desire for such control — perhaps hope, delight, and pride but also rage and discontent, mockery and self-mockery, a sense of the absurd, boredom, contrariness, and selective nostalgia for the past. Western lyric poetry takes up these themes from this period on, showing how in any art individual experience can be made to mirror collective feeling — the common may be rendered in terms of the personal.

The irrational forms of fashion, using the individual body, do the same. They seem to honor, for example, such changes as the renewal of lust after a spell of satiety, or the birth of laughter after a spell of solemnity. Fashion

records a continuous insistence on dissatisfaction; it traffics in irony and a refusal of satisfying cadence or cyclic endlessness. One of its favorite ways of doing this is to suggest an ever-dramatic relation between the two sexes, so that they constantly seem first to divide sharply and then to merge disturbingly. Fashion is only provisionally comfortable; and it is never wholly safe. Like freedom, it requires eternal vigilance — and, also like political freedom, it is by nature secular. It refuses to be governed by established religion, which very often does deal in comfort and safety and always hates fashion.

The nonfashion scheme, such as can be seen in the early sculptures and mosaics, follows that alternative convention. It offers a sense of beauty as conformable with a desired visual ideal, illustrating an ideal of life itself as forever harmonious and eternally recycling, supported by a fixed cosmology and by adherence to stable religious traditions based on it, including a stable and sanctified division between male and female, parent and child. Formal expressions register a primary pleasure in the repetition, variation, and refinement of confident assertions, the equivalent of ritual chant, the very opposite of fashion's perpetually uneasy suggestions. Beginning in the nineteenth century, the adoption of modern Western clothing by nonmodern and nondemocratic cultures indicated a desire exactly for the kind of disturbing expression — the freedom of speech — guaranteed by democracy, even in the absence of the real thing.

Although fashion fantasizes collectively about individual feeling, since it deals in terms of one body at a time, we have noted that fashion permits its actual individual expressions only within a generally agreed-upon esthetic scheme, generally agreed upon, that is, until the agreement undergoes a general shift. This idea begins to bear some relation to certain democratic ideals: individual freedom and equality of opportunity, protected by a governing system that may be changed only with majority consent. It should be noted that there were no fashion designers during the half-millennium of brilliant, inventive fashion before the end of the eighteenth century. Tailors and clients together, whether at court, in cities, or in villages, worked everything out between them each time. Some clients and some tailors certainly had more flair and more influence than others, but no one "dictated" anything. Fashion seemed to change by itself, as certain things stopped looking right to everyone, and others started to look marvelous.

The real contradiction, of course, appears to lie in the word *equality*. In all that time, from the twelfth century to the end of the last, fashion would seem to have applied only to rich leisured folk, and that was largely true in practice. But something else arose along with fashion in the late Middle Ages,

and that was the spread of printed pictures. Printed text followed later; but single-sheet prints were made and sold inexpensively all over Europe at fairs, to be pasted into box lids and tacked onto walls and cupboard doors; pictures were printed on playing cards and in cheap books. Most of this imagery was of clothed persons, many of them elegant, in the form of saints and legendary characters, or current, in the form of prostitutes and soldiers, royalty, notorious criminals, wonder-workers, and other strictly modern types.

In many such prints, moreover, people in ordinary circumstances would often be rendered with as much artistic suavity as nobles. Everyone would wear current fashion in bodily shape, style of hair, drape of garment; and these would change a year or so later, in the pictures for sale at the next fair. So everyone could keep seeing what the well-dressed person in all ranks should look like, according to the work of the visually alert, market-sensitive printmakers of those centuries, who worked in towns and stylishly rendered the latest in dressed effects, probably without thinking too much about it. There may have been no velvet or feathers for poor villagers, but if they could get them, they would know how to wear them. Through print media, a visual standard of chic looks had already come into existence for the general public. A village maiden could tighten her bodice or hitch up her skirt with up-to-the minute panache.

Printed imagery was among the things that made fashion's life possible then, exactly as it still does now. Only a few actually play the high-fashion game really seriously; but many others know about it, care about it, think about it, and fantasize about it, because they see it in pictures, and they play the game as they can. Meanwhile, untold others who do not really care nevertheless absorb the rules of the game unconsciously, again through pictures, so that they, too, have an idea that some things look right and others do not at any moment and that this rightness keeps changing and might possibly affect them.

For centuries it could properly be said, however, that fashions themselves were invented at the highest level and adapted by those below to their own circumstances. It was also true that fashion was regional and that all ranks tended to look similar in particular countries or principalities; and so did printed pictures, of course, since style in pictorial art was also regional. But I want to emphasize that what fashion offered, for a long time before everyone could play the game, was an equality of opportunity for taste, for attractive personal style, an equality suggested and spread by gifted graphic artists in the print medium, the earliest equivalents of photojournalists, fashion photographers, and cinematographers.

But what about truly democratic fashion, such as now exists, which shows

itself to be a game for everyone at once, open to influence from all directions? I have borrowed my title, "Suiting Everyone," from a book subtitled "The Story of Ready-to-Wear"; and that story, the story of fashion for everyone, in fact begins with men's fashion in England. The great move into modernity made by fashion, which resulted in it being the actual clothing of real democracy, not just a bodily fantasy about individual expression within an expressive community, was made by men, specifically by the invention of modern male tailoring for gentlemen at the highest level of English society at the end of the eighteenth century.

Appropriately enough, however, the first fashionable ready-to-wear garments were the elegant men's suits mass produced in America at the beginning of the nineteenth century by enterprising merchant-tailors in the democratic and commercial New World. These suits were based on the English gentleman's suit, and they first made it possible for all — meaning, of course, for all male citizens — to look as elegant as he.

But I want to lead up to the original English gentleman's suit, which began it all. It is a fact that fashion itself, the triumph of changing form in dress, had originally been instigated by men, in connection with the invention of fitted and sculpted plate armor in the late Middle Ages, following centuries of chain mail and loose robes. After the rise of body-defining plate armor and its prestige, modern Western fashion required a chic, sexy changeable articulation for the whole male form, created by cut and fit and combined with close covering of its surface. The look of armor, translated into cloth, set a rigid, trussed-up, and padded standard for male tailoring for a long time, in most social classes.

Women conservatively kept the long, full drapery of antiquity for the skirts of their dresses, worn as if to suggest the antique virtue of modesty as their special province, at least below the waist. But to counter the sexy new masculine articulation, women invented sexy décolletage for the upper body. With further provocation, women also soon began to copy the male, armor-inspired stiff doublet for their corseted torsos, along with male hats, collars, and shoes. Fashion was thus originally a male proposition, to which women eventually responded. So was equality, of course, and democracy itself.

By 1700, fashion in Europe and England was no longer regional. Since the rise of Louis XIV, all European and English elegance had come to be based on the taste of the French aristocracy, and lower-class regional fashion started to be something called Peasant Costume, often assumed to be the opposite of Fashion. Armor had ceased to be efficacious by Louis XIV's time and had come to be ceremonial, so male fashion had loosened up, and the chic man was no longer upholstered in his clothes. Chic had indeed begun

to come up from below, as it has often done since, in the form of the bunchy, rough-and-ready military gear made familiar all over Europe during the Thirty Years' War.

By the mid-eighteenth century, chic coats, vests, and knee breeches wrinkled deliberately but also sumptuously, and so did stockings. Everything had a mobile surface emphasized by many buttoned and unbuttoned buttons; coatskirts swung out at hip level, and cuffs were huge. Subtle cut did not matter very much, and seams were hidden by braid and embroidery.

The new lack of padding was further emphasized by a very tight fit around the upper body, which made a hollow chest, narrow shoulders, and a potbelly extremely elegant, along with the wrinkles. Male legs were made to seem short by knee breeches and big shoe buckles; at this time, length of leg and breadth of shoulder were suitable for footmen, not gentlemen. Court dress might be made of brocade and embellished with embroidery and lace, but even in more modest social circumstances, the standard of taste was based on surface richness and ornamental buttons, with frills for the shirt and a formal wig for the head. The expression of rank was everywhere of utmost importance, and the higher the richer.

But not in England. Long before Louis XIV, the English had already beheaded their absolute monarch, and they now had no equivalent of Versailles. The aristocracy of eighteenth-century England agreed to appear at ceremonial court functions in full fig but much preferred shooting over the country estate, dressed in the appropriate simple gear. This country costume had an affinity with the natural world — plain wool and leather in dim colors and plain linen, in harmony with the smooth coats of beasts and the look of the natural landscape.

Ideals of the natural were on the rise in the late eighteenth century, in France as well as elsewhere, and the perversity of Paris fashion had already seized on simple English country dress by the 1780s. Soon the English, following France, as everyone did, had no choice but to make it fashionable for themselves; and old-guard types were shocked to see young bloods arriving at London dinner parties in dusty boots and drab coats, rather than damask and sparkling shoe buckles. But with respect to overall style, another important new element soon entered the fashion picture.

During the same last two eighteenth-century decades, while democracy was being invented in America, the neoclassic movement had taken over European visual taste, with different flavors according to different cultural customs. All these nevertheless depended on radical simplicity, based on antique forms now rediscovered for buildings and bodies. Protestant England already had a simpler material ideal than Catholic France and Italy; English

Georgian and Regency houses and furnishings right now constitute one modern model, including an American one, for classic simple taste. The simplified costume invented for Englishmen during this neoclassic period came to set the modern sartorial tone for the democracies of the next two centuries, even though the actual architects of American practical democracy were still wearing the much-buttoned modes of the previous generation. The new fashion was still in formation; it so far lacked the force that would propel it into the future. More was to come.

Back in the 1760s, the rough, English country costume already carried suggestions of distance from aristocratic pomp, and in the 1780s it already had a nascent vogue; but by the century's end, the flavor of natural virtue, expressed as a classical male figure, was added to this image to create a complete new standard for the elegant man, one we still follow. Such a creation was possible in this period because the antique form of the nude had come to be conflated with the truth of the natural body. According to neoclassic aesthetics, the sculptors of ancient Greece were not thought to have invented an ideal but to have discovered the essential nature of human anatomy. Modern civilized men who respected nature would of course try to conform physically to this natural ideal; and fashionable dress would illustrate this desire. To achieve it practically, the already chic but rather sloppy country costume was progressively rethought, recut, and refined to look as if it clothed the Greek athlete of antiquity.

With the aid of very subtle cutting, steaming, and discreet padding, the dumpy figure wearing the country coat developed a muscular chest and shoulders, a flat stomach, lean flanks, and long legs. His natural hair reappeared, naturally windblown. The chic male costume lost its frills, full skirts, and wide cuffs, its distracting surface richness, and most of its buttons; and it acquired a new scheme for fit. The smooth coat had only to outline and skim the heroic torso, merely suggest its noble sculptural contours, while permitting the coat to button without a wrinkle. At this stage of the new fashion, long and tight doeskin pantaloons from waist to ankle emphasized a sweeping length of leg, no longer broken by knee-length breeches and often set off by the sleekest of boots, elegantly cut and polished.

This reformation could appear to render the man more physically natural and at the same time to display contempt for outmoded standards of elegant appearance that depended on the surface marks of rank at the expense of personal virtue — of which perfect bodily beauty was known in antiquity as the visual symbol. Meanwhile, this same classic male beauty could be further identified with the perfect natural nakedness of Adam before the Fall, also the sign of his purity and native worth.

The new unadorned wool, leather, and linen moreover could clothe the modern neoclassicized man in the same fabrics worn by those natural heroes of antiquity, the citizens of democratic Athens. But those materials could now re-create the nude body entirely with modern tailoring, without exposing any skin. Exposed instead were the smooth texture of the wool and the seams of the garment, standing for the surface and the structure of the heroic body. In his new classical muscles, sculpted in natural fabrics, modern man could begin to seem like the candid vessel of reasonable opinion, his uncorrupted self expressed in natural and simple modern dress.

When Beau Brummell, then flourishing as a friend of the Prince Regent, made this fashion famous, he was also famous for not being a nobleman, for being a man with no coat of arms, no acres, and no fortune, only wit, intelligence, character, and personal style. In fashionable life such a man and not the aristocrat had become the model of the modern superior person. All men, it was moreover implied, could be visually equalized by the new natural dress, so that the true worth of each, mirrored in his unique face, crowned with his natural hair, might manifest itself in honest speech and action free of ancient constraints.

All men's equality of opportunity could seem guaranteed by such a governing scheme of clothing, which enhanced all male bodies across class barriers, as artists had done in Greek sculpture. Furthermore, the scheme seemed to protect an individual freedom, signalized by each face and again without regard to class, to assert a personal will; but also freedom to be clever or stupid, to be engaged or detached, to be eager to rise and succeed or to subside and stagnate — to be, in fact, modern. By its concern with tailoring each body, the new sartorial scheme took the opposing stance to that of the uniformly cloaking dress of religious orders, which seeks to drown each body and thus appears to drown each face, each character, each will.

Meanwhile, across the channel, other forces were at work on the future marriage of fashion and democracy. The French Revolution brutally did away with the prestige of richly noble dress in France and at first elevated a coarse untidiness as the chic masculine note to strike in Paris, once again borrowing from below. The scheme was still based on the English country model, but it soon had help from another source, the formidable image of the *sans-culotte*, the enraged street fighter of revolutionary Paris. And here is where the last and most lasting element of modernity was added to the modern democratic male image: trousers.

Trousers were essentially proletarian. *Sans-culotte* means without the standard knee breeches of polite life, that is, the work pants of the lowest working class. Basic and unshaped long pants of tough cotton fabric were

the normal dress of common sailors, agricultural laborers, and slaves on colonial plantations. They were occasionally worn by gentlemen, for convenience when attending to business in those same colonies, and also for comfort when at private leisure; but they were strictly unacceptable in town, in public life, or in society. They were the working dress of the rabble. Their adoption as part of the new civil male image during the first two decades of the nineteenth century was thus extremely daring and revolutionary in itself.

Although trousers were less revealing than the doeskin tights of the new high society, their connotations of political violence and rugged male effort gave them a potent appeal. This appeal got a further assist when trousers were adopted as part of the regulation uniform of Napoleon's heroic Grande Armée, and so trousers added the needed note of controlled power to the new male tailored image. This image already contained suggestions of respect for nature and hunting, of natural virtue and physical beauty, of honesty and good sense, of contempt for the vain trappings of rank. With the addition of trousers, the combination gained a virile plebeian potency and readiness for action. After 1815, trousers for urban civil use were speedily refined and smoothly tailored to correspond to the sleeves of the tailored coat, and modern man was suitably clad for his active participation in democracy in the coming century.

But I am still talking about fashion as urban costume of the comfortable classes. Low-life effects, considered desirable in fashion during this period, nevertheless could not be worn in their original crude form (except perhaps for two minutes by the outrageous young) but had to be modified and troped into a convention of refinement. Despite the abolition of lace and brocade and the vision of equality, fashion was still actually moving from the top down.

Nevertheless, the question was already being posed in 1815 of how to suit everyone, to get the elegant and perfected democratic costume onto everyone's back. The perfect Enlightenment hero had been created out of beautifully carved wool, but new democratic impulses led to the ideal of making him universal. Ready-to-wear, mass-produced versions of his bodily form had to be invented to fulfill this fantasy. The first modern clothing miracle was getting really good-looking suits ready-made in a range of sizes and prices — not lumpy, proletarian-looking clothes but sleek and neat gentlemanly garments for the ambitious young men of a newly competitive nineteenth-century world.

Neoclassicism had produced great interest in the general study of proportion, which was thought to be the secret of classical beauty. And it was

the most sophisticated custom tailors of England who began to experiment with schemes for cutting out suits for the many based on proportionate bodily measurement. For the first time, length of back and leg, width of shoulder, waist and chest circumference were seen to alter proportionately and similarly from body to body. Whereas no two men were exactly alike, many were in fact quite similar in overall size and shape. Only now was the tape measure invented, to create a single standard for such measurements.

Formerly, a tailor would have one basic pattern. Before cutting a coat, he adjusted the pattern to each client's shape according to a long paper strip notched with all the client's personal specifications: one notch at the neck measurement, another at the sleeve length, and so on. The client would have such a strip notched on his first visit, and it would remain in the workroom with his name on it, along with the strips of all the tailor's other customers.

Schemes for making the new smooth, body-skimming suits in large numbers according to general principles of bodily proportion began to be published in England in the first third of the nineteenth century, but they were put to most profitable effect in America. There, it was soon alleged by visitors from the Old World, artisans and farmers were indistinguishable from gentlemen when both appeared on Main Street. The common man was clad in suits ready-made to the same high standard of cut used for bespoke ones, not cobbled together according to inferior craftsmanship; and this was only possible because of the smooth generalizing envelope of plain wool that the elegant costume had now become, with its accompanying plain shirt and smooth cravat.

In the nineteenth century, the suit came to be worn by men in all modern countries, at all levels of society, in its several variants. Distinctions of class and clear assertions of taste could be made within its small, abstract compass. It was a triumph of strong and flexible modern design. Its surface was integral with its structure and with the body itself; the body and its clothing formed a fluid, natural-seeming composition. The simple suit always threw the individual face into relief, while flatteringly classicizing each body. The gradual refinement of its tailoring scheme had thus produced the look of distinct individuality, expressed through an aesthetic scheme that itself already expressed integrity and adherence to the rule of law.

Meanwhile, what about women? Female fashion had its own famous neoclassic moment, beginning with the simple cotton gown of rural life, which soon became the even simpler, high-waisted shift of classical antiquity. But then female dress took a separate course from male attire; whereas his suit would continue to develop its restrained simplicity, her modern shift proved as ephemeral as a stage costume and changed just as quickly back into frills

and furbelows. The abstracting and simplifying impulse in male dress, resulting in the modern democratic suit, arose in the context of a deeply divided fashion convention. Sartorially, women were left out of democracy for more than a hundred years.

Male tailors had made everyone's clothes for the first six centuries of fashion. This served to keep the dramatic fashions for the two sexes in a sort of constant balance, since the same tailors used the same materials and craftsmanship for both. Women were never more ornate than men, only interestingly different. But in the eighteenth century, women had taken over the making of women's clothes, and feminine fashion had become a world of its own, as it largely still is. It was at this point that fashion's reputation, always low, was definitively sunk by being associated only with women. Romantic ideals, crystallizing toward the end of the century, made it desirable to give only women's clothes the job of expressing the fearful and unstable aspects of emotional life, while men kept firmly to sobriety, candor, and strength governed by reason. Female fashion took on the task of suggesting the ungovernability of natural forces, both inward and outward — sexual fantasy, dreams and unreason, along with unaccountable wind and water, clouds and flowers. A woman's political power was supposed to take the form of influence on a man, either unconsciously, just the way the weather or private fears and obsessions might affect him, or with a will and an intellect deployed in his service.

All this produced a complexity in female fashion that defied mass production, so that throughout most of the nineteenth century, only feminine outer garments and frivolous accessories were ready-made. The fitted bodices and inventive sleeves and skirts of feminine costume were all made to order or made at home until the last quarter of the nineteenth century, during a period when ready-to-wear suits were already available to most of the male population.

The modern democratic world was thus born into a situation wherein fashion seemed to be both undemocratic and naturally female. All those simple and reasonable suits seemed (falsely) not to participate in it at all, only in the ancient and honorable craft of tailoring and its ready-to-wear descendants. Women soon understood that the way to modernize and become perceptible as forceful and reasonable beings with integrity was to dress as men did — or, rather, since wearing men's clothes was certainly questionable and even forbidden, to adopt the same abstracting principles for their own fashionable clothes. Female fashion began to do this at the turn of the century.

There finally followed the story of female ready-to-wear, which became possible only in this century, when female dresses and suits became abstract

and compact and began to fit approximately, so that many could be cut out at once to fit many women and could be proportionately sized. Soon women's clothes, too, were permitted to slide loosely over the body, as men's suits did. Women's skirts were permitted to display the feet and legs and to move with them, so as to suggest, but not actually reveal, the true shape, dimensions, and capacities of the body inside the clothes, just like men's suits, and, like them, to use minimal illusory tactics — only the subtlest touch of padding or interfacing to improve the line of the total composition. At this point, even before World War I, democratic fashion began to mean a democracy of gender, a new kind of equality, a visual parity of men and women that was expressed in dress long before women actually got the vote.

But the divided expressive tasks remained. Female fashion reserved the right to be fanciful, and a vast multibillion-dollar industry arose to serve that idea in hundreds of ways. This business is now what people think of as fashion, and it is the one that makes the news. Until very recently, men's fashion remained an apparent subsidiary of it, even an exemption, even though fashion in menswear did keep developing and changing. Until the 1960s, however, men's suits remained the real expression of democracy, the ubiquitous visible illustration of freedom and equality of opportunity. In all that time they were known for their comfort, flexibility, and ease of wear.

Female fashion, always essentially conservative and even reactionary, looked much less democratic because it still seemed based on the old idea of conspicuous outrage, conspicuous waste, and conspicuous consumption — originally the privileges of the pampered few of both sexes, later on what came to be seen as the trappings of the expensively Objectified Other. Even the working women of the first two-thirds of this century held on to their right to visible fantasy, each aiming for its unique expression each time. Ordinary female wardrobes thus still needed multiple guises that male ones did not — and that men were glad not to need. Men could still feel superior in their perfect easy trousers and jackets, suitable for all in the brotherhood of good sense. Women got the actual vote in 1920, but fashion demonstrates that an ideal of true equality for men and women was not actively desired until much later.

It is only in the last third of this century that fashion has become truly democratic, in that the principle of equality of aesthetic opportunity has broken down the barriers between male and female dress and between infant and adult dress, between the ordinary attire of different classes, groups, occupations, regions, and whole cultures. The first and most enduring fashionable expression of this principle of universal freedom was the adoption of bluejeans by the young of both sexes in the 1960s, often accompanied by

T-shirts and work shirts and alternating with army fatigues, overalls, and other work clothes. All these items are now available in all variations of fashionable adaptation.

This universal costume began (as always) as adult and masculine. Its components had first been manufactured in America well before the middle of the nineteenth century, when the early ready-to-wear coat-and-suit business was extended to include tough, proportionately well-fitting and well-made work clothes for rural laborers, miners, and railroad men, as well as for the military. One hundred and twenty-five years later, well after the middle of this century, such work clothes became androgynous, multigenerational, and multicultural, always expressing a generic idea of the physical freedom (sometimes conflated with the moral superiority) of the young, the tough, the dispossessed, the restless in all areas of life. Fashion, in complete accord with restlessness, seized on the theme and proliferates it still.

Like the laborer's handmade work pants of the eighteenth century, which rose to become the trousers of gentlemen and of Everyman, bluejeans began at the bottom — except that they were originally factory made and mass produced, machine cut and machine sewn. In this century, they consequently can demonstrate the beauty of the factory-made garment, matching the beauty of factory-made objects already established by the aesthetic ideals of modern industrial design, which also were based on democratic ideals. Soon work clothes engendered myriad offshoots in the fashionable forms of active wear of every kind, now also worn by people of all ages and sexes, classes and races, in their original form or in adapted ones that are constantly modified. These constitute the present-day scheme for democratic fashion, which is being worn all over the world in countries with no history either of fashion or of democracy, and on weekends by privileged Western men who may feel imprisoned in their once universally valued suits.

Such informal clothing is sometimes considered outside fashion, but it actually carries fashion's main stream. In a violent epoch, all the variations on tough pants and shirts, sturdy jackets, and strong shoes originally meant as work clothes, battle dress, and sportsgear, now including visible underwear, are the clothes offering a direct physical armor against threatening external forces, both natural and manmade. And some of them have lately been designed to project an answering danger, the flavor of menace. Glittering adaptations of such clothes also were created for rock stars and other popular performers, who have added infinite glamour, also tinged with danger and violence, to the same plebeian forms.

As a result of all this, classic tailored suits are no longer the true expression of democracy but its official symbol. This means that heads of state,

businessmen, lawyers, and politicians all wear suits to negotiate deals and decisions with insistent civility, but as if ceremonially robed, not naturally clad, in the vestments of enlightened modern probity and adult civic responsibility. Apparently, they do not all feel completely at home in suits anymore — or perhaps in those civil virtues that suits have always directly expressed. Women, of course, have lately added men's suits to the feminine arsenal of seduction and have varied their forms with audacity, in ways classic male suits used to avoid. Envious men may now be feeling stuck with that classicism, and male suits have begun to show a new flexibility in cut and fabric not visible since much earlier days.

The democratic modern woman's right to wear trousers was visibly asserted in the first half of the twentieth century, but that right was only irreversibly confirmed by the bluejeans revolution in the second half. This has now even been extrapolated into versions of male sports pants and work pants feminized in velvet, organdie, and satin. The new idea is no longer that the common man look as elegant as a gentleman but that real elegance consists in wearing imaginative versions of the multiple tough garments originally designed for the common man. The common woman naturally wears them all, too, but they are now freely mixed or alternated with the jewelry, cosmetics, and exotic and fetishistic effects that only a short while ago were her exclusive medium. Some of that freedom, in a climate of female success, is being gradually sought by increasingly adventurous men.

The most important recent work of democratic fashion has been to turn the whole game into a costume party, which was the reserve of feminine fashion for two centuries. It may be necessary to dress one way for one reason at certain times, but you may express yourself differently at other times, adopt different guises at will, and mix them up for subtle effect. The original function of fashion, to register discontent in a fundamental semiconscious emotive way, has become much more conscious in the context of real democracy and truly free speech; we can now deliberately adopt forms with specific political meaning, ethnic flavor, or sexual nuance. We may deliberately use fashion if we wish; or we can still ignore it and allow it to work on us unconsciously, as it always has.

The old feminine fantasy trappings are continually out there in force, full of imaginative suggestions; but everyone knows they are quite optional and that they may be blended or alternated with masculine simplicities, now by both sexes. Nevertheless, men still do not assert their right to wear skirts. Men were conditioned against extreme sexual fantasy after women took it over; and skirts still have that flavor for men, as earrings, scarves, purses, strange shoes, and long hair do not. Those, after all, were masculine origi-

nally. Drag queens and transvestites wear skirts comfortably, but ordinary Western male clothing itself has so far not incorporated them into its acceptable schemes. Maybe it will in the new millennium.

Since democratic fashion is propelled by commercial markets that depend on consumers in all income groups, everyone now understands that change in fashion is promoted by fashion designers at all levels, not by the caprices of the leisured classes — but the exciting idea of ridiculous caprice at the top is apparently still attractive. The most famous fashion designers are perceived to keep inventing fantastic gear for a few fashion models and perhaps for a few women to wear, creations to admire but not to copy except in a considerably modified form. The exhibitions of their work have become a sort of autonomous branch of show business intensively promoted by journalism, which everyone can enjoy and adore, judge and criticize with care, or ignore at will, just like basketball or opera. It seems disconnected from the fashion everyone takes personally, with full consciousness or not.

Most fashion designers are just like other modern industrial designers whose names are rarely known — the ones who conceive the water faucets and beer bottles and toothpaste tubes of the modern world, only they are designing the career suits, nice dresses, and myriad components of casual sportswear that everyone buys and wears. To sustain the clothing business, all designers must gauge the current shifts in public sartorial taste, translate them into actual garments, and hope they sell.

At all times, fashion's own freedom of expression is complicated by democracy's corollary freedom of expression *about* fashion — the visual and verbal media, especially advertising, that help move it in, move it out, and move it along. Fashion still proves democratic by nature, engendered by the changing visual will of the people in general. Designers and their collaborators in the media, while they hope to manipulate it, can in fact only serve it. Fashion, as I have noted, is by nature not safe and not comfortable, for its purveyors or its consumers. And since fashion expresses desire, its most common forms now show that the democracies somehow wish to acknowledge being unsafe and uncomfortable, alert against violence or ready to exert it, in perpetually guarding their precarious freedoms.

Democracy, Reality, and the Media: Educating the *Übermensch*

Gianni Vattimo

Aesthetics is generally acknowledged to be a characteristically modern discipline, originating with Vico, Baumgarten, and Kant. And as it began, so may it also come to an end. Perhaps what has happened in this late modernity in which we live is not the death of art as announced by Hegel but rather the death of aesthetics: the death, that is, of the philosophical discipline, which could supposedly grasp the "eternal" conditions of the possibility of an aesthetic experience conceived as a "natural" feature of human existence. Now, at least since Walter Benjamin's essay, "Das Kunstwerk im Zeitalter seiner mechanischen Reproduktizierbarkeit" (1936),[1] it has become clear that one decisive factor signaling the end of aesthetics as the modern philosophical tradition conceived it is the new predicament of mass

society, that is, of industrial democratic societies that are also, not incidentally, "media societies."

As Benjamin realized, the issue is not to reconsider the role of the artist and his relationship to the public from a simply sociological perspective. My claim will be that these aspects of the matter, as important as they may be, can be understood only when connected with the transformation of the very notion of *reality* that has taken place in the world of mass communication. Kant taught that aesthetic experience is neither theoretical nor practical: it has no bearing on the world's objective reality, which is the ground for scientific knowledge and for moral action. Today, however, our aesthetic experience can no longer be described in Kantian terms, because the very "objective" reality of the world that defined *ex negativo*, as it were, the borders of the aesthetic domain has undergone a process of transformation or, rather, of actual dissolution.

Such a dissolution occurs in the society of mass media and of late-modern democracy: in the predicament, that is, which Heidegger taught us to call the end of metaphysics.[2] The end of metaphysics means, in Heidegger's terminology, the dissolution of the concept of "true" being (*ontos on*, in Plato's terms) as full-fledged objectivity before the mind's eye (i.e., before the *logos*, which is both reason within man and reason within things). From Parmenides to Nietzsche, this metaphysical account of being has developed into a view (which is the view of modern technoscience) which acknowledges that the truest and most assured objectivity rests on the degree of certainty wherewith the object is posited by the subject that certifies, measures, and manipulates it.

To see this, one need only recall that already for classic nineteenth-century positivism the "positive" fact on which any scientific proposition is to be based is one arrived at only in experimental conditions. When Nietzsche conceives of being in terms of will-to-power, he is simply placing himself at the end point of the development of the notion of being as assured objectivity. In Nietzsche's thought metaphysics culminates while also reaching its conclusion, since the illusion of objectivity is finally and fully unveiled. Unveiling this illusion, however, cannot mean its replacement by another, truer, and more "adequate" conception of being: This would amount to yet another alleged "objectivity." What drives Heidegger in his attempt to overcome metaphysics is not the need for a truer, namely, more objective, notion of being. It is, rather, an ethical and political predicament: The notion of being as objectivity, and ultimately as will-to-power, makes it impossible to think of man's existence (which is never sheer objective presence) in terms of

being; moreover, and most important, it paves the way for the coming of a totally organized society, in which human existence is eventually reduced to objectivity fitted for prediction and manipulation.

Here it needs to be remarked that just as overcoming metaphysics cannot mean correcting one mistaken view with a more accurate (and still objective) one, likewise the end of metaphysics does not simply mean that man drops a certain notion of being and adopts a different one. That end is a complicated event affecting being itself, which accordingly can no longer be conceived metaphysically as an object before us but as an event: *Ereignis*, in Heidegger's term.

What I mean by this sketchy reference to Heidegger is that his thinking of modernity as the fulfillment and conclusion of metaphysics provides the key into a comprehensive interpretation of modern existence that remains free from the limits of sociological and moralistic accounts, while it sets the tone for a renewed thinking of emancipation.

Let us now return to the connection between democracy and the end of metaphysics. There are two sides to it that can be summarized as follows. First, if some such thing as an objective truth exists, then democracy is merely a kind of expedient, a compromise *pro bono pacis*. Second, democracy has only developed to the full precisely in the age in which metaphysics has unveiled itself and come to an end as will-to-power, that is, as the lawless struggle among world views. (Once more, I am referring to the title of an essay of Heidegger's in *Holzwege*.[3])

Karl Popper provided a well-known and disturbing reconstruction of the responsibility of metaphysical thinking for the success of "closed" societies. Popper meant metaphysics in the traditional sense, as based on the notion of an objective truth to be definitively apprehended. Thus, the alternative he proposed, "falsificationalism," remains too largely subservient to an "objectivist" and realistic view of the scientific enterprise to be able to avoid the dangers threatening democracy today: in a nutshell, the danger of the "rule of the experts." In his last few years, through interviews and newspaper articles,[4] Popper certainly expressed largely convincing and legitimate concerns regarding mass media. The trouble is, he did not seem to rule out the possibility that some form of censorship might be justified; most important, his attitude shows, I believe, how difficult it is for a theory to remain faithful to the ideal of the open society if it has not fully acknowledged all the implications of metaphysics and its end — in Heidegger's much more radical interpretation. In the dissolution of metaphysical being, mass media have a decisive role that cannot be "normalized" or "neutralized" but must be rec-

ognized and "accepted" altogether; this is something that Popper did not or perhaps could not do, within the limits of his theory.

As long as individual and social existence is represented as oriented to the *telos* of objective truth (so that science must grasp structures of reality that are "given," morals must conform to a law that is "given" in the nature of things, and so on), a democratic constitution will always be, in the end, nothing more than a pragmatic adjustment that is accepted for the same reason the principle of toleration has been: to remove the greater risk of a war of all against all. The ordinary justification of democracy as the guarantor of citizens' "essential" natural rights does not detract from this basic point. After all, from a metaphysical standpoint, democracy can count on no more reasons than those traditionally adduced in favor of hereditary monarchy: By the time the king dies, it must be clear to all that his male first-born is bound to succeed him, in order to prevent the outbreak of a civil war. It does not matter whether the first-born is still a child, or an imbecile, and so forth. Such a theory holds only within the framework of a pessimistic view of human nature and earthly life. (Incidentally, a similar attitude may also help explain why the practice of compromise, of corruption even, seems to be so rooted among political parties of Christian orientation, even today. I am thinking not only of the recent history of the Christian Democrats in Italy but also of seventeenth-century Machiavellianism.)

One hardly needs these examples, however, to see that many of modern democracy's hard problems can be traced back to the issue of the connection between democracy and metaphysics. When a democratic constitution is based, for its justification, on the law of nature, it often happens that the specific contents of natural law are defined in ways that limit the actual freedoms of rights-bearing individuals. Think of the current raging polemics concerning abortion or, particularly in traditionally Catholic countries, divorce and the "natural" family pattern. Things do not look better — indeed, they look worse, as communist totalitarianism has made clear — when democracy is legitimized within a historical framework, as with Marxism, rather than within one of natural law. In all these cases, democratic decision making must always tally with a basic truth, one, moreover, that is guarded and represented by a priestlike caste.

Of course, here I shall not try to reconstruct the history of the democratic idea in its full scope. I only wish to suggest along which lines I believe one should follow up on the claim that the affirmation of democratic ideals and the dissolution of metaphysics are connected. In effect, the transformation of the nature of power in modern societies (as Norbert Elias, among others,

has described it) is a constitutive feature of the process of the dissolution of metaphysics, not simply an accidental practical or political consequence. Thus conceived, the development of democracy in modern societies (from at least the breakdown of the Christian unity of Europe at the age of the Protestant Reformation) is not simply an aspect of the affirmation of enlightened reason — as the typical Enlightenment account would have it; it is, rather, a key factor within the process of the dissolution of being as objectivity. The reason for favoring the latter hypothesis over the pro-Enlightenment one (as well as over the overtly reactionary one that views modernization as a loss of the sacred sources — the only true ones — of human existence) becomes clear when one thinks of those problems of modern democracy to which I have just referred — of those, more precisely, specifically affecting mass communication societies.

The second side of the connection between democracy and the end of metaphysics is, as I noted earlier, the circumstance that metaphysics has come to its actual close in the very age when world and reality have become the site of the confrontation between manifold wills-to-power, or, in Paul Ricoeur's phrase, of the "conflict of interpretations."[5] Thinking and living democracy radically, on the political as well as on the social level, are possible only when one adopts a philosophical perspective that has entirely done away with the notion of objectivity — all sorts of objectivity: of structures, essences, principles, and so forth.

Such a liquidation actually takes place in the society of mass communications, the same one Max Weber thought would make possible a new "polytheism" of values and loyalties.[6] This is just another way of saying that "the medium is the message." Mass communication society is not simply the domain of increasingly powerful and pervasive high-tech communications; it is also the place where, as a result of the new technological capabilities, a radical transformation is taking place in the nature of political power, while at the same time the notions of being and reality are undergoing decisive changes. One can make the same point as follows. The fact that the social effects, both educational and diseducational, of television worried Popper so much shows that the very predicament of communication in the public sphere, especially of television, poses the compelling issue of the contradiction between residues of metaphysical thought (truth, objectivity, "absolute" values) and democracy.

The hypothesis I should like to propose may seem paradoxical, but it is crucial for illuminating the society in which we live and its emancipating potential. I wish to suggest that mass society is perfectly fitted for Nietzsche's *Übermensch*.[7] Of course, this thesis is not at all paradoxical if we take it in the

literal sense, that is, if we stop at the trivial picture of Nietzsche as a supporter of reactionary and elitist doctrines, even of slavery. Under this perspective, the notion of *Übermensch* has a bearing on mass society because it sounds like an extreme reaction against the nineteenth-century foreshadowing of that society. According to several of Nietzsche's texts, the democratic, socialist, Platonic/Christian, humanitarian society of our time tends to universal homogenization. In order not to be engulfed, a few "superior" human types must find the strength and the courage to dominate the others much more explicitly and systematically than in "master" societies of the past.[8] There is little point in discussing here whether this is the only possible, or even the most adequate, reading of Nietzsche: It is difficult, for example, to accept that his project of *Übermensch* could really tally with the view of a totalitarian society ruled by a select few, if only because Nietzsche was well aware that imposing a rigid and oppressive social discipline was bound to mar not only the "slaves" but also the "masters" (by stifling their creativity, creating resentment, and so forth). Furthermore, does it really make sense to imagine that free symbolic creativity is made possible by a "military" regime of domination by a few over the majority of "slaves"? In fact, the plurality of interpretations, or redescriptions (as Rorty calls them[9]), can develop only under a democratic regime. Admittedly, it is a contradiction of Nietzsche's, but to resolve it on the aristocratic, authoritarian side, as is customary with his right-wing readers, does not make sense.

Whatever the literal sense of Nietzsche's texts may be, or even his intention, what we can all see is that in mass society several traits of what Nietzsche called the *Übermensch* have become widespread and common. What is polytheism of values but superhuman morals that have become accessible to the masses? "God's death," which for Nietzsche opened the way to the birth of the *Übermensch*, is no longer a secret to anyone (unlike what Nietzsche still thought). At the end of the 1920s, the sociologist Karl Mannheim could still maintain that classics-educated intellectuals were free from the constraints of ideology because they were aware of the transient character of all values.[10] Today, this blend of skepticism and historical awareness is common knowledge. As is often very pointedly said, by now everyone knows that "TV lies" and, more generally, that every allegedly objective view of reality is the result of an interpretation, laden with prejudices that it would be absurd to wish to eradicate, since by so doing one would give up one's own possibility of "access" to the world.

When posing the issue of the meaning of mass culture for democracy — in other words, whether the media-induced transformation of experience is a threat to democracy or its indispensable buttress — we should keep in mind

all the intricate connections exposed thus far. First, accomplished democracy is really possible only within the framework of the dissolution of metaphysics (when the world has become the conflict of interpretations); second, the dissolution of metaphysics occurs mainly as an effect, or perhaps as an essentially related aspect, of the rise of mass communications; third, in the dissolution of metaphysics that becomes explicit in democratic mass society, daily existence paradoxically exhibits several features analogous to those that Nietzsche envisaged for his *Übermensch*.

This network of interconnected concepts also helps explain why in the last decades a certain "antihumanistic" view has gained wide philosophical currency. It opposes the traditional highbrow-lowbrow culture distinction, as well as the typical hostility of twentieth-century philosophically oriented sociology, to the mass media (think, for one, of the Frankfurt School). Its arguments are drawn from Nietzsche and especially from Heidegger's antihumanism — first expressed in his famous 1946 essay[11] — and it attempts to detect in mass society and culture the signs of a chance of emancipation to be pursued through the overcoming of humanism and also (to a considerable extent at least) of all the *Bildung* ideals of the past. Such an attempt to search for authenticity and emancipation in mass society — just there, that is, where they appear to be most in jeopardy — matches that peculiar tone of "extreme challenge" one finds in the thinking of Nietzsche, Heidegger, and, more recently, Deleuze, Foucault, and Lyotard. What is perhaps most disquieting and "disturbing" about these thinkers — in fact, what makes their work suspect in the eyes of academic philosophy — is their view that late-modern "nihilistic" society is the place where, as a result of the radical transformations that have taken place, the encounter with man's renewed relationship to being may be possible, even expected. Such hope is asserted only paradoxically and equivocally in Nietzsche's work. It is Heidegger who provides a clearer theoretical justification for it. From his perspective, the unacceptable consequences of metaphysics becoming planetary rule — dehumanizing man and destroying his freedom by making him an object of manipulation within the system of technoscience — are grounded precisely on metaphysics itself.[12] Thus, there cannot be any question of returning to an earlier stage of metaphysics to find the weaponry to combat its own outcomes. In short, if the dehumanizing technological world is the son, the grandson perhaps, of Plato, then we cannot return to Plato with the expectation that he will show us the way to salvation.

The fact is, however, that many of the dehumanizing traits of the contemporary world are only such when viewed in the light of a certain conception of "humanity" inherited from our philosophical tradition, a concep-

tion about which we should be very suspicious, given its complicity with metaphysics. Here, indeed, is the ground of the paradox whereby certain strands of contemporary thought are opening to mass culture and postmodern society from the viewpoint of what I would call a "leftist" reading of Heidegger (which I would also regard as the only one faithful to his intent). At the same time as we see the culmination of metaphysics and the beginning of its dissolution, modernization is producing dehumanizing consequences (or, rather, consequences unacceptable to us since we cannot simply erase the tradition to which we belong). If salvation is possible, it cannot be found in values and lifestyles that belong to previous stages in the history of metaphysics but in today's new, unprecedented life chances.

Though Heidegger is not very explicit about it, he is nonetheless aware that everything revolves around the fact that, in the world of accomplished metaphysics, which he called the world of *Ge-Stell*, of technoscientific rationalization, man as well as being have lost those traits through which metaphysics had featured them as subject and object.[13] From this standpoint, many of the harshest criticisms of mass culture (think of Adorno's, among others) would be untenable, inspired as they are by a defense of subjectivity modeled after an ideal of man as a self-knowing, self-appropriating, self-centered individual. It is well known, in fact, that after *Being and Time*, Heidegger was more and more reluctant to refer to the authenticity (*Eigentlichkeit*) that had been a key term in the more existentialist phase of his thought. One is also reminded of the many pages in which Nietzsche speaks of the lightness of the *Übermensch* — and to this "light spirit" I would also link Nietzsche's insistent references to physiology, as if in the end the *Übermensch* was, first and foremost, a matter of good temperament.[14] In short, perhaps the alternative to the other-directed man of the crowd, targeted by advertising and propaganda, lost in the phantasmagoria of consumer goods, does not lie with the figure of the responsible, property-holding, rights-bearing bourgeois, endowed with a well-defined and clear-cut identity — something like Kierkegaard's "ethical" man, although you may recall that Kierkegaard himself was ready to take him seriously only on the condition that ethical life be retrieved into absurdity, as in Abraham's story.[15]

We do not have — perhaps no one does — a full theory about this ideal, as yet merely conceivable, of man and of an ontological, postmetaphysical *Bildung*. The reference to Kierkegaard's Abraham, as well as to the title of Heidegger's dramatic *Spiegel* interview ("Only a God Can Still Save Us," 1966[16]), may perhaps point toward a deep religious meditation. But this would only be acceptable if resorting to religion would not mean returning, once more, to an earlier stage of the same metaphysical tradition that has be-

come the totalizing, quasitotalitarian society and from which we wish to escape. This should be the discriminating principle *vis-à-vis* current religious revivals aiming at the sheer reconstruction of good old moral values (family, in the first place) and sometimes even age-old metaphysics (I am thinking of the "philosophy" of the Roman Catholic church and its present pope).

Can we then regard democracy as the standard we seek for evaluating the ideal of *Bildung* and humanity? Philosophically, democracy is not a final good to be pursued for its own sake, as if it were an essential element of the law of nature (which could be grounded, I should add, only by returning to metaphysics). Therefore, when considering a viable *Bildung* ideal to serve as the litmus test for the pros and cons of mass culture (still better: for the emancipating factors in it), we must acknowledge that compliance with democratic principles will not do. From the Heideggerian standpoint of the overcoming of metaphysics, "emancipation" refers to everything that concurs in such overcoming and realizes it radically and thoroughly. Democracy therefore appears to be an agency of emancipation, for it partakes in the process of dissolution of the strong, centralized, authoritarian structures of political power, thus contributing decisively with other aspects of modernization to create the chance for being to give itself (to occur, to presence) outside metaphysics' violent and objectifying patterns. (I shall not deal in any further detail with these theses about Heidegger's ontology, which elsewhere I have collected under the label of "weak thought."[17])

The issue of whether mass culture is democratic or undemocratic must be raised only because we must ask ourselves more generally whether this culture can promote emancipation, namely, whether it can contribute, and how, to the process of overcoming metaphysics. According to my hypothesis, it does so contribute through a process of weakening or dissolving the "strong" traits of the structures of social life and of the individual personality as well. (In passing, apropos of "weakened personality," a typically late-modern science like psychoanalysis points in the very same direction: Freud's "narcissistic wound of the self" epitomizes the comprehensive meaning of weakening that psychoanalysis has eventually taken, well beyond Freud's own intentions, and that can be more clearly seen both in Lacan and in Jungian scholars, such as James Hillman.) I realize that when compared with issues such as those that drew Popper's attention, and which concern us as well (i.e., the diseducating effect of mass media on society), this notion of emancipation may sound too abstract and especially hard to apply. But it may at least function as a warning against a whole family of solutions that are bound to fail because they still center on a view of *Bildung* that has proved incapable of grasping the changed predicament of the self in the world of mass culture.

What I am suggesting is that any attempt to grasp theoretically — and possibly to promote practically—the emancipating aspects of mass culture must focus on the leitmotif of the weakening and dissolution of metaphysics.

Difficult as it is to offer concrete examples and to propose specific policies (which is not philosophy's task, after all), the motif of weakening shall nonetheless prevent us from indulging newly found authoritarian rhetorics, or the creeping demand for censorship rising from various sectors of our societies — especially compelling in the case of television, for one. The rationale for this resistance would not be found in the claim to inviolable natural rights but, rather, in the recognition that in our postindustrial societies restrictive or even repressive policies are bound to fail, unless they are implemented through a shift to a decidedly undemocratic political regime; but such a shift would be unthinkable in societies like ours, based as they are on the growth of consumption and accordingly on the expansion of individual desires as well as on the increase in acquisitive power.[18]

After all, rather than the successful affirmation of a given set of values, the modern story of (intellectual, moral, political) emancipation has been a sequence of processes of "neutralization,"[19] a continuous gliding, as it were. Modern emancipation — at least for those who consider it such — has been possible not because a new, different order has imposed itself over the traditional one (in religious life, in social and individual morals, in the political constitution of the states) but because the old order has become weaker and weaker and its once solid and compact core has disassembled. When the term "secularization," commonly designating a certain transformation of religious behavior, is understood in a wider sense, it expresses exactly the point I am trying to make. Against Hans Blumenberg, for whom modernity is essentially self-assertion (*Selbstbehauptung*), I side with Karl Löwith, who thinks of secularization as a process of "drifting," the rise of a different world through a "reductive," perhaps distorted, interpretation of the sacral "hard" core inherited from tradition.[20] This is indeed the case, one might argue, with every paradigm shift, to use Thomas Kuhn's categories. But that this remark strikes us as obvious only shows, perhaps, our tendency to conceive paradigm shifts as modeled after the very shift that affects us all, namely, modernization understood as emancipation by way of secularization (or also as emancipating secularization).

This brings us to conclude that the Babel of mass culture can be "fought against" (that is, interpreted as a chance for freedom) only by our being even more radically Babelic than it is. Besides, even from the standpoint of the more traditional moral concerns, who could completely rule out that deliverance from the slavery of the flesh may be reached through the very same

trivialization of sex brought about by the mass pornography of our times? True libertines have never favored sexual liberation. Foucault's theses may also be read in this sense: To put sex into words amounts to depriving it of its "immoral," subversive charge. What I am proposing is a kind of inflationary asceticism, which, after all, has several illustrious precedents in literature and art and is seen wherever excess has been celebrated for the sake of asceticism (think of Bataille, for instance).

Is it sheer coincidence that we have run into the term "asceticism," just as we encountered Abraham's figure from Kierkegaard? By now it should be clear: Mass culture as we see it here is not *necessarily* a culture of emancipation; yet, it does open some opportunities, some chances of emancipation, that are linked to its very own vocation and direction. Asceticism means that a decision is indeed required in order to interpret, both theoretically and practically, mass culture in the direction of emancipation. In Heidegger, too, overcoming metaphysics demands a *Verwindung*,[21] which in his vocabulary means both the acquiescent acceptance of a course of events to which we acknowledge to belong and the "distortion" or misconstruction of the sense of it.

In the name of a reasonable suspicion about traditional humanistic values (in a nutshell: the idea of a self-knowing or, if you wish, perfectly "psychoanalyzed" subject made self-transparent and fully "repossessed"), twentieth-century philosophy and radical culture, the "avant-garde," have entertained the thought that the chances for a new ideal of man and *Bildung* lie only in an open, amicable attitude toward mass culture. Leaving metaphysics and its fate of universal objectification — in the end: of violence — may also mean attempting to accept the "dissolution" of the traditional humanistic subject that mass culture seems bound to produce. On the social level this amounts to what we proposed to call, following Weber, a polytheism of values. A metaphysical-humanistic reaction to it would try to reconstruct a monotheistic predicament. On the one hand, that is the case both of Habermas's attempt to construe an opacity-free social dialogue and of communitarian theories, which, while seeming to allow for a plurality of gods (the various communities' value systems), do in fact still conceive the "good life" as possible only within the framework of fully shared value horizons (it is no accident that they speak of "community," of course). The weakening thesis, on the other hand, suggests a diametrically opposed attitude: Only an increasingly pronounced polytheism makes emancipation possible. What we should guard against is the return, either explicit or implicit, of monotheism, be it due to nostalgia or to a kind of socialized individual neurosis.

Yet perhaps we need to return to Weber's phrase and try to take it literally: The reference to the gods cannot be, to us at least, an innocent, harmless metaphor. The mass *Übermensch* that we are trying to make the guiding ideal of the new *Bildung* resembles very closely the two figures of Abraham and Don Giovanni in Kierkegaard's philosophy: a blend of, or perhaps a wavering between, religious faith and aesthetic existence. What becomes increasingly inconceivable in the world of conflicting interpretations is Kierkegaard's other figure: the "ethical" man, steadfastly secured by the tranquility of universal laws. Of course, as the texts easily show, Kierkegaard himself did not seem to consider the peaceful security of ethical life a really viable hypothesis. After his adventure on Mount Moriah, Abraham still obeys his people's laws; he does so, however, only "by virtue of absurdity," that is, on the basis of the "extraordinary" call that came from God, not, certainly, out of love for the universal. The analogy between Kierkegaard's Abraham and Nietzsche's Zarathustra has seldom been noticed; despite the obvious, profound differences, their proximity lies in this: They are both keenly aware of the exceptionality of their own respective calls.

In the polytheistic society, in which the interpretive (and therefore idiosyncratic and somehow "aesthetic") character of all knowledge has become explicit, even commonsensical, everyone is called, wish it or not, to be both an Abraham and a Zarathustra, that is, a poet whose moral education consists in his capacity to give an original "redescription" of the world (in Rorty's term), and a "faith cavalier" (in Kierkegaard's phrase) staking everything on this description precisely because he knows that it is not universal truth. Yet, some truth it is. It cannot be reduced to sheer poetic metaphor or to an innocent language game.

Of course, it is not "realistic" to suppose that mass culture can be approached successfully from such a philosophical angle. Furthermore, current ethical views in philosophy are rather inclined to place emphasis on the ethical "general," namely, on Kierkegaard's ethical life, though stripped of its absolute claims and reduced to sheer stipulation or agreement. There is already a widespread sense, however, of how close all this is getting to an ethics of conformity — be it communitarian or communicative. But neither is it conceivable that moral philosophy should turn into purely edifying discourse and apology for good sentiments. From the standpoint of such ethics, it is as if mass culture could ultimately be saved only by entrusting its control to some good Big Brother, who should keep violence, excesses, and disturbing ideas away from the good citizen's mind. The alternative is yet to be construed, and it consists perhaps in promoting — in preaching, for the time

being — a kind of mass aestheticism made less frivolous by its acknowledgment of its compelling religious vocation: Zarathustra plus Abraham, as I was saying. All of this is unlikely to suffice as a viable philosophical proposal for a concrete media policy. It may be, however, that the appropriate philosophical answer to the "monstrosity" of mass culture lies in acknowledging that in some sense Nietzsche was right; "we are no longer material for a society."[22] Philosophy contributes to the open society also when it drops its claims to state planning and attempts instead to place the separate individual before his or her quite individual responsibility.

Tubular Nonsense:
How Not to Criticize Television

Martha Bayles

During the 1980s, when I was television critic for the *Wall Street Journal*, I enjoyed telling people about my job. Nine times out of ten, they would respond with lively opinions, probing questions, and (sometimes) the germ of my next column. The tenth time — the exception — was when I would tell members of the academy what I did for a living. They would react as though a cat had spat a hairball on the rug. "Oh," they would say, eyes glazing politely, "I never watch television."

If this comment had been true, then it would not have bothered me. But in most cases it was not true: Some other party to the conversation would find my job interesting and pepper me with questions until, five minutes later, the pure soul who claimed not to watch TV would pipe up: "Tell me — why are there so many reruns on *Miami Vice*?"

This anecdote captures the ambivalence that many educated people have toward television. They understand that the medium is in flux, having been transformed in recent decades by cable, satellite technology, and the video-cassette recorder. And they predict that soon there will be no such thing as television — or radio, or recordings, or movies, or computers, or telephones, or libraries, or databases, or publishing — because all of these functions will be combined in what W. Russell Neuman of the University of Pennsylvania calls "the home videotex terminal," a gizmo that looks like a personal computer but is in fact connected, through two-way fiber-optic cable, to all the electronically stored information in the world — in Neuman's evocative phrase, "the universal Alexandrian library."[1]

Yet, most educated people persist in treating this evolving medium with contempt. When they do watch television, they say they do not. And when they approve of something they see on a television screen, they avoid confessing the fact, presumably for fear of being perceived as couch potatoes in thrall to the boob tube, the idiot box, the plug-in drug, the vast wasteland.

The price of this ambivalence is incoherence in our public discourse about television. Consider, for example, the art critic Robert Hughes. Writing about television in the *New York Review of Books*, Hughes mounts the same high ground as the academics I mentioned earlier. Fastidiously, he distances himself from the tube: "I have no idea what it is like to spend a childhood in front of a TV set, to have my dreams and fantasies administered by the Box." Then he issues the standard warning against "passive submission to the bright icons of television, which come complete and overwhelming, and tend to burn out the tender wiring of a child's imagination because they allow no re-working."[2]

Pretty dire. Yet, read on and you learn that this danger exists only when the program being watched is on one of the commercial networks. If the program is on PBS (which Hughes is defending from the budgetary ax), then presumably the child's tender wiring will remain intact.

To be fair, Hughes makes a cogent argument in favor of public broadcasting. But, like many educated critics, he cannot decide whether he is criticizing a particular program (say, the *Mighty Morphin Power Rangers* as opposed to *Sesame Street*) or issuing a blanket denunciation of the medium itself. Does it matter which program one is watching if the tube *qua* tube causes cognitive meltdown?

The point is that the tube is changing faster than our understanding of it. I do not mean our technological understanding but our cultural understanding. When it comes to fathoming the cultural effect of the medium, intelligent observers such as Hughes tend to fall back on received ideas.

In this essay I hope to adjust the picture by challenging those received ideas. The problem is not that these ideas are old but that they are not old enough. Our habits of thinking about television reflect not the wisdom of our cultural tradition but certain theoretical preconceptions that have remained unchallenged since the days of the rabbit-ear antenna.

Broadly construed, these received ideas fall into two categories. The first is communications theory, which focuses on the relationship between media and the individual. Influenced by Marshall McLuhan, communications theory emphasizes the ways in which media shape human consciousness. Indeed, it was McLuhan's bold claim that the electronic media are retooling the human sensorium, just as their print predecessors did before them. Within this McLuhanesque tradition there are optimists and pessimists. The optimists envision the electronic media giving individuals unprecedented power, especially political power.[3] The pessimists envision those same media, especially television, transforming human nature for the worse.[4]

The second category of received ideas is, of course, Marxism. In America, Marxism dominated the postwar debate over what was then called "mass society." Here, too, we find a pessimistic school and an optimistic school. The pessimistic school, the original one, regards the electronic media as *the* capitalist tool for shaping and controlling the consciousness of "the masses."[5] The optimistic school dates back to the 1960s, when a younger generation of Marxist critics embraced the sexy idea that the electronic media could be used for liberating or "emancipatory" purposes. This generation had grown up with television, not to mention rock 'n' roll, so they found it hard to reject the electronic media outright. Drawing also upon communications theory, they launched a passionate debate about which elements of the media were emancipatory, which repressive. Its sex appeal has faded somewhat, but this debate still dominates the "cultural studies" approach to television and popular culture.[6]

After sketching the limits of these received ideas, I will set forth a modest proposal: Instead of regarding television as a totally new medium capable of altering human nature or controlling human consciousness, we should pay attention to the continuities between it and the older arts, especially the performing arts. The trouble with both communications theory and Marxist-oriented cultural studies is that their discourse on television leaves no room for the aesthetic. I am not saying that everything on television is art, or that the medium itself is an art form. The first statement is idiotic, the second lunatic. But we will never make sense of television until we acknowledge that its claims on us are related, more or less directly, to the claims of art.

Let me begin with the received ideas we inherit from communications theory. This field of inquiry takes as its starting point not the image of the all-seeing, all-controlling telescreen in George Orwell's *1984* but a very different futuristic fantasy. Writing in 1945, four years before *1984* was published, the eminent American engineer and physicist Vannevar Bush regaled the readers of the *Atlantic Monthly* with a miraculous device called Memex.[7] In this respect, communications theory was prescient: Memex was a vision, several decades before the fact, of what Neuman calls the home videotex terminal.[8]

To some communications theorists, the Memex vision promised a solution to the problem of mass society. The great fear among postwar American intellectuals was of a growing gap between an ever-larger, more powerful, and centralized state, on the one hand, and a mass of isolated, undifferentiated, powerless individuals, on the other. In the middle, where a rich variety of social and political institutions had once flourished, these social critics saw decay. They warned that the voluntary associations celebrated by Tocqueville as the lifeblood of democracy were disappearing and that the result would be a new totalitarianism.[9]

Before the Internet was even a gleam in the Pentagon's eye, communications theorists who shared these concerns were placing their hopes in the Memex vision — or rather in what that vision promised: a decentralized, user-controlled, efficient communications system that would allow citizens to create a whole new species of voluntary associations, groupings happily liberated from the constraints of space and time, not to mention government oversight.[10] Today, of course, there are many people who would argue that this "teledemocracy" has arrived. At least, countless Americans now engage in on-line activism, supporting the political causes of their choice and flaming out all those whom they take to be their adversaries.

But in spite of the rhetoric surrounding the sudden expansion of the Internet, there are limits to this Memex vision. I cannot improve on Neuman's analysis, which cites two major impediments. The first is the political economy of the American communications industry, which is privately owned and under constant market pressure to achieve certain economies of scale. Because of these conditions, Neuman argues, and despite the transformations wrought by cable and the Internet, the system continues to tilt strongly in the direction of concentrated ownership and mass-produced entertainment.[11]

The other, and for the purposes of this essay more important, impediment is what Neuman calls "the psychology of the mass audience." The research on media use demonstrates quite consistently that most people are

not interested in complex interactivity and deep information retrieval. The majority — the mass audience — want from the electronic media pretty much what they have always wanted from the print media: programs of general interest and, especially, entertainment.[12] And there is a definite limit to the number of buttons most people will push to access those programs, as the hapless marketers of interactive media can attest. This general pattern of media use may change with future generations, of course. But then again, it may not.

The political implications, as laid out by Neuman, are sobering. When citizens are mobilized, they will use whatever communications system is at hand. But by itself a new system is not likely to mobilize citizens. Neuman concludes that the key factor is "less the push of the new media than the pull of the political cultures that may choose to use these technologies."[13]

In other words, human nature is more obdurate with regard to media than is generally supposed. This is bad news if you were expecting some positive transformation, such as the Internet turning every citizen into a model of political engagement. But by the same token, the psychology of the mass audience is good news if you were expecting a negative transformation. The communications theorist Neil Postman, for example, asserts that we live in a "technopoly" ruled by media that, unlike their print predecessors, are inherently irrational.[14] Postman sees the discontinuity, the nonlinear nature of electronic media as interfering with human cognitive and moral development. It was Andy Warhol who said, "If it moves, they'll watch it." To Postman, they'll never be able to do anything else.

To refute this pessimism, you and I need only contemplate ourselves and some of the people we know. It is clear, from the example of countless literate people who are also fully conversant with the electronic media, that the human mind can, given the opportunity, handle both the new and the old media — just as it can handle more than one language. There is no *inherent* reason the print and electronic media cannot coexist, each doing what it does best, in an appropriate balance. The challenge, as any parent or teacher can tell you, is finding that balance in an era when the electronic media enjoy the overwhelming advantage of novelty.

Of late, the most visible pessimists are those activists who push for a regulatory crackdown on the violent entertainment television brings into the home. This group is a special case, because the enemy is not the medium per se but a certain kind of programming. Nevertheless, the group's approach is heavily influenced by communications theory. In a nutshell, these activists regard television as very strong and the human mind as very weak. They ignore the evidence on media use and place their faith in the countless studies

purporting to prove a direct causal connection between violent entertainment and societal violence.

To be sure, these studies are suggestive. In particular, recent longitudinal research by Brandon Centerwall of the University of Washington found that the homicide rate among the white populations of the United States, Canada, and (most recently) South Africa doubled within ten to fifteen years after the introduction of television, with its standard violent programming fare.[15]

Yet, at best, social scientific evidence of this kind demonstrates correlation, not cause. It can never be dispositive with regard to government policy.[16] Most antiviolence activists understand this. But they also understand the political uses of "hard data."[17] Others, including many concerned educators and health professionals, see violent entertainment purely in the context of public health. That is, they define entertainment as a commodity and assume that, because the harmfulness of this particular commodity has been scientifically proven, the government has the right to yank it off the shelves.[18]

The error of this assumption is self-evident. Yes, violent entertainment is manufactured, bought, and sold as a commodity. But it is also a form of speech and artistic expression, however debased. By avoiding this question, the antiviolence activists trivialize the argument. The point is made eloquently by Anthony Smith, the former director of the British Film Institute:

> Media research has made it possible to open up debates that had been temporarily concluded in liberal societies, but to do so on ground that is scientifically and morally shaky. The objection is not to the opening up again in new guise of the ancient debate about the role of the state in art and representation, but to its being done in these forms and with these motives.
>
> When we are dealing with questions of science pure and simple, we may adopt a tighter notion of causality than when we are dealing with influences that operate within the personality, within human nature.
>
> If objective knowledge were possible concerning the shaping of the mind by the products of art or by the sending of messages or by the contemplation of mimesis, then we would be admitting to a narrow version of the subject, narrowed to a mere pathology.[19]

I will not dwell any longer on the antiviolence activists, because although their political influence is considerable, their intellectual influence is slight. In the academy, the debate over television and popular culture in general takes a different form: Marxism on life support.

Like communications theory, the Marxist critique of the electronic media harks back to the postwar debate over mass society and what was then called "mass culture." Indeed, the contemporary term "popular culture" is often used as a stand-in for that older, more loaded term. By "loaded" I mean steeped in the Marxist social criticism of the Frankfurt School. Arriving on these shores in the 1930s, Theodor Adorno, Herbert Marcuse, and their colleagues had been spooked by the Nazis' skillful use of radio and film. As men of the Left, they were also predisposed to take a dim view of capitalism. Gazing with fascinated horror at the American mass media, they decided that here was a totalitarianism all the more powerful for being more subtle. Indeed, the Frankfurt theorists drew a direct parallel between Nazi propaganda and the "marketing psychology" of "organized capitalism."[20] Drawing on the insights of Freud as well as Marx, they developed a complicated theory of how the so-called consciousness industry of advanced capitalism planted its seeds in the irrational soil of the individual psyche, making them impossible to uproot by rational means. The process involved artistic techniques, but in no way were the products to be considered art.[21]

What *was* art? Well, here the Frankfurt theorists differed greatly from their former Stalinist comrades. The Frankfurt theorists were highbrows who admired artistic modernism and hated Stalin for persecuting artists deemed too difficult for "the masses." Indeed, Adorno went to the opposite extreme of admiring difficulty more than he admired art. In difficulty Adorno found the quality he valued most, which was not beauty or spirituality. Those were bourgeois concepts. Instead, he valued *negation*, meaning either an implicit protest against the capitalist social order or an authentic projection of human freedom into the glorious socialist future.[22]

The glorious socialist future is not exactly a big item these days, but the Frankfurt School's rigid distinction between mass culture and genuine art persists among the intellectuals of the war generation — leftist, liberal, and neoconservative alike. From Irving Howe to Irving Kristol, this generation has never quite accepted the notion that genuine art may emerge from popular culture. It is possible that their distrust of popular culture stems from their memory of seeing both the Nazis and the Stalinists crush artistic freedom in the name of "the masses." But if that is the case, then we must note a certain irony: "The masses" have never cottoned to the official culture fashioned for them by their totalitarian masters. Given half a chance, "the masses" have always gravitated toward the American alternative, that is, toward a genuinely popular culture shaped not by ideological decree but by market forces working within a pluralist society.[23]

We now arrive at the contribution of the 1960s generation, which was to

boldly go where none had gone before, that is, across the uncrossable line between art and popular culture. The trouble is, they crossed it in a way that has done more harm than good.

In the late 1960s, some of the leading lights of the European New Left took their fellow Marxists to task for failing to appreciate or make use of the electronic media. To a generation that had grown up with television, movies, and rock 'n' roll, it came as a breath of fresh air when Hans Magnus Enzensberger wrote: "With a single great exception . . . Marxists have not understood the consciousness industry and have been aware only of its bourgeois-capitalist dark side and not of its socialist possibilities."[24]

Enzensberger's "single great exception" is none other than Walter Benjamin, the Frankfurt scholar who committed suicide in 1940 while trying to flee Nazi-occupied France. In despair at being detained at the Spanish border and (in Martin Jay's understated phrase) "unenthusiastic about his future in America," Benjamin swallowed several morphine pills and died in agony.[25] The next day, his companions were allowed to cross.

It may sound strange, given his tragic end, to describe Benjamin as the father of the optimistic school of Marxist cultural theory. But that is his role. His 1936 essay, "The Work of Art in the Age of Mechanical Reproduction," is without a doubt the founding document of post-1960s cultural studies. So it is worth taking a moment to summarize — and criticize — its argument.

Benjamin takes as his starting point the fact that "the work of art," by which he means a painting or a sculpture, is a unique, original, one-of-a-kind object. Such an object possesses a kind of magical power, or presence, which Benjamin calls its *aura*.[26] He then traces the aura back to the artwork's presumed prehistoric function as an idol inhabited by a deity. The evolution of art, he argues, involves the gradual emergence of the art object from the forbidden inner recesses of the temple, where it was seen only by the high priests, into the semipublic environment of the church, where it symbolized divinity in a less literal sense, and finally into the secular setting of the museum, where, because of this history, it still trails clouds of ritual significance.[27]

Then, in a bold formulation, Benjamin states that the electronic media, especially film, have "emancipated" the art object from this ancient ritual function. A photographic negative, he declares, has no aura. Indeed, it is "a work of art designed for reproducibility."[28] Benjamin ends his essay with the suggestion that film is inherently progressive and in the right hands — not Hollywood's — could serve the revolution.[29]

It is impossible to exaggerate the significance of Benjamin's embrace of reproducibility for post-1960s cultural theory. Thanks to influential critics

such as Fredric Jameson and Jean Baudrillard, it is now academic orthodoxy that all of culture — indeed, reality itself — is a torrent of images cut off from one another and from time, space, and meaningful reference and without emotional impact.[30] To put the matter in nontheoretical parlance: Life is channel zapping.

If I may pull the plug: This academic orthodoxy rests on a notion of the relationship between the traditional arts and the electronic media that is (to put it mildly) misconceived.

Benjamin's potted history of art is quite unsupported by the anthropological evidence. The oldest known works of art are the cave paintings of the Upper Paleolithic period, the first of which were discovered at Altamira in northern Spain in 1879. By 1936, when Benjamin was writing, there was considerable debate among anthropologists about the possible function of these cave paintings. Were they "art" in the modern sense? Or were they fetishes in a long-forgotten protoreligion? The answers are still unknown. But it has never been a foregone conclusion that the paintings were hidden from all but priestly eyes. Many sites were host to large numbers of people. And in the early Neolithic period the locus of painting shifted from deep caves to shallow rock shelters, many of which were so accessible that they continued to attract visitors through Roman times.[31]

Nonetheless, Benjamin is right to point out that in modern times the typical one-of-a-kind work of art resides in a special location, where it is protected to the extent that it is valued. And he is right to observe that such protected locations are controlled by powerful social groups, whether high state officials or wealthy private citizens, with the result that the typical work of art *does* possess an aura — if only one of money and social prestige.

But this is not the whole story. Is *every* work of art a one-of-a-kind object? Or are painting and sculpture unique in this respect? What about the other arts? Were any of them reproducible even before "the age of mechanical reproduction"? Literature is perhaps the most salient example. Enzensberger strains to equate "the book" with "easel painting."[32] But in terms of reproducibility, there is simply no comparison. Unlike easel paintings, books have been reproducible on a mass scale since the invention of movable type. However precious and irreplaceable the original manuscript of a book may be, it is not wholly identified with the work of art. As long as a valid and legible copy exists, the loss of a manuscript would not be considered the loss of a literary classic.

That goes double for the performing arts. What Benjamin the art critic overlooked is that painting and sculpture are not the only ancestors of film. From its inception, film was also a vehicle for drama, comedy, and music.

And these performing arts have always been reproducible. There is only one *Mona Lisa*, and it hangs in the Louvre. But is there only one *King Lear*? Not in the material sense intended by Benjamin. To the contrary, *King Lear* exists whenever, and wherever, it is performed.

To complicate matters, consider that the electronic recording of a classic performance can acquire an aura. Today, an actor contemplating the role of Lear must take into consideration not only the stage productions he and his audience may have seen but also the films: Paul Scofield in 1971, Mike Kellen in 1982, Lawrence Olivier in 1984, Patrick MaGee in 1988, to name a few. In art forms that came of age within the electronic media, there is simply no difference between the reproducible object and the precious original: Jimmy Stewart's 1946 performance in *It's a Wonderful Life*; Louis Armstrong's 1928 recording of *West End Blues*.

We now return to the realm of the aesthetic. According to Jameson, the triumph of reproducibility has led to "the necessary death of art and the aesthetic."[33] More ponderously, Enzensberger asserts that "the revolution in the conditions of production in the superstructure has made the traditional aesthetic theory unusable, completely unhinging its fundamental categories and destroying its standards." Reproducibility, in Enzensberger's view, has led to "a tremendous shattering of tradition . . . the liquidation of the traditional value of the cultural heritage."[34]

Is this true? Not in my experience as a working critic who has written about literature, film, television, and music. To be sure, the electronic media have wrought changes in the traditional arts of scriptwriting, acting, directing, comedy, music, and dance. Just to cite one example: Stage acting is not the same as film acting, as Olivier's career can attest. But it is simply false to say that there is no continuity between the two, or that traditional standards no longer matter. Tell that to the Hollywood agents scouring the London theaters for the next Emma Thompson, Helen Mirren, Ben Kingsley, or Anthony Hopkins.

About television, though, there remains the tendency I noted in Robert Hughes: to draw that old uncrossable line between art and popular culture. Unless, of course, they are talking about public television. The tube is OK, Hughes and other critics say, as long as it conforms to the shining example set by the British Broadcasting Corporation.

Far be it from me to deny the advantages of placing the electronic media under the control of a state-funded elite cultural establishment. To cite only one benefit, the BBC has long fostered the circulation of top literary and theatrical talent through radio, film, and television. But let us not forget the disadvantages of such a system. The week of February 16, 1995, the week in

which Hughes's article appeared, the most popular programs on the American commercial networks were *Seinfeld* and *ER*. These were also, I venture to say, close to being the best programs on the air that week. Certainly, they were superior to *Tales of the City*, the PBS drama that Hughes singled out for praise. Could *Seinfeld* and *ER* have originated within the BBC? I doubt it. *Seinfeld*, for instance, draws on a tradition of Jewish American comedy that, like African American music, developed from folk culture precisely because it could turn a profit, especially when disseminated by the electronic media. Such grassroots traditions as Jewish American comedy and African American music would likely have been stifled by a British-style elite cultural establishment. Fortunately, they flourished in the wide-open commercial environment of America.

Let me pause for a moment and summarize the received ideas — the "tubular nonsense" — that I have criticized so far. First is the notion, derived from communications theory, that the medium of television is inherently harmful because it has the power to reverse the civilizing effects of print. Against this notion I have argued that the effects of media on human consciousness are less drastic than are dreamt of in McLuhan's philosophy. Second is the Marxist belief that the process of reproducibility and commercialization — what the cultural theorists call "commodification" — renders obsolete any notion of art and the aesthetic. Against this belief, firmly entrenched in the academy, I hold that neither reproducibility nor commerce is to blame for what is wrong with television.

How, then, does one criticize television? Assuming that criticism is called for (and nothing in this essay is intended to suggest otherwise), I repeat that the ground of such criticism should be aesthetic. What is wrong with television, and with popular culture in general, is inseparable from what is wrong with the larger artistic culture. I will close by making some very general remarks about that larger problem.

A prominent conservative recently asked me why art could not be more like sport, with a clear set of rules. All I could reply was, art is not that kind of game. On the contrary, it is a game in which Team A is playing baseball, Team B is playing rugby, and the umpire is enforcing the rules of ladies' tennis. In short, we possess not one idea of art but three, each inherited from a different phase in the history of Western thought.

The first idea is the *didactic*, which conceives of art as having a direct, unmediated effect on the thoughts and behavior of the audience. According to this idea, art must be closely monitored and frequently censored, because any sympathetic depiction of evil is bound to foster evil in the body politic. This didactic idea has a noble pedigree, going back to Plato's injunction that

the poet must sing only the truth of the philosopher-king. But it also has a shameful history, as tyrants past and present have forced art into ugly official molds intended to serve philosophical, religious, and (more recently) political-ideological truths.

The second idea, which I call *latitudinarian*, gives art a realm of its own, in which evil may be depicted, even sympathetically, as part of a larger whole. This idea, which harks back to Aristotle, is more sophisticated than the didactic one and gives art more liberty. But it is important to note that, until the nineteenth century, artistic liberty was never total. On the contrary, most Western artists, including the romanticists, continued to believe that art was an imitation of nature and that its ultimate purpose was to serve truth and virtue. There have been countless disagreements: about technique, about how audiences are affected, about what aspects of nature should be imitated, and about what constitutes truth and virtue. But in all that time, and indeed in all the other civilizations of the world, art was never seen as supplanting religious or philosophical truth.

Only in the West, and only in the last hundred years, has the third, *radical* idea appeared. It, too, has a pedigree, going back to expressionism and futurism at the turn of the century; to dada and surrealism in the 1920s and 1930s; and to postwar movements like Fluxus, happenings, and (more recently) performance art. Basically, the radical idea says that art is, and ought to be, a law unto itself. Not just in its own realm, as in the romantic idea of "art for art's sake," but also in the world. The radical idea says that artists can do whatever they want, because art is above philosophy, above religion, and especially above the moral values by which ordinary human beings conduct their lives.

To a large extent, the history of artistic modernism is the history of this radical idea. It arose with the dream of total social and political revolution, and, like that dream, it decayed into arrogance and folly. People who think seriously about the arts have long since abandoned it. But the radical idea still attracts the unserious and the untalented. And it has come to pervade popular culture.

The question is not just "sex and violence." In the abstract, sex and violence are the bottom line, the bedrock of civilized life. Demand their removal from art and you look pretty silly. All your opponents need do is point out how much sex and violence there is in the world's great masterpieces and you stand accused of wanting a culture made up entirely of Barney the purple dinosaur. The real problem, which shows up most clearly at the so-called cutting edge of popular culture, is that sex and violence are being re-

duced to a nasty joke. Seduced by the radical idea of art, certain writers, directors, and performers pride themselves on taking a deliberately obscene view of these primal experiences. That is, they portray sex and violence in a way that is unfeeling, indifferent, detached from the consequences of actions, and contemptuous of moral concerns.

Neither the Left nor the Right has a very good record of criticizing this radical idea. On the Left we get a principled defense of artistic freedom, coupled with an uneasy acceptance of obscenity and moral ugliness. Of course, the more popular the art, the more uneasy the acceptance, which is why liberals are given to bursts of regulatory fervor.

On the Right we get two very different reactions. Out of understandable concern for public morality, social conservatives tend to advocate censorship. At its most sophisticated, this approach cites Plato and Rousseau to the effect that art corrupts civic virtue. This is a cogent line of reasoning, but it is important to recall that it is not a criticism of *bad* art. It is a criticism of *all* art. It is, in essence, a return to the didactic idea.

The other conservative reaction, more in the headlines these days, is a libertarian shrug that assigns all valuative functions to the market. But this is just as wrongheaded as blaming commerce for everything that is wrong. Commerce is neither the root of all evil nor its remedy. It is, ultimately, neutral. With increasing efficiency the market can multiply, amplify, and magnify cultural trends. But try as it will, it cannot initiate them. All it can do is respond to shifts in public taste, which — to sound an optimistic note — can sometimes be for the better.

Dare we hope that the first decade of the next century will bring such a shift for the better? It is hard to say. Television is being roundly criticized these days by a range of political actors, from conservative religious groups, to liberal antiviolence activists, to politicians seeking an easy target. Some of these political actors are calling for outright censorship, others for tighter regulation. Unfortunately, none of their criticism cuts to the heart of the problem, which is that television, and popular culture in general, now partakes of a radical aesthetic that used to be the exclusive province of the elite artistic culture.

This situation is without precedent and, I think, quite dangerous. Certainly, it will not be remedied by such clumsy measures as ratings systems and v-chips. It is too deep and subtle and pervasive for that. The only hope I can hold out is that aesthetically educated people will somehow overcome their diffidence toward television and learn to praise and condemn its products as energetically as they do those of any other medium.

Waiting for Godot and the End of History: Postmodernism as a Democratic Aesthetic

Paul A. Cantor

The movement known as postmodernism seems to dominate the cultural world today.[1] From architecture to music, from painting to literature, it cuts across all boundaries of artistic medium and genre. Moreover, postmodernism is a worldwide movement; though it may seem to be largely confined to the orbit of American and European art, persuasive arguments have been made to categorize what is known as postcolonial literature, the literature of the Third World, as a species of postmodernism.[2] In short, postmodernism appears to be the art of our time. But since our era can be char-

For help in articulating my view of postmodernism in this essay, I wish to thank Richard Begam, Frank Lentricchia, Michael Valdez Moses, Carroll William Westfall, and Richard Zinman.

acterized as the Age of Democracy, the question arises: Is there any connection between democracy and postmodern art? This may initially sound like an odd question; after all, postmodern art seems to be elitist in nature, often obscure, esoteric, incomprehensible to the majority of people, seemingly out of touch with popular taste. But in fact I want to argue that postmodernism is a democratic form of art and it is therefore no accident that the movement has flourished most fully in the United States. I will explore several respects in which postmodernism is linked to democracy, looking at both the ways in which a democratic form of life fosters the postmodern movement and the ways in which postmodern art reflects what might be called democratic principles of aesthetics. I will focus on what is probably the most famous text of postmodernism, Samuel Beckett's *Waiting for Godot*.[3]

At first sight, no work of literature would seem farther removed from the world of politics. Indeed, in the sparse, bare, abstract world of *Waiting for Godot*, Beckett seems to have emptied human life of all content, let alone anything specifically political. Yet, by paying attention to the political subtext of the play, I hope to give a fresh reading of *Waiting for Godot*, one that will establish a connection between its postmodern elements and a democratic ethos. The concept that links postmodernism with democracy turns out to be the posthistorical, in particular the idea of the end of history as developed by Hegel as well as by Beckett's contemporary, Alexandre Kojève. The postmodernism of *Waiting for Godot* flows from the fact that it portrays posthistorical existence, and a posthistorical world is a democratic world.

I

But before turning to *Waiting for Godot*, I should try to define this most elusive of terms, postmodernism. The meaning of *postmodernism* can best be seen in the field of architecture, where the term first achieved wide currency and where the contrast between modernism and postmodernism is most readily apparent.[4] Picture a modernist skyscraper. Standing proudly in all its steel-and-glass glory, it claims to be true. Embodying the modernist principle of "form follows function," the skyscraper distinguishes itself from all previous buildings. Unsullied by any wasted ornament or unnecessary bows to convention, the modernist building is purely functional.[5] The premise behind the skyscraper is that modernist architecture has made a genuine discovery and thereby exposed the fact that all previous architecture was false, false because it was not purely functional.

Now picture a postmodernist skyscraper. For dozens of stories, it may resemble its modernist cousin, but when we get to the top we find something

resembling a hat, or a set of curtains, or a piece of Chippendale furniture.[6] Postmodernism involves the return of architectural ornament, often with a vengeance. But now the decoration is totally random. We may find an Egyptian pyramid at one point, a Roman arch at another, a Gothic turret somewhere else, and a Renaissance arcade beyond that. This is *postmodern pastiche*;[7] postmodern architecture throws together different historical styles, often with no regard to any traditional sense of harmony. In short, the postmodern building no longer claims to be true. In fact, the basic premise of postmodern architecture is that there is no one true way of building. Postmodernism is the product of the discovery that modernism was just another style. Modernist architects had claimed that all previous architecture was a matter of conventional styles but that modernism had advanced beyond mere style to the true way of building, in which form follows function. Postmodernism flows from the claim that there are only styles in architecture, and hence no uniquely true architecture. That is why postmodern architects are free to choose any historical style they want, and are not even restricted to just one style in buildings.

Postmodernism is the first artistic style that admitted from the beginning that it *is* just a style; hence, it never needed to confine itself to one particular style. Alternatively phrased, postmodernism is the first form of art that accepts the idea of the radical historicity of all art. No aesthetic principles are simply true or universal; all are time-bound and culturally limited. We might even describe postmodernism as historicism elevated into an aesthetic principle.[8]

We can already see in this characterization a kind of democratization of art, a flattening out of the centuries. Modernist architecture still maintained a strongly linear sense of artistic history, a sense of artistic progress. For the modernists, history is always leading us somewhere, somewhere better, and modernism presented itself as the genuine culmination of the history of art. The modernist architects thought they had made genuine artistic discoveries that effectively outmoded all previous work in their field. One can see this attitude in all modernist art. For example, T. S. Eliot's *The Waste Land* proudly displays its tough-minded attitude toward life in the twentieth century, using quotations from earlier poets to make their poetry seem saccharine and irrelevant by comparison — all of which goes to suggest that Eliot has discovered the truth about life that eluded his soft predecessors. They thought the Thames River was the home of sweet nymphs; he knows it is the trash heap of modern urban life. In this way, *The Waste Land* exudes all the brashness and self-confidence of modernism.

Postmodernism can thus be understood as the failure of nerve of mod-

ernism, revealing what happens when modernist art loses faith in its own truth and uniqueness. The result is a vast leveling out and equalization of history. The twentieth century loses its claim to having a monopoly on truth; indeed, the new claim is that no period can achieve the truth in art. This attitude is rooted in certain conditions of twentieth-century democratic life. For example, the rise of postmodernism is related to the triumph of the museum as a dominant cultural institution. Public museums as we know them were created in the late eighteenth century, developed in the course of the nineteenth, and truly came into their own only in the twentieth. The institution of public museums constituted an effort to democratize art, to make what had been the private preserve of the aristocracy freely available to public view — a movement best symbolized in France by the conversion of the royal palace of the Louvre into a museum for bourgeois Parisians. The museum may seem like a neutral site merely for the display of art, but in fact it works to change attitudes toward the very nature of art. In the modern museum, all art is spread out equally, and that leads to a kind of democratic aesthetic: "All styles are created equal." In walking from room to room in a typical art museum today, one travels with ease from the Middle Ages to the Renaissance, from the baroque to the rococo. The fact that centuries of art in all different styles are thus simultaneously available in the twentieth-century museum contributes to the historicist attitudes of postmodern artists.

The dominance of museums is only one factor creating a new situation in the twentieth century, what we might call the omnipresence of art, which is at the same time a form of democratization of art. We are surrounded by art in the twentieth century because of the availability of cheap and increasingly accurate artistic reproductions. Indeed, the twentieth century could be labeled the Age of the Copy. Many of the most famous inventions of the modern world have been means of reproduction: the photograph, the phonograph record, the motion picture, the tape recording, the photocopy, the videocassette, the fax, the compact disk, the laser disk. The accumulation of these forms of copying, which make it increasingly difficult to tell the copy from the original, has changed artistic consciousness in this century. A music lover in the nineteenth century was lucky if he heard Beethoven's *Ninth Symphony* five or six times in his lifetime. Today, one can listen to it, in a magnificent performance in magnificent sound, every day if one likes, and even if one has grown tired of it, one may suddenly find oneself listening to it in the middle of a movie like *Clockwork Orange*.

Modern technology has made much more of the music of the past available than ever before, as part of the process in which consumer capitalism excels: taking goods that were once the exclusive privilege of the wealthy and

the aristocratic and making them readily accessible to a broad public. But the results of this process, while providing great joy to Vivaldi lovers, have been very intimidating to twentieth-century composers, who have had to compete with their predecessors in ways no previous artists ever experienced and thus must find ways to come to terms with their artistic heritage.[9] And the omnipresence of art has affected the viewers of art as well as the creators. As Walter Benjamin argued, in the age of mechanical reproduction, the work of art begins to lose its special aura.[10] For centuries, the *Mona Lisa* was a unique artifact, and one had to make a kind of pilgrimage to Paris to see it. Today, middle-class art lovers can hang virtually flawless reproductions of the *Mona Lisa* in their living rooms. The ready reproducibility of images has itself become a theme in postmodern art, as witness the Andy Warhol creations in which the same image of Marilyn Monroe or Mao Zhe Dong appears over and over again.

The widespread availability of copies of artworks in the twentieth century — a democratic attempt to turn art into public property — has helped make the very act of representation problematic for artists. Faced with a variety of competing means of representing reality, and even of representing representations of reality, artists have been forced to ask themselves: What is real, and what is a reproduction? These doubts have contributed to the weakening sense of reality in postmodern art, the feeling that art cannot represent reality, that the very notion of reality is some kind of fiction.

In general, the more artists become aware of the art of the past, the more problematic art itself becomes for them. Thus, postmodernism is the product of artists who have spent much of their time in universities, which have increasingly promoted the democratic notion that creativity is not the exclusive privilege of a few geniuses but something that can be taught to everyone, almost like a trade. The tendency to incorporate one's college education into one's art is already evident in a modernist classic like *The Waste Land*. Supplying the notes to his learned sources himself, Eliot seems to have professors in mind even as he writes the poem, catering to the academic love of references and allusions. Faced with an overwhelming burden of the past or an anxiety of influence,[11] twentieth-century artists have tried to deal with their aesthetic insecurity by finding ways of incorporating the art of the past into their creations and thereby somehow making it work for them. In that sense, *The Waste Land* can be seen as a forerunner or prototype of postmodernist art. The poem certainly has the character of a pastiche, as Eliot uses bits and pieces out of older literature to create his new poem.

My argument may seem to have taken a strange turn. First I referred to Eliot's *Waste Land* as a classic of modernism, and now I am calling it post-

modern. This case is a good reminder that the terms *modern* and *postmodern* are not absolute, and the distinction between the two categories cannot always be sharply drawn. The case of *The Waste Land* reflects a strange fact in artistic history: Postmodernism does not simply come after modernism in the way the names of the movements would imply. Though the issue has been hotly debated, postmodernism seems to have shadowed modernism all along.[12] We can certainly see elements of what is thought of as postmodernism as early as the 1920s in art, in the Dada movement, for example.[13]

I can suggest one reason modernism and postmodernism have been strangely intertwined as aesthetic movements. The nihilism of philosophers such as Nietzsche underlies much of modernism, and nihilism provides a problematic basis for the creation of art. Nihilism is what many twentieth-century artists have implicitly or explicitly put forward as their great discovery, the discovery that makes all prior art outdated.[14] Following Nietzsche, many twentieth-century artists have claimed as their privileged truth the idea that all previous cultures were based on illusion, particularly a set of religious beliefs or myths. In this sense, modernist artists could claim to know the truth, the truth that all cultures have been founded on illusion, and hence no real foundation at all. As Yeats writes in one of his "Supernatural Songs" entitled "Meru":

Civilisation is hooped together, brought
Under a rule, under the semblance of peace
By manifold illusion; but man's life is thought,
And he, despite his terror, cannot cease
Ravening through century after century,
Ravening, raging, and uprooting that he may come
Into the desolation of reality.[15]

Here the modernist poet presents himself as the culmination of a long historical process, in which the truth, the truth of nihilism, only gradually emerges. Hence, modernism could pride itself on its truthfulness, presenting itself as the only art that does not require illusions to sustain it. That is the source of the tough-mindedness and self-confidence of high modernism, with its overwhelming certainty: "We're right, and everyone in the past was wrong."

But the truth of nihilism is a peculiar truth, the truth that there is no Truth, that there are no absolutes, only relative truths, only perspectives on reality. Hence, from the beginning, modernism had the potential of undermining itself. If the only truth is that there is no Truth, what are we to say of

the truth of modernism? Ultimately, the logic of modernism forces it to call into question its own truthfulness and hence its brash confidence. We can see this paradoxical aspect of modernism, its inexorable propensity to undermine itself, in *The Waste Land*, a poem that alternates between ringing self-confidence and painful self-doubt. On the one hand, *The Waste Land* is like a modernist skyscraper, confidently proclaiming: "Look at me, I'm the hippest poem that has ever been written. All those old poets didn't have a clue where it's at. They thought the Thames was something beautiful — but this is the 1920s and I know it's polluted. I'm true and they're false." On the other hand, *The Waste Land* is postmodernist, almost whimpering in its uncertainties: "I don't know what is true. Somebody help me out. I hear a lot of different voices out there. Do you have a few Buddhist truths I could borrow? Would a little Sanskrit incantation help out at the end?" Because of the peculiar nature of the truth on which modernism was founded — the truth that there are no genuine foundations — modernism has always been linked to what we now call postmodernism. Modernism began by claiming a privileged historical position for itself — that the moderns have discovered a new truth — but the nature of that truth necessarily dissolved the notion of any privileged position in history, any final and absolute truth. Modernism takes us up to and self-confidently proclaims the end of history; postmodernism is the form artistic creativity takes after the end of history,[16] once the great aesthetic battles of the past have been resolved or rather shown to have been empty, empty because they were based on limited historical perspectives.

Up until the twentieth century, artistic styles in some sense claimed to be true, to have found, for example, the true way of representing reality. That is why different artistic styles came into conflict — they made exclusive claims to truth. Coming at the end of history, postmodernism is the democratic art form, for it denies that any form of art can truthfully represent reality, thereby making all aesthetic points of contention effectively moot and proclaiming the equality of all artistic styles.

II

By means of a Hegelian analysis of *Waiting for Godot*, I wish to pursue the idea that postmodernism is the style of art appropriate to the posthistorical period or what has been called the end of history. I must therefore give a brief outline of Hegel's theory of history. For Hegel, at the heart of history stands the struggle for freedom, and that means the struggle between master and slave. According to the *Phenomenology of the Spirit*, history begins

with the struggle for recognition, a fight for pure prestige. Two men come to fight, not over food, not over land, not over a woman, but merely for the sake of struggle, to see who is boss, to see who is master. This desire for mastery is for Hegel the distinctively human impulse, the one characteristic humans do not share with other animals. The fight for recognition would be a fight to the death, except that in the struggle one of the men gives up. This outcome reflects the fundamental human distinction, in Hegel's view, between the man who values life over honor and the man who values honor over life. The man who gives up in the struggle becomes the slave, while the man who does not becomes the master. This process thus provides the origin of aristocracy. For Hegel, history begins with the struggle to establish difference or distinction, and that means primarily the different orders of rank in society.

The master begins history in Hegel, but there his role basically ceases. For Hegel, the slave is paradoxically the motive force behind historical progress. The master is lazy and rests on his laurels, desiring nothing more than the prestige of lordship. In Hegel the slave does all the work. Entitled to enjoy the fruits of the slave's labor, the master does nothing. Hence, the slave develops all human skills and talents, becoming clever and productive. For Hegel, history is in essence the story of the cunning of slaves, who are always looking for the opportunity to turn the tables on their master.

To make what is truly a long and complicated story in Hegel short, for him history culminated in the French Revolution, when the slaves at last successfully revolted against their masters and overthrew the aristocratic old regime. But the slaves did not enslave their former masters; the French Revolution was not a matter of exchanging the roles of master and slave. Such an outcome would not, according to Hegel, fundamentally change anything. Rather, the goal of the French Revolution was to obliterate the whole notion of masters and slaves. The French sought to establish a democratic regime, based on the notion of the universal rights of man. The famous principles of liberty, equality, and fraternity are one way of expressing the point that no aristocratic order can any longer be accepted, no idea of natural masters and natural slaves.

The establishment of this democratic principle is what Hegel calls the end of history, "end" largely in the sense of "goal." This is the outcome toward which all history has been moving, a form of universal recognition in which all human beings reciprocally acknowledge one another's dignity as human beings. No one will any longer have the natural or divine right to rule over another; from this point on, all rule must be based on the consent of the

governed, the fundamental principle of democracy. According to Hegel, the French Revolution first established this principle; it did not succeed in making it work in practice. Still, henceforth, aristocracy and the old regime will always be on the defensive, having lost their legitimacy once and for all. The old regime may cling to power, it may even temporarily restore itself after revolutions, but its days are numbered; it is only a matter of time before democracy is successfully established everywhere. Once the hollowness of the aristocratic principle has been exposed, democracy becomes the wave of the future. The democratic principle will wipe out all sense of natural hierarchy, all sense of inherent human distinctions, and thereby establish a classless society, a universal and homogeneous classless society. Having begun with the creation of human difference, history ends with the overcoming and abrogation of difference.

I have already begun to formulate Hegel's view in the terms of Alexandre Kojève, perhaps the most profound student of Hegel in this century.[17] His interpretation of Hegel's *Phenomenology* is much disputed, but for my purposes it is irrelevant whether Kojève gives an accurate account of Hegel, because I am going to argue that Hegel's ideas reached Beckett via Kojève.[18] I cannot offer any evidence that Beckett knew Kojève, though they were both living in Paris in the 1930s and moving in roughly the same circles. In any case, as perhaps the most important and influential intellectual force in Paris at that time, Kojève, or at least his ideas, must have been known to Beckett.[19]

Whatever the personal connections, I hope to show the influence of Hegel's idea of the dialectic of the master and slave on *Waiting for Godot*.[20] The main characters of the play, the two tramps, Vladimir and Estragon, represent democratic man at the end of history, watching the master and slave, Pozzo and Lucky, play out the last stages of their dialectic. Beckett creates a disturbing allegory of democratic man haunted by the pale and empty shades of the aristocratic past.

With Lucky as his servant, Pozzo is a good example of the Hegelian master. He tries to project the image of a god: "As though I were short of slaves! Atlas, son of Jupiter!" (21).[21] Accordingly, Pozzo attempts to lead a life of leisure, letting Lucky do all the work. Lucky has all the talent in the pair; he is the one who can dance, the one who can sing, and above all the one who can think, as Pozzo himself admits: "Guess who taught me all these beautiful things. My Lucky! . . . But for him all my thoughts, all my feelings, would have been of common things. Professional worries! Beauty, grace, truth of the first water, I knew they were all beyond me" (22).

Thus, Pozzo and Lucky act out the Hegelian dialectic: Pozzo is the mas-

ter, but in every important respect Lucky is his superior.[22] In the terms of the play, they occupy the world of history, the world of clock time, which explains Pozzo's continuing obsession with his watch. Pozzo and Lucky represent the principle of linearity of time in the play. Only they have the possibility of ever getting anywhere; they keep moving across the stage, while Vladimir and Estragon stay in the same place, or at most move around in circles. Indeed, when Vladimir claims, "Time has stopped," Pozzo disagrees: "Don't you believe it, Sir" (24).

But something has gone wrong with Pozzo as a master. He is only a shell of his former self, a master with a bad conscience. Indeed, the key to posthistorical existence is the fact that even the lingering masters are forced to accept democratic ideology:

Pozzo: The road is free to all.
Vladimir: That's how we looked at it.
Pozzo: It's a disgrace. But there you are.

(16)

Pozzo does not like this new principle of freedom, but he can offer no real alternative to it. The crucial issue in the postrevolutionary world is not whether some form of slavery persists but how the phenomenon is interpreted. Mastery may not be completely eliminated, but it has lost its claim to legitimacy and can maintain itself only by brute force. Pozzo would in fact like to reassert the old aristocratic claim to one-sided recognition: "I am Pozzo! Pozzo! Does that name mean nothing to you?" (15). But while Pozzo tries to play the role of the heroic master, he finds he has to accept the new idea of equality, embracing Vladimir and Estragon in their common humanity: "You are human beings none the less. As far as one can see. Of the same species as myself. Of the same species as Pozzo! Made in God's image!" (15).[23]

Pozzo has developed such a bad conscience as a master that he can no longer even maintain a clear distinction between himself and Lucky: "Remark that I might just as well have been in his shoes and he in mine. If chance had not willed otherwise" (21). This is a remarkable concession to democratic ideology on the part of a master. Pozzo admits that there is nothing natural or divine about social hierarchy anymore; who is the master and who is the slave has become a purely arbitrary matter, a matter of chance.

In the character of Pozzo, Beckett explores the paradox of the Hegelian master. The master builds his heroic self-image by having others look up to him. Thus, although the master claims to be self-sufficient and above ordi-

nary human need — "Do I look like a man who can be made to suffer?" (23) — in fact he needs recognition, he needs an audience. Hence Pozzo's obsession with being the center of attention: "Is everybody looking at me? Will you look at me, pig! . . . Is everybody listening? . . . I don't like talking in a vacuum" (20). Here is the source of the hollowness of the master's position: He builds his sense of self-respect on the basis of the admiration of men he himself despises. As Pozzo tells Vladimir and Estragon: "Yes, gentlemen, I cannot go for long without the society of my likes . . . even when the likeness is an imperfect one" (16). Thus, Pozzo is profoundly insecure: "I have such need of encouragement! I weakened a little towards the end, you didn't notice?" (25). In Pozzo we see how difficult it is to maintain an aristocratic aura in the modern democratic world. He tries to project an image of *noblesse oblige* with Vladimir and Estragon: "The more people I meet the happier I become. From the meanest creature one departs wiser, richer, more conscious of one's blessings. Even you . . . even you, who knows, will have added to my store" (20). But Pozzo is taken aback by Estragon's inquiry about how he treats Lucky: "A question! Who? What? A moment ago you were calling me Sir, in fear and trembling. Now you're asking me questions! No good will come of this!" (20).

Here is the end of history as Hegel viewed it. The common people used to be in awe of their aristocratic masters, accepting their rule as natural and looking up to them in fear and trembling, as if to gods, but then came the Enlightenment with its demythologizing of the old regime. Once the common people learned to question the myth of aristocracy, to raise doubts about the behavior of their masters, something like the French Revolution and the establishment of democracy became merely a matter of time.

If Pozzo and Lucky form Beckett's image of the lingering but moribund aristocratic world of masters and slaves, then Vladimir and Estragon are representatives of democratic man. They live together on the same level, and, unlike Pozzo and Lucky, they treat each other more or less as equals. Vladimir and Estragon are spokesmen for democratic ideology, disturbed, for example, by the way Pozzo treats Lucky: "To treat a man . . . like that . . . I think that . . . no . . . a human being . . . no . . . it's a scandal!" (18). To be sure, moments later Vladimir and Estragon reverse their position and take Pozzo's side against Lucky, sympathizing with the master and berating the servant for his ingratitude: "How dare you! It's abominable! Such a good master! Crucify him like that! After so many years! Really!" (23). But this reversal only shows how weak their convictions are, how prone Vladimir and Estragon are to take their bearings from the opinions of others. They live in a world of proverbs, moving from one cliché to another:

VLADIMIR: Let's wait till we know exactly where we stand.
ESTRAGON: On the other hand it might be better to strike the iron before
it freezes.

(12)

Vladimir and Estagon continually exhibit what sociologists call the other-directedness of democratic man. They are incapable of making up their own minds and feel a constant need to consult others. They even project this attitude onto Godot:

ESTRAGON: And what did he reply?
VLADIMIR: That he'd see.
ESTRAGON: That he couldn't promise anything.
VLADIMIR: That he'd have to think it over.
ESTRAGON: In the quiet of his home.
VLADIMIR: Consult his family.
ESTRAGON: His friends.
VLADIMIR: His agents.
ESTRAGON: His correspondents.
VLADIMIR: His books.
ESTRAGON: His bank account.
VLADIMIR: Before taking a decision.
ESTRAGON: It's the normal thing.

(13)

Tocqueville provides a penetrating analysis of this peculiar tendency of democratic man, the paradoxical way in which his new freedom exposes him to the tyranny of public opinion:

When the inhabitant of a democratic country compares himself individually with all those about him, he feels with pride that he is the equal of any one of them; but when he comes to survey the totality of his fellows and to place himself in contrast with so huge a body, he is instantly overwhelmed by the sense of his own insignificance and weakness. The same equality that renders him independent of each of his fellow citizens, taken severally, exposes him alone and unprotected to the influence of the greater number. The public, therefore, among a democratic people, has a singular power, which aristocratic nations cannot conceive; for it does not persuade others to its beliefs, but it imposes them and makes them per-

meate the thinking of everyone by a sort of enormous pressure of the mind of all upon the individual intelligence.[24]

Tocqueville's analysis helps us understand how Vladimir and Estragon can keep claiming to be free and yet utterly lack independence in their thought. Though they manifest a distinctively democratic concern for their rights, the two men seem to be ambivalent about them and willing to dispense with them:

> VLADIMIR: Your Worship wishes to assert his prerogatives?
> ESTRAGON: We've no rights any more?
> VLADIMIR: You'd make me laugh if it wasn't prohibited.
> ESTRAGON: We've lost our rights?
> VLADIMIR: We got rid of them.
> ESTRAGON: We're not tied?
>
> (13)

Characteristically, Vladimir and Estragon are lukewarm even in their commitment to democracy. For them, freedom really means not being tied to anything, and that evidently includes even their rights.[25]

Obsessed with avoiding any kind of commitment, Vladimir and Estragon hold back from taking any decisive actions. Their guiding principle seems to be: "Don't let's do anything. It's safer" (12). Thus, whereas Pozzo and Lucky are plunged into the movement of history, Vladimir and Estragon stand removed from it, becoming mere spectators within the world of the play:

> VLADIMIR: Charming evening we're having.
> ESTRAGON: Unforgettable.
> VLADIMIR: And it's not over.
> ESTRAGON: Apparently not.
> VLADIMIR: It's only beginning.
> ESTRAGON: It's awful.
> VLADIMIR: Worse than the pantomime.
> ESTRAGON: The circus.
> VLADIMIR: The music-hall.
> ESTRAGON: The circus.
>
> (23)

The role of Vladimir and Estragon as spectators is emphasized moments later when Vladimir, having to leave the stage to relieve himself, tells Estragon, "Keep my seat" (23). Pozzo and Lucky act out the drama of the dialectic of the master and slave, in a shabby and much reduced version to be sure, but they provide the only dramatic action to be found in *Waiting for*

Godot. By contrast, Vladimir and Estragon are democratic men, who can only passively stand on the sidelines and watch the struggles of Pozzo and Lucky. At most, Vladimir and Estragon produce a pale imitation of the already shadowy aristocratic world:

> VLADIMIR: We could play at Pozzo and Lucky.
> ESTRAGON: Never heard of it.
> VLADIMIR: I'll do Lucky, you do Pozzo.
>
> (47)[26]

This is Beckett's haunting image of the posthistorical, democratic age. The powerful dialectic of master and slave is reduced to an empty and formulaic ritual, the halfhearted and idle playing out of what was once the serious work of history.[27]

III

Waiting for Godot embodies a strange vision of the world, one that makes for a peculiar kind of drama, a distinctively postmodern drama whose character becomes clearer if we contrast it with traditional drama. In the traditional view of tragedy, stretching all the way back to Aristotle, the genre deals with heroes raised above the level of ordinary humanity, usually drawn from the higher ranks of society, the aristocratic world. This understanding of tragedy is based in the idea that serious drama requires truly elevated heroes, the kind of men and women who make a difference in life. As we have seen, aristocracy implies the notion that there are two different orders of human beings; some are heroic, and some are not. Often tragedy grows out of precisely the tension between these heroic types and the ordinary run of humanity. Thus, Hegel's view of history has ominous implications for the genre of tragedy. If a homogeneous society will come into being at the end of history, then that will mean the end of a distinct order of heroes and hence the end of tragedy as traditionally understood.[28]

In Hegel's own view, tragedy grows out of a conflict of two legitimate principles, and indeed these tragic conflicts are the engine of history for him, driving it to ever-higher forms of synthesis that transcend the conflicts. But this view of history means that once it pushes to the point where all conflicts are finally resolved, the basis for any kind of Hegelian tragedy will have disappeared. Hegel sees a great leveling at the end of history, the erasure of fundamental aristocratic distinctions. This outcome produces the world of what Nietzsche calls the last man, who is decidedly not heroic and not tragic: "Everybody wants the same, everybody is the same; whoever feels different

goes voluntarily into a madhouse."[29] In short, what Hegel looks forward to as the "end of history" horrifies Nietzsche in the form of the last man.[30] The dialectical overcoming of the historical world of difference threatens to produce a world of complete indifference.

This is precisely the issue raised by *Waiting for Godot*. In the figures of Pozzo and Lucky, Beckett shows the shadow of the world of aristocratic distinction haunting the posthistorical world of democratic leveling. In Act II, Vladimir and Estragon enjoy having Pozzo and Lucky at their mercy, making fun of their distress and disasters, relishing the sight of their supposed betters brought down to their level. Vladimir and Estragon love thinking that these figures out of the aristocratic past are really no different from them. Here is where the posthistorical links up with the postmodern. In the idea of the posthistorical, history comes to its end with the final leveling out of all aristocratic distinctions. But we have already seen that postmodernism is the form of art that levels out distinctions in historical styles, in the form of postmodern pastiche or postmodern flatness. In postmodernism, such distinctions are no longer thought of as in any way rooted in nature; they are viewed as purely arbitrary, merely matters of style or convention, wholly ungrounded in any underlying reality. What the posthistorical and the postmodern have in common is the idea of the effacement of essential or natural difference.[31]

Accordingly, toward the end of the play, when the aristocratic world of Pozzo has completely collapsed, he rejects the strongly linear sense of time that earlier dominated his consciousness: "Have you not done tormenting me with your accursed time! It's abominable! When! When! One day, is that not enough for you, one day he went dumb, one day I went blind, one day we'll go deaf, one day we were born, one day we shall die, the same day, the same second, is that not enough for you?" (57).

In postmodern fashion, all moments of time level out for Pozzo and become equally present. His earlier belief that there is "a natural order" to events (26) dissolves, and he now sees moments succeeding one another in an arbitrary order, making it difficult to tell one minute from another. In Act II, the blind Pozzo finds himself staring blankly at a world of universal sameness.

In general, *Waiting for Godot* is a play filled with differences, but they are all viewed as purely arbitrary, with no foundation in either a natural or a divine order. In a typical moment, Estragon enigmatically declares: "My left lung is weak! But my right lung is sound as a bell!" (27). In the flat postmodern world, the characters seem to grasp at any form of differentiation they can find, no matter how minimal or marginal: "He has stinking breath

and I have stinking feet" (31). Beckett even builds the principle of marginal differentiation into the structure of the play. In a sense Act II is merely a repetition of Act I, with minor variations, as the characters themselves come to feel: "Off we go again" (58). The lack of differentiation is emphasized in the stage directions for Act II: "*Next day. Same time. Same place*" (36). Only a lone tree seems to allow the characters to tell one day from the other: "But yesterday evening it was all black and bare. And now it's covered with leaves" (42). *Waiting for Godot* presents characters desperately trying to spy out some shred of difference in a world of numbing sameness, a flat and uniform landscape that stretches out equally in all directions.

To be sure, throughout the dialogue, the characters have their differences, but their disagreements do not run very deep; indeed, they seem to differ with one another merely for the sake of differing, in a kind of game: "That's the idea, let's contradict each other" (41). Vladimir and Estragon often seem to be struggling to differentiate themselves from each other, sometimes just in terms of their appearance (12), sometimes in their convictions:

> ESTRAGON: Funny, the more you eat the worse it gets.
> VLADIMIR: With me it's just the opposite.
> ESTRAGON: In other words?
> VLADIMIR: I get used to the muck as I go along.
> ESTRAGON: Is that the opposite?
>
> (14)

Repeatedly in the play the characters seem confused as to whether two things are the same or opposites.[32] *Waiting for Godot* portrays a world in which difference constantly threatens to melt into sameness, into indifference. Pozzo eloquently describes the twilight character of the world of the play, which begins with the sharp contrasts of "torrents of red and white light" but gradually "begins to lose its effulgence, to grow pale, ever a little paler" (25).

Difference lingers on in *Waiting for Godot*, but it becomes increasingly mysterious. At the beginning of the play Vladimir is preoccupied with a case of difference in the gospels: "Two thieves, crucified at the same time as our Saviour. . . . One is supposed to have been saved and the other . . . damned" (9). But Vladimir can find no explanation in the Bible for why these two thieves were treated differently. *Waiting for Godot* is filled with many such images of arbitrary difference, often with overtones of divine arbitrariness.[33] Consider the case of the boy who comes as Godot's messenger, a boy with a shadowy brother:

VLADIMIR: You work for Mr. Godot?

BOY: Yes Sir.

VLADIMIR: What do you do?

BOY: I mind the goats, Sir.

VLADIMIR: Is he good to you?

BOY: Yes Sir.

VLADIMIR: He doesn't beat you?

BOY: No Sir, not me.

VLADIMIR: Whom does he beat?

BOY: He beats my brother, Sir.

VLADIMIR: Ah, you have a brother?

BOY: Yes Sir.

VLADIMIR: What does he do?

BOY: He minds the sheep, Sir.

VLADIMIR: And why doesn't he beat you?

BOY: I don't know, Sir.

VLADIMIR: He must be fond of you.

BOY: I don't know, Sir.

(33–34)

With its more than faint echoes of the Cain and Abel story — one brother favored and the other not, but no explanation given as to why — this incident seems to cast Godot in the role of God, but a God who remains mysterious in his differing treatment of like individuals. The idea of divine arbitrariness is at the heart of Lucky's extraordinary speech, in which he babbles about "a personal God . . . who . . . loves us dearly with some exceptions for reasons unknown but time will tell and suffers like the divine Miranda with those who for reasons unknown but time will tell are plunged in torment plunged in fire" (28). In its stream of unconsciousness, Lucky's speech may seem meaningless, but it keeps circling around the idea that salvation and damnation are purely arbitrary, meted out differently to people "for reasons unknown."

Under the old regime, people accepted distinctions among human beings as based in nature or divine will or a combination of the two. In the ideology of aristocracy, people thought they had an explanation for social ranks, and in that sense the distinctions seemed justified, something with which people could live. In the posthistorical world, the grounding of human difference has disappeared. In the enlightened world of *Waiting for Godot*, God has in effect been abolished for the sake of democratic rights. Memories of the Bible linger in the minds of Vladimir and Estragon (see especially p. 8), but the only remaining effect of Christianity seems to be to promote the prin-

ciple of human equality. Clearly, the age of the great faiths is gone, but Beckett's characters still cling to difference. Indeed, with their sense of natural distinction dissolved, they fall back on purely arbitrary social distinctions. In their own tramplike way, Vladimir and Estragon are snobs.[34] They try to appropriate the language of aristocracy: "May one inquire where His Highness spent the night?" (7). But such gestures have a hollow ring to them, for Vladimir and Estragon can no longer explain or justify difference:

> VLADIMIR: All the same, you can't tell me that this bears any resemblance
> to . . . to the Macon country for example. You can't deny there's a big
> difference.
> ESTRAGON: The Macon country! Who's talking to you about the Macon
> country?
> VLADIMIR: But you were there yourself, in the Macon country.
> ESTRAGON: No, I was never in the Macon country! I've puked my puke of a
> life away here, I tell you! Here! In the Cackon country!
>
> (39–40)

Macon — Cackon: Beckett reduces the dialogue to the barest of differences, a merely linguistic and hence a totally arbitrary difference, the difference between two phonemes, "ma" and "ca." Such purely phonemic differences resound throughout *Waiting for Godot*: "Is it Pozzo or Gozzo?" (15) or the repeated sequence, "Godet . . . Godot . . . Godin" (19, 24). In his structural linguistics, Ferdinand de Saussure presents the difference between two phonemes as the product of a pure binary opposition; the two are defined solely in terms of each other and not in terms of anything external to their relation. In short, phonemic difference is internal to a linguistic system and not rooted in a real world outside it. In a striking anticipation of the poststructuralism of Jacques Derrida, Beckett seems to take a purely linguistic difference like that between *Macon* and *Cackon* as the model of all difference. In Beckett's play of language, difference is systematically deconstructed throughout *Waiting for Godot* and thus revealed to be purely arbitrary.

But this deconstruction is not solely a linguistic phenomenon. The key to understanding the process seems to be the larger political context we have uncovered in the play. What links the posthistorical, the postmodern, and the poststructural is a central act of deconstruction, the deconstruction of the difference between the master and the slave, and that is a political, not a linguistic, act. More specifically, it is the fundamentally democratic act; the postmodern flatness of the world of *Waiting for Godot* flows from its democratic character. Sharp distinctions begin to blur, as happens when Estragon tries to identify his boots:

ESTRAGON: They're not mine.
VLADIMIR: Not yours!
ESTRAGON: Mine were black. These are brown.
VLADIMIR: You're sure yours were black?
ESTRAGON: Well they were a kind of gray.

(43)

The world of *Waiting for Godot* is a gray world, a posthistorical world in which the difference between white and black has been effaced. The aesthetic consequences of this political development are serious: It is not easy to write drama about such a world. Drama thrives on conflict, and it needs sharp opposites to generate that conflict. This is perhaps one reason drama has flourished in aristocratic communities, such as Elizabethan England, or in communities in which the conflict between aristocracy and democracy was a living issue, such as ancient Athens.

These considerations raise a disturbing question: What happens to drama once democracy finally and fully triumphs? Perhaps *Waiting for Godot* offers an image of that situation. All the natural bases of tension in traditional drama have been undermined if not eliminated.[35] Only the fading shadow of an aristocratic past remains to provide a feeble source of dramatic conflict in the world of democratic leveling. As we watch the spread of postmodernism throughout the arts and throughout the world today, with its systematic tendency to flatten out and even trivialize difference, what we may be witnessing is the ultimate working out of the aesthetic logic of democracy.

To be sure, postmodernists and poststructuralists would counter that they in fact *celebrate* difference and try to promote it. But the key question remains: What kind of difference do they celebrate and promote? I would argue that it is not *essential* or *fundamental* difference (indeed, postmodernists insist that *no* differences are essential or fundamental). It is precisely because postmodernists trivialize difference that they feel free to let differences proliferate. This point can be seen most clearly in the contemporary ideology of multiculturalism, which claims to champion the cause of cultural diversity. But what such advocates have in mind is a kind of cultural smorgasbord from which everyone can happily pick and choose; they are interested solely in diversity in ethnic styles of art, song, food, costume, and so on. In short, multiculturalists *aestheticize* difference. In practice, they are not open to fundamental political differences among cultures. They do not celebrate warrior cultures, slave-holding cultures, cultures that treat women as chattel, in short, aristocratic cultures in general. In fact, the contemporary celebration of diversity confines itself to an extremely limited range of *political* possibili-

ties, which hardly ever extends beyond the bounds of liberal democracy. *Waiting for Godot* dramatizes such a world of diminished political possibilities, as the differences between regimes, and in particular between masters and slaves, have been effaced at the end of history. Once one accepts the abrogation of the substantive differences over which human beings have fought throughout history, one is free to celebrate the differences in style or fashion that remain, the kinds of marginal differentiation Beckett emphasizes in the world of the play. "The celebration of a kind of aesthetic diversity within the limits of political uniformity"—that is another formula for postmodernism.

That formula helps explain why postmodernism seems such a protean phenomenon, alternating between moments of exhilaration and despair; it all depends on whether one emphasizes the surface diversity or the underlying uniformity. I have concentrated on the depressing aspects of *Waiting for Godot* and, indeed, have risked giving a false impression of the play by neglecting its humor, its often brilliant comic routines. But I have done so because I believe that the comedy of *Waiting for Godot* is a kind of gallows humor (quite literally, when Vladimir and Estragon consider hanging themselves). Beckett's comic routines are always a high-wire act suspended over an abyss, the abyss of nihilism, "astride of a grave and a difficult birth" (58). The comedy ultimately flows from a recognition of the absurdity of human existence, which comes into view at the end of history.

Kojève argued that once the serious work of history has been accomplished and the great issues that divided humanity have been settled, a whole realm of play opens up, a form of activity that may be engaging but that remains essentially meaningless, posthistorical rituals emptied of their traditional content.[36] Postmodernism is the game that takes place at the end of history. Beckett's characters often participate in that game, sometimes even contributing comic routines that border on the high-spirited. But Beckett's humor always has an undercurrent of melancholy to it, even a sense of desperation, since the comedy seems to be straining to fill a void. As the drama he wrote after *Waiting for Godot* suggests, for Beckett the game at the end of history is a long, drawn-out endgame, the shuffling and reshuffling of the few remaining pieces on a chessboard, leading to nothing more exciting than a grandmaster's draw.

If in Beckett the playfulness of postmodernism is always coupled to an underlying sadness, one reason is that he experiences the leveling of the old aristocratic world as a loss. To be sure, Beckett does not share Yeats's nostalgia for aristocracy, and he has no hope for the revival of some kind of old-style heroism in the modern world.[37] Still, Beckett is not willing to celebrate

the eradication of aristocracy as an unequivocal liberation. In *Waiting for Godot* modern man appears to purchase his freedom at a great price; once he gets rid of anything he might die for, he seems to lose all sense of what to live for.

I have tried to show that the aristocratic world is paradoxically present in *Waiting for Godot* as a looming absence, the gaping void that lies at the heart of the play. As only one author, Beckett does not exhaust the whole range of postmodernism. One would never guess from the stark and featureless land-scapes of Beckett's plays that postmodernism would equally take the form of the gaudy buildings that now dot urban and suburban scenes or the glitzy videos that dominate television. Yet, I would argue that the two modes of postmodernism are related and that Beckett's is the more fundamental. In his uncompromising way, Beckett reveals what is at the foundation of all the sound and fury of contemporary culture; rather, he lays bare its lack of foundation, the hollowness at its core, the fact that it grows out of the dissolution of the historical basis of traditional culture. Where many postmodernists hear the ringing of the chimes of posthistorical liberation, Beckett hears the rattling of the bones at the end of history.

NOTES

Museums and the Thirsting Millions

1. Henry James, *The Golden Bowl*, ed. Gore Vidal (London: Penguin English Library, 1985), pp. 142–43.

2. Linda Ferber, "History of the Collections," in *Masterpieces in the Brooklyn Museum* (Brooklyn: Brooklyn Museum, 1988), p. 12. See also "Part One: History," in *A New Brooklyn Museum: The Master Plan Competition* (Brooklyn: Brooklyn Museum and Rizzoli, 1988), pp. 26–76.

3. John Ruskin, communication to his father, in Tim Hilton, *John Ruskin: The Early Years* (New Haven: Yale University Press, 1985), p. 256.

4. James, *The Golden Bowl*, p. 220.

5. Michael Brenson, "Healing in Time," in Mary Jane Jacob, ed., *Culture in Action: A Public Art Program of Sculpture Chicago* (Seattle: Bay Press, 1995), pp. 28–29.

6. Arthur C. Danto, *Beyond the Brillo Box: The Visual Arts in Post-Historical Perspective* (New York: Farrar, Straus and Giroux, 1992), p. 12.

7. I discuss this in "Post-Modern Art and Concrete Selves," in *From the Inside Out: Eight Contemporary Artists* (New York: Jewish Museum, 1993).

8. Caroline Tisdale, *Joseph Beuys* (New York: Guggenheim Museum, 1979), pp. 195–96.

9. As luck would have it, the book review section of the *New York Times*, January 15, 1995, advertises "the new bestseller" by Doris Mortman, *True Colors*, with "everything you want in a novel," itemized as "family, love, betrayal, rivalry, talent, triumph." It is clearly about an artist — the full-page ad shows us a vase with brushes and some twisted tubes laid out on a piece of exotic fabric. "*True Colors* sweeps you into the international art scene, where the intense pressures of success compete with the deeper dictates of the heart." But the artist we may be sure did not compact to paint a picture "with everything you want in a painting," such as George Washington, blue sky, folks like you and me, wild animals, and so on.

Architecture and Democracy, Democracy and Architecture

1. Ada Louise Huxtable, "The New Architecture," *New York Review*, April 6, 1995, p. 21. It is notable that Huxtable, who is purportedly reporting on the new architecture, not merely on the latest modernism, fails to mention any of the ongoing activity among those who reject modernism, for example, Allan Greenberg, Leon Krier, or Demetri Porphyrios. It is also noteworthy that among the more than one hundred accredited schools of architecture in this country, the curriculum of only one, the University of Notre Dame, is explicitly grounded in the classical tradition, and almost all the others exclude even the most basic exercise in classicism, that of drawing the orders.

2. This is the most neglected of the three aspects of classical architecture, the one that architects, since the 1920s or 1930s, for example, in John Russell Pope's National Gallery in Washington, have been most negligent in investigating in order to discover how to in-

corporate new technology into the realm of classical architecture. For a brief glance at some of the earlier investigations, see C. W. Westfall, "Benjamin Howard Marshall of Chicago," *Chicago Architectural Journal* 2 (1982): 8–27. For a detailed discussion of classical tectonics, see Demetri Porphyrios, *Classical Architecture* (London: Academy Editions, 1991) and *Selected Buildings and Writings* (London: Academy Editions, 1993).

3. See Leo Strauss, *Natural Right and History* (Chicago: University of Chicago Press, 1953), esp. pp. 136ff. for the meanings of my use of the term "regime,"which is his rendering of the term "*politeia.*" See also M. I. Finley, *Democracy Ancient and Modern*, rev. ed. (New Brunswick: Rutgers University Press, 1985), pp. 13–14, in which he attributes to the Greeks the understanding of "the art of reaching decisions by public discussion and then of obeying those decisions as a necessary condition of civilized social existence."

4. For this point, see esp. Aristotle, *Politics*, 1281a48–1281b10.

5. For an assessment of what we actually know about this episode, see A. H. M. Jones, *Athenian Democracy* (Oxford: Blackwell, 1957), pp. 65–72. See also the interpretation by Robert Jan van Pelt in van Pelt and Carroll William Westfall, *Architectural Principles in the Age of Historicism* (New Haven: Yale University Press, 1991), pp. 104–6 and 233–42.

6. The following material draws heavily on Jean-Pierre Vernant, *The Origins of Greek Thought* (Ithaca: Cornell University Press, 1982); George Hersey, *The Lost Meaning of Classical Architecture* (Cambridge: MIT Press, 1988); and Indra Kagis McEwen, *Socrates' Ancestor* (Cambridge: MIT Press, 1994).

7. My translation of *De architectura* I, i, 1: "Opera ea nascitur et fabrica et ratiocinatione," Loeb edition of Frank Granger, 2 vols. (Cambridge: Harvard University Press, 1933). This does not mean that the explanation is about the building and without it the building would be unintelligible, as occurs in modernism. Rather, it means that the building and the explanation are both about the same thing, each rendering the account in a different way or medium. Granger's rendering ("His personal service consists in craftsmanship and technology.") suggests an opposition between the hand and the head, and that is not Vitruvius's meaning. Morgan's rendering ("This knowledge [of the architect] is the child of practice and theory") is similar but is more obscure. A penetrating analysis, which I follow here, sees the pair of *fabrica* and *ratiocinatione* as parallels to *res* and *verba* and similar ancient couplings; it is found in P. H. Schrijvers, "Vitruve I, i, 1: explication de texte," in *Manus non ingratium*: *Proceedings of the International Symposium on Vitruvius' "De Architectura" and the Hellenistic and Republican Architecture, Leiden: 1987,* ed. H. Geertman and J. J. de Jong, *Babesch*: *Bulletin Antieke Beschaving: Annual Papers on Classical Archaeology*, sup. 2, 1989 (Leiden: Stichting Bulletin Antieke Beschaving, 1989), pp. 49–54.

8. See the important study by Brian Carter Broadus, "Enduring and Transitory Aspects of Civic Life Implicit in Fifth-Century Athenian City Form: The Hellenic Agora within Athens," M.Arch. thesis, University of Virginia, 1986; and Joh. S. Boersma, *Athenian Building Policy from 561/0 to 405/4 B.C., Scripta Archaeologica Groningana* 4 (Groningen: Wolters-Noordhoff, 1970), for the quite subordinate role of domestic architecture.

9. For the following interpretation I follow closely the important article by Herman Geertman, "Teoria e attualità della progettistica architettonica di Vitruvio," *Le Projet de Vitruve* (Proceedings of the International Conference Organized by the École Française de Rome, Rome, March 26–27, 1993), Collection de l'École Française de Rome 192 (Rome: 1994), pp. 7–30, and I acknowledge the benefits of discussion of this material with

him. Lest the explanation that follows become unintelligibly sketchy, note that *symmetria* incorporates the criterion of *ordinatio* and that *eurythmia* incorporates that of *dispositio*. Interchanges with Samir Younés also enriched and clarified the thoughts found here.

10. See discussions by Richard Krautheimer in *Rome: Profile of a City* (Princeton: Princeton University Press, 1980) and in *Three Christian Capitals: Topography and Politics* (Berkeley: University of California Press, 1983); and Lidia Storoni Mazzolini, *L'idea di città nel mondo romano* (Milan: Riccardo Ricciardi, 1967).

11. Augustine, *De Civitas Dei*, XIX, 17, 696–97.

12. See, for example, Mark 10:41–45.

13. See Wolfgang Braunfels, *Mittelalterliche Stadtbaukunst in der Toskana*, 3d ed. (Berlin: Mann, 1966), and *Monasteries of Western Europe: The Architecture of the Orders*, trans. Alastair Laing (London: Thames and Hudson, 1972); and Chiara Frugoni, *A Distant City: Images of Urban Experience in the Medieval World*, trans. William McCuaig (Princeton: Princeton University Press, 1991).

14. The legal doctrines were carved out of political theory and practice by a pair of fourteenth-century Italian lawyers, Bartolus of Sassaferato and Marsilio of Padua, who were defending the claims of independence made by city states against the imperial claims of pope and emperor. For a brief review, see Quintin Skinner, *The Foundations of Modern Political Thought*, 2 vols. (Cambridge: Cambridge University Press, 1978), chap. 1; for Marsilio, see Leo Strauss, "Marsilius of Padua," in Leo Strauss and Joseph Cropsey, eds., *History of Political Philosophy*, 3d ed. (Chicago: University of Chicago Press, 1987), pp. 276–94.

15. The assertions in this paragraph are developed in my *In This Most Perfect Paradise* (University Park: Pennsylvania State University Press, 1974).

16. See the important interpretation of the city as the setting for the ethical life in Norris Kelly Smith, *Here I Stand: Perspective from Another Point of View* (New York: Columbia University Press, 1994).

17. The role played by the French during this period in developing the formal potential of architecture and its relationship to authority has been perceptively discussed by John Hancock, "Who Put the 'ism' in Classicism? A Theory of Authority," in *The Classicist: Annual of the Institute for the Study of Classical Architecture* 1 (New York, 1994–95): 12–19. Hancock argues that once that authority collapsed, classicism could achieve the freedom that would allow it to thrive by linking itself with what became the modernist doctrines of recent years and produce the provocative extensions of classicism found in the best works of Louis I. Kahn. Hancock's point is well argued but fundamentally at odds with the one presented here. Important in this context is the development of ideas that reject architecture as an embodiment of beauty. See, for example, Wolfgang Herrmann, *The Theory of Claude Perrault* (London: Zwimmer, 1973); and Alberto Pérez-Gómez, *Architecture and the Crisis of Modern Science* (Cambridge: MIT Press, 1983), and "Introduction," in Claude Perrault, *Ordonnance for the Five Kinds of Columns after the Method of the Ancients*, trans. Indra Kagis McEwen (Santa Monica: Getty Center for the History of Art and the Humanities, 1993), pp. 1–44.

18. This point is developed in Allan Greenberg, "The Architecture of Democracy," in Andreas Papadakis and Harriet Watson, eds., *New Classicism: Omnibus Volume* (London: Academy Editions, 1990), pp. 68–72. For more on the material in this paragraph, see

C. W. Westfall, "The True American City," in *The New City: The American City* (Miami: University of Miami School of Architecture, 1993–94), 2: 8–25.

19. See Aristotle, *Politics*, 1281a48–1281b10.

20. This topic is seldom central to discussions of urban development in this period. For example, it is not mentioned by any of the fourteen contributors to the section on the period 1870 to 1918 in the publication sponsored by the Aspen Institute, Joseph Paul Kleihues and Christina Rathgeber, eds., *Berlin and New York: Like and Unlike* (New York: Rizzoli, 1993). For a few suggestive remarks but not concerning Berlin, see Donald J. Olsen, *The City as a Work of Art: London, Paris, Vienna* (New Haven: Yale University Press, 1986), chap. 17, tellingly titled "Architecture as Language: Representation and Instruction." The political content of German architecture does loom large in discussions of the next years; see the work of Barbara Miller Lane, cited below.

21. Anyone who doubts the centrality of this idea in the origins of the current modernism need only consult the material from that period in Ulrich Conrads, *Programs and Manifestoes on Twentieth-Century Architecture*, trans. Michael Bulloch (Cambridge: MIT Press, 1970).

22. For the broader program and practice of architecture by the National Socialists, see Barbara Miller Lane, *Architecture and Politics in Germany, 1918–1945* (Cambridge: Harvard University Press, 1968); Robert R. Taylor, *The Word in Stone: The Role of Architecture in the National Socialist Ideology* (Berkeley: University of California Press, 1974); Robert Jan van Pelt in van Pelt and C. W. Westfall, *Architectural Principles in the Age of Historicism*, pt. III; and, most important, Leon Krier, "An Architecture of Desire," in *Albert Speer: Architecture, 1932–42*, ed. Leon Krier (Brussels: Archives d'architecture moderne, 1985), pp. 222–23, as well as an abridged version in *Architectural Design* 56 (1986): 31–36. Krier does not make the distinction between modern classicism and neoclassicism presented below; one is not needed for his argument.

23. See Debórah Dwork and Robert Jan van Pelt, *Auschwitz: 1270 to the Present* (New York: Norton, 1996), passim.

24. A comprehensive study of Washington's urban history has yet to be written; for a useful outline, see John Reps, *Monumental Washington* (Princeton: Princeton University Press, 1967).

25. The most provocative revision, presented as a positive polemic intended to guide the development over the next century, just as the McMillan proposals have guided thought during this century, is Leon Krier, *Completion of Washington, D.C.*, trans. M. Lucic Jakovljevic (Brussels: Archives d'architecture moderne, 1986), pp. 7–43.

26. This point is most forcefully made in Roger Scruton, "Architectural Principles in an Age of Nihilism," and especially "Art History and Aesthetic Judgment," as well as in other essays republished in *The Classical Vernacular: Architectural Principles in an Age of Nihilism* (Manchester: Carcanet, 1994).

The Old, Weird America

1. Mark Merlis, *American Studies* (New York: Houghton Mifflin, 1994), pp. 244–45. My thanks to Paul Cantor for information on F. O. Matthiessen.

2. Harry Smith, editor and annotator, *Anthology of American Folk Music* (Folkways Records, 1952); rereleased on CD by Smithsonian Folkways Records, 1997. The *Anthology* was originally issued in three hinged sets of two LPs each; these sets were replaced by boxes, again each with two LPs. The cover art was affixed as a sticker, in tones of blue (air), red (fire), and green (water). A fourth volume, for earth (brown), and covering music of the post-1932 Depression period — Smith was fascinated with the plethora of brother acts and of songs referring to food in their titles — was planned but never issued. Pictured in the cover design was a "Theodore DeBry drawing out of" Robert Fludd, the seventeenth-century English physician and theosophist: a godlike hand "tuning the Celestial Monochord," framed by balanced spheres of energy or force-fields (John Cohen, "A Rare Interview with Harry Smith," *Sing Out!* 19 [1969]: 9). In the early 1960s, *Sing Out!*'s Irwin Silber took over the marketing of Folkways Records and replaced Smith's chosen art with a Ben Shahn Farm Security Administration photograph of a battered, starving farmer, effectively transforming a mystical statement into protest art. In the context of the time, when folk music was linked to protest, specifically to the civil rights movement and the "national shame" of Appalachian poverty, and poverty itself understood as ennobling, and the poor themselves often perceived as art statements, it was a smart commercial move.

3. Bruce Conner, conversation with the author, San Francisco, May 25, 1995.

4. Norman Mailer, "The White Negro," in *Advertisements for Myself* (1959; Cambridge: Harvard University Press, 1992), p. 339.

5. Quoted in P. Adams Sitney, "Harry Smith Interview," *Film Culture* 37 (Summer 1965).

6. Richard Cándida Smith, *Utopia and Dissent: Art, Poetry, and Politics in California* (Berkeley: University of California Press, 1995), p. 141.

7. Smith, *Anthology*, notes to introduction. In *Stars of Country Music*, ed. Bill C. Malone and Judith McCulloh (Urbana: University of Illinois Press, 1975), Norm Cohen notes that record sales fell during the Depression: "by 1933, to 7 percent of what they had been in 1929." Sales revived in the mid-1930s, partly because of the introduction of 78s selling for 25 cents and 35 cents, and, in fields of vernacular music, the replacement, in the main, of itinerant or community-based musicians by full-time professionals. "The music of the 1920s had been left behind," Cohen says; the commonplace banjo, with its limited vocabulary, was replaced by the guitar, which allowed for greater virtuosity and, in the more competitive milieu of professional recording, led to a demand for it; "the proportion of older folk material was considerably reduced" (pp. 9–10).

8. Robert Cantwell, "Smith's Memory Theater: *The Folkways Anthology of American Folk Music*," *New England Review* 13 (1991): 388.

9. Nora Ephron and Susan Edmiston, "Bob Dylan Interview," in Craig McGregor, ed., *Bob Dylan: A Retrospective* (New York: Morrow, 1972), p. 85.

10. Nat Hentoff, "The Playboy Interview," in McGregor, *Dylan*, p. 130.

11. In the video *Legends of Old Time Music* (Vestapol/Rounder, 1995), in a performance filmed around 1963 by George Pickow in Morgan County, Kentucky, Ashley, interviewed by folklorist D. K. Wilgus, describes "The Coo Coo Bird" as a "lassy-makin' song," the kind of song you sing when you're making molasses. With pugnacious amuse-

ment, or even defiance, he also describes the New York session where he first recorded the song:

WILGUS: When you were making records, how much did the people who were making the records know about this kind of music?

ASHLEY: How much did they know about it?

WILGUS: That's right.

ASHLEY, grinning: Not anything.

WILGUS: Well, how did they know what to record?

ASHLEY: Well, they was just looking for something and hoping they'd find it. In other words, they wasn't musicians; they didn't have the talent, and they didn't have the feeling—and they wouldn't know whether you was in tune or whether you was out of tune.

In Lee Smith's novel *The Devil's Dream* (New York: Putnam, 1992), "The Cuckoo" is, along with "Black Jack Davy," a leitmotif throughout eight generations of an Appalachian Virginia family, from the 1830s into the present, appearing everywhere, an ordinary song that is always a portent.

12. Peter van der Merwe, *Origins of the Popular Style: The Antecedents of Popular Music* (Oxford: Oxford University Press, 1989), p. 45.

13. Smith, *Anthology*, notes to selections no. 7, Buell Kazee, "The Wagoners Lad (Loving Nancy)," and no. 57, Ashley, "The Coo Coo Bird."

14. Oliver Wendell Holmes, *The Poet at the Breakfast Table* (1872), quoted from the *Oxford English Dictionary* 2:1236.

Democracy, Reality, and the Media: Educating the Übermensch

1. In Walter Benjamin, *Schriften* (Frankfurt: Suhrkamp, 1955).

2. The theme is discussed repeatedly by Heidegger in almost all his later works (after the "turn" of the 1930s). See especially the two volumes on *Nietzsche* (Neske: Pfullingen, 1961).

3. "Die Zeit des Weltbildes," in *Holzwege* (Frankfurt: Klostermann, 1950).

4. I refer especially to an interview given to an Italian magazine and published separately in a book by Karl Popper and John Condry, *Cattiva maestra televisione* (Rome: Reset, 1994).

5. See Paul Ricoeur, *Le conflit des interprétations* (Paris: Seuil, 1969).

6. See "Science as Vocation," in Hans Gerth and C. Wright Mills, eds., *From Max Weber* (Oxford: Oxford University Press, 1948), p. 147.

7. The doctrine of the *Übermensch* was developed by Nietzsche in the late period of his thought, starting with *Also sprach Zarathustra*. My discussion in the following pages will refer mainly to this book, to *Der Antichrist*, and to *Ecce Homo*. I quote from Friedrich Nietzsche, *Werke in drei Bänden*, 6th ed., ed. K. Schlechta (Munich: Hanser, 1969).

8. See, for instance, *Ecce Homo*, "Warum ich so gute Bücher schreibe," sec. 1, 2:110; *Ecce Homo*, "Also sprach Zarathustra," sec. 7, 2:1137; *Der Antichrist*, sec. 4, 2:1166. See also a note from "Nachlass der achtziger Jahre," 3:628.

9. See Richard Rorty, *Contingency, Irony, and Solidarity* (Cambridge: Cambridge University Press, 1989), chap. 5.

10. See Karl Mannheim, *Ideology and Utopia* (1929; New York: Harcourt, Brace 1953).

11. See Martin Heidegger, "Über den Humanismus" (1946), in *Wegmarken* (Frankfurt: Klosterman, 1976).

12. See Heidegger, "Über den Humanismus."

13. See Heidegger, *Identität und Differenz* (Neske: Pfullingen, 1957), pp. 25–27.

14. See, for instance, all the last sections of the first book of *Menschliches Allzumensch-liches, Erster Band*, in *Werke* 1:465–71.

15. I am referring to the interpretations of the story of Abraham given by Søren Kierkegaard in *Frygt og haeven* (1843).

16. Published after Heidegger's death in *Der Spiegel*, May 31, 1976.

17. See G. Vattimo and P. A. Rovatti, eds., *Il pensiero debole* (1983), 10th ed. (Milano: Feltrinelli, 1995). See also, more recently, G. Vattimo, *Beyond Interpretation* (Stanford: Stanford University Press, 1997).

18. On this point, see the very interesting book by Colin Campbell, *The Romantic Ethic and the Spirit of Modern Consumerism* (Oxford: Blackwell, 1987).

19. This is a favorite term of Carl Schmitt. See, for instance, "Das Zeitalter der Neu-tralisierungen und der Entpolitisierungen" (1929), in *Der Begriff des Politischen* (Berlin: Düncker und Humblot, 1963).

20. See Hans Blumenberg, *Die Legitimät der Neuzeit* (Frankfurt: Suhrkamp Verlag 1963), and the review of this book by Karl Löwith, "Besprechung des Buches Die Legi-mität der Neuzeit," in *Philosophische Rundschau* 15 (1968): 195–201 (reprinted in Karl Löwith, *Sämtliche Schriften*, vol. 2 [Stuttgart: Metzler, 1983], pp. 452–59).

21. On the meaning of this term in Heidegger's thought, see, for instance, "Überwin-dung der Metaphysik," in *Vorträge und Aufsätze* (Neske: Pfullingen,1954).

22. See *Die Fröhliche Wissenschaft*, sec. 356, 2:225.

Tubular Nonsense: How Not to Criticize Television

1. W. Russell Neuman, *The Future of the Mass Audience* (New York: Cambridge University Press, 1991), p. 37.

2. Robert Hughes, "Why Watch It, Anyway?" *New York Review of Books*, February 16, 1995, p. 37.

3. See Benjamin J. Barber, *Strong Democracy: Participation Politics for a New Age* (Berkeley: University of California Press, 1984); and Robert G. Meadow, *New Communications Technologies in Politics* (Washington, D.C.: Washington Program of the Annenberg School of Communication, 1985).

4. Three variations on pessimism can be found in Jerry Mander, *Four Arguments for the Elimination of Television* (New York: Morrow, 1978); Neil Postman, *Amusing Ourselves to Death* (New York: Viking, 1985); and Marie Winn, *The Plug-in Drug* (New York: Viking, 1977).

5. In its most sophisticated form, this basic Marxist perception is articulated in Theodor W. Adorno, "Television and the Patterns of Mass Culture," in Bernard Rosenberg and David Manning White, eds., *Mass Culture: The Popular Arts in America* (New York: Free Press, 1957).

6. The classic texts include Hans Magnus Enzensberger, *The Consciousness Industry*

(New York: Seabury Press, 1974), and Jürgen Habermas, *The Theory of Communicative Action*, 2 vols. (Boston: Beacon Press, 1981), and *The Structural Transformation of the Public Sphere* (Cambridge: MIT Press, 1989). See also the various writers in Donald Lazere, ed., *American Media and Mass Culture: Left Perspectives* (Berkeley: University of California Press, 1987).

7. Vannevar Bush, "As We May Think," *Atlantic Monthly*, July 1945, pp. 101–8.

8. Neuman, *Future of the Mass Audience*, p. 37.

9. This perspective is developed in several classic works, including Hannah Arendt, *The Origins of Totalitarianism* (New York: Harcourt Brace, 1951); Erich Fromm, *Escape from Freedom* (New York: Farrar & Rinehart, 1941); William Kornhauser, *The Politics of Mass Society* (New York: Free Press, 1959); David Riesman, *The Lonely Crowd* (Garden City, N.Y.: Doubleday, 1953); and, more recently, Jacques Ellul, *The Technological Society* (New York: Random House, 1964), and *Propaganda: The Formation of Men's Attitudes* (New York: Random House, 1965).

10. See Ithiel de Sola Pool, "The Mass Media and Politics in the Modernization Process," in Lucian W. Pye, ed., *Communications and Political Development* (Princeton: Princeton University Press, 1963).

11. Neuman, *Future of the Mass Audience*, chap. 5.

12. Ibid., chap. 3.

13. Ibid., p. 166.

14. Neil Postman, *Technopoly: The Surrender of Culture to Technology* (New York: Knopf, 1992).

15. Brandon S. Centerwall, "Television and Violent Crime," *Public Interest* 111 (Spring 1993): 56–71.

16. For reservations expressed by social scientists themselves, see Edward Donnerstein, Daniel Linz, and Steven Penrod, *The Question of Pornography: Research Findings and Policy Implications* (New York: Free Press, 1987), chap. 1; Donald Alexander Downs, *The New Politics of Pornography* (Chicago: University of Chicago Press, 1989), pp. 23–24, 169–75; and James Q. Wilson, "Violence, Pornography, and Social Science," *Public Interest* 22 (Winter 1971), pp. 45–61.

17. A case in point is the media activism of Tipper Gore. In the 1970s, as a member of Action for Children's Television, she used social-scientific data to persuade the FCC to impose quite heavy regulation on children's television. In the 1980s, as a founding member of the Parents Music Resource Center, Gore made similar use of the data to convince mainstream allies (such as the National PTA) that the graphic sex and violence in some rock music was harmful to young people. Of course, in the antigulatory environment of the Reagan administration, Gore chose to focus her demands on the record industry, rather than on the FCC.

18. For a cogent summary of the activist position, see Sissela Bok, "TV Violence, Children, and the Press: Eight Rationales Inhibiting Public Policy Debates," Discussion Paper D-16 (Cambridge: Joan Shorenstein Barone Center, John F. Kennedy School of Government, Harvard University, April 1994).

19. Anthony Smith, "The Influence of Television," *Daedalus* 114:4 (Fall 1985): 12–13.

20. Paul Connerton, "Introduction," in Paul Connerton, ed., *Critical Sociology* (New York: Penguin Books, 1976), pp. 24–25.

21. See Andrew Arato and Eike Gebhardt, eds., *The Essential Frankfurt School Reader* (New York: Continuum, 1990); and Martin Jay, *The Dialectical Imagination* (Boston: Little, Brown, 1973).

22. Theodor W. Adorno, "On the Fetish-Character in Music and the Regression of Hearing" and "Commitment," in Arato and Gebhardt, eds., *The Essential Frankfurt School Reader*.

23. For an excellent discussion of this neglected insight, see S. Frederick Starr, *Red and Hot: The Fate of Jazz in the Soviet Union* (New York: Limelight, 1985).

24. Hans Magnus Enzensberger, "Constituents of a Theory of the Media," in John Hanhardt, ed., *Video Culture: A Critical Investigation* (Rochester, N.Y.: Visual Studies Workshop Press, 1986), p. 113.

25. Martin Jay, *The Dialectical Imagination* (Boston: Little, Brown, 1973), p. 198.

26. Walter Benjamin, "The Work of Art in the Age of Mechanical Reproduction," in Hanhardt, ed., *Video Culture: A Critical Investigation*, p. 30.

27. Ibid., pp. 32–33.

28. Ibid., p. 33.

29. Ibid., pp. 43–47.

30. See Jean Baudrillard, *Simulations* (New York: Semiotext(e), 1983), and Fredric Jameson, "Postmodernism, or the Cultural Logic of Late Capitalism," *New Left Review* 146 (1984).

31. Marilyn Stokstad, *Art History* (New York: Abrams, 1995), chap. 1.

32. Hans Magnus Enzensberger, "Constituents of a Theory of the Media," in Hanhardt, *Video Culture*, p. 104.

33. Fredric Jameson, quoted in John Storey, *Cultural Theory and Popular Culture* (Athens: University of Georgia Press, 1993), p. 169.

34. Hans Magnus Enzensberger, "Constituents of a Theory of the Media," in Hanhardt, *Video Culture*, pp. 115–16.

Waiting for Godot *and the End of History:*
Postmodernism as a Democratic Aesthetic

1. Among the more useful and influential discussions of postmodernism are David Harvey, *The Condition of Postmodernity: An Enquiry into the Origins of Cultural Change* (Oxford: Basil Blackwell, 1980); Linda Hutcheon, *A Poetics of Postmodernism: History, Theory, Fiction* (London: Routledge, 1988); and Fredric Jameson, *Postmodernism, or, The Cultural Logic of Late Capitalism* (Durham, N.C.: Duke University Press, 1991). For a good collection of essays about postmodernism, see Thomas Docherty, ed., *Postmodernism: A Reader* (New York: Columbia University Press, 1993).

2. On the relation of the two terms, see Kwame Anthony Appiah, "The Postcolonial and the Postmodern," *In My Father's House: Africa in the Philosophy of Culture* (New York: Oxford University Press, 1992), pp. 137–57. See also my essay, "Happy Days in the Veld: Beckett and Coetzee's *In the Heart of the Country*," *South Atlantic Quarterly* 93 (1994): 83–110; and Mark Edmundson, "Prophet of a New Postmodernism: The Greater Challenge of Salman Rushdie," *Harper's Magazine*, December 1989, pp. 62–71.

3. For a brief overview of Beckett in relation to various concepts of postmodernism,

see Nicholas Zurbrugg, "Seven Types of Postmodernity: Several Types of Samuel Beckett," in *The World of Samuel Beckett*, ed. Joseph H. Smith (Baltimore: Johns Hopkins University Press, 1991), pp. 30–52.

4. See Jameson, *Postmodernism*, p. 2. Docherty has collected some of the seminal texts that define postmodern architecture; see *Postmodernism: A Reader*, pp. 265–315, especially the excerpts from Charles Jencks's *Postmodernism*, which give a succinct and lucid statement of the principles behind postmodern architecture. For a fuller elaboration, with a wealth of illustrations, see Charles Jencks, *The Language of Post-Modern Architecture*, 5th ed. (New York: Rizzoli, 1987).

5. For the *locus classicus* of the modernist attack on architectural ornament, see the manifesto by the Austrian architect Adolf Loos, "Ornament and Crime," in *Programs and Manifestoes on 20th-Century Architecture*, ed. Ulrich Conrads (Cambridge: MIT Press, 1971), pp. 19–24.

6. Obviously, I have in mind Philip C. Johnson's AT & T Building in Manhattan, perhaps the single most famous work of postmodern architecture. See Jencks, *Language of Post-Modern Architecture*, p. 131.

7. On this subject, see Jameson, *Postmodernism*, pp. 16–19.

8. I use *historicism* in the philosophical sense of the doctrine that all human thought and culture are historically determined. I am aware that *historicism* is also the name of a specific movement in architecture, which can be viewed as either a species or a forerunner of postmodernism. See Jencks, *Language of Post-Modern Architecture*, pp. 81–90.

9. For reflections on the effect of modern technology on music in the twentieth century, see Leonard B. Meyer, *Music, The Arts, and Ideas: Patterns and Predictions in Twentieth-Century Culture* (Chicago: University of Chicago Press, 1994).

10. See Walter Benjamin, "The Work of Art in the Age of Mechanical Reproduction," in *Illuminations*, trans. Harry Zohn (New York: Schocken, 1969), pp. 217–51.

11. See Walter Jackson Bate, *The Burden of the Past and the English Poet* (Cambridge: Harvard University Press, 1970); and Harold Bloom, *The Anxiety of Influence: A Theory of Poetry* (New York: Oxford University Press, 1973).

12. On this issue, see Matei Calinescu, *Five Faces of Modernity* (Durham, N.C.: Duke University Press, 1987), especially pp. 265–312.

13. In Peter Bürger's attempt to articulate the principles behind various twentieth-century avant-garde movements such as Dada and Surrealism, he makes them sound like forms of postmodernism: "The availability of and mastery over artistic techniques of past epochs (like the old-masterly technique in certain paintings of Magritte, for example) owed to the avant-garde movements make it virtually impossible to determine a historical level of artistic procedures. Through the avant-garde movements, the historical succession of techniques and styles has been transformed into a simultaneity of the radically disparate. The consequence is that no movement in the arts today can legitimately claim to be historically more advanced *as art* than any other." See Peter Bürger, *Theory of the Avant-Garde*, trans. Michael Shaw (Minneapolis: University of Minnesota Press, 1984), p. 63.

14. Though the truth of modern architecture appears to be positive and not nihilistic, in fact it rejects all previous centuries of achievement in its field and displays a negative at-

titude toward artistic convention itself. Modernism exposes the illusory foundation of all previous architecture, and indeed claims to reject all conventionality in building in the name of the new principle of pure functionality. See Massimo Cacciari, *Architecture and Nihilism: On the Philosophy of Modern Architecture*, trans. Stephen Sartarelli (New Haven: Yale University Press, 1993). Cacciari deals chiefly with Adolf Loos, who, he points out (p. 111), was pleased that one of his buildings came to be known as "Café Nihilismus."

15. Quoted from the edition of Richard J. Finneran, *W. B. Yeats: The Poems* (New York: Macmillan, 1989), p. 289.

16. Jameson similarly formulates the difference between modernism and postmodernism; in his view (*Postmodernism*, pp. 310–11, 366), modernism is the artform of the period when the world was still modernizing (that is, still encountering resistance from tradition); postmodernism is the art form of the period after modernization has been completed and the principles of modernism have thoroughly triumphed.

17. For his interpretation of Hegel, see Alexandre Kojève, *Introduction to the Reading of Hegel*, trans. James H. Nichols, Jr. (New York: Basic Books, 1969).

18. Thus, for the purposes of my analysis, I do not have to go into such complicated questions as whether Hegel's view of the end of history changed in the course of his career or whether he retained some notion of ranks in society in his mature thought. Though important and fascinating in themselves, these questions are not relevant to my analysis of postmodernism and *Waiting for Godot*.

19. For example, we do know that Beckett had contact with Raymond Queneau, who both edited and published Kojève's lectures on Hegel. See Deirdre Bair, *Samuel Beckett: A Biography* (New York: Harcourt Brace Jovanovich, 1978), p. 287.

20. Analyzing *Waiting for Godot* in terms of Hegel's idea of the dialectic of the master and the slave has become common. See Michael Robinson, *The Long Sonata of the Dead: A Study of Samuel Beckett* (New York: Grove Press, 1969), pp. 253–56; David H. Hesla, *The Shape of Chaos: An Interpretation of the Art of Samuel Beckett* (Minneapolis: University of Minnesota Press, 1971), pp. 193–200; Lance St. John Butler, *Samuel Beckett and the Meaning of Being: A Study in Ontological Parable* (New York: St. Martin's, 1984), pp. 142–48; and Michael Worton, "*Waiting for Godot* and *Endgame*: Theatre as Text," in *The Cambridge Companion to Beckett*, ed. John Pilling (Cambridge, U.K.: Cambridge University Press, 1994), p. 71. Of these, Robinson's analysis is the most thorough and the most illuminating, but none of them mentions Kojève or connects the master/slave dialectic to the end of history. They all, however, reinforce the importance of the idea of the master/slave dialectic in Beckett by showing how it is also at work in *Endgame* in the relationship of Hamm and Clov. Several of these critics suggest with some plausibility that Sartre may have been the link between Hegel and Beckett. See Jean-Paul Sartre, *Being and Nothingness*, trans. Hazel Barnes (New York: Philosophical Library, 1956), pp. 235–44, for an exposition of Hegel's master/slave dialectic. Hesla even suggests that *Being and Nothingness* may be Beckett's source for the name *Pozzo* (see Hesla, *Shape of Chaos*, p. 199; Sartre, *Being and Nothingness*, p. 162). But in the section on the master/slave dialectic in *Being and Nothingness*, Sartre does not link the idea to the end of history. Still, given the personal connection between Beckett and Sartre (see Bair, *Samuel Beckett*, pp. 352–53), Sartre might have served as a means for Beckett to learn more fully about Kojève's ideas; Sartre attended

Kojève's famous Paris lectures on Hegel at the École des Hautes Études. For a thorough discussion of the relation of Sartre to Kojève and, more generally, of the influence of Kojève's Hegel studies on modern French intellectual history, see Vincent Descombes, *Modern French Philosophy*, trans. L. Scott-Fox and J. M. Harding (Cambridge, U.K.: Cambridge University Press, 1980), pp. 9–54. Descombes writes (p. 158): "Since Kojève, the *Master-Slave relationship* has been a constant in French thought." A good example of this development is the chapter "The Deicides" in Albert Camus, *L'Homme révolté* (1951), which contains an excellent exposition of Hegel's view of the master and the slave, including explicit mention of Kojève and the idea of the end of history. See Albert Camus, *The Rebel*, trans. Anthony Bower (New York: Vintage Books, 1956), pp. 133–48, especially pp. 142–43, for the references to Kojève. For the record, one book with a promising title for my subject, Hans-Joachim Schulz's *'This Hell of Stories': A Hegelian Approach to the Novels of Samuel Beckett* (The Hague: Mouton, 1973), does not deal either with the master/slave dialectic or with *Waiting for Godot*.

21. All quotations from *Waiting for Godot* are from the 1954 Grove Press edition. For reasons of brevity, I have in all cases omitted the stage directions.

22. See Robinson, *Long Sonata*, pp. 254–55: Pozzo "is capable of enjoying sensual delights and depends upon a collection of cherished possessions (his Kapp and Peterson, vaporizer and watch). Pozzo recalls the feudal lord of the manor, self-consciously magnanimous in his disposal of time and charity. . . . It is Lucky who, like Hegel's slave, has transformed the world for his master and given Pozzo what intelligence and culture he now possesses."

23. In this reference to Genesis, Beckett subtly confirms Hegel's point about the role of biblical religion in helping to undermine aristocratic ideology. The traditional aristocratic view of humanity is well represented in the *Iliad*, in which Homer portrays two orders of human beings, the heroes (*andres*) and the ordinary men (*anthropoi*), almost as if they were different species. Pozzo has been forced to abandon this aristocratic understanding because he accepts the Bible's view that all men are created in the image of God. On this point in Homer, see Seth Benardete, "Achilles and the Iliad," *Hermes* 91 (1963): 1–5.

24. Alexis de Tocqueville, *Democracy in America*, trans. Henry Reeve and Frances Bowen (New York: Vintage, 1959), 2: 11.

25. In the old aristocratic world, the slave was bound to his master, a point made literal in the play by the rope that ties Lucky to Pozzo. But notice that even Pozzo has come to accept the democratic ideology of rights, as he shows in his response to Estragon's challenge to his treatment of Lucky: "Why he doesn't make himself comfortable? Let's try and get this clear. Has he not the right to? Certainly he has. It follows that he doesn't want to" (21).

26. For other moments when the tramps imitate Pozzo and Lucky, see p. 26, where, according to the stage directions, Estragon imitates Lucky; p. 43, where Vladimir calls Estragon "pig"; p. 44, where Vladimir calls Estragon "hog"; p. 47, where Vladimir has Estragon order him: "Think, pig!"; and p. 57, where Vladimir mimics the fall of Pozzo and Lucky.

27. On the importance of ritual at the end of history, see Kojève's fascinating note on

his trip to Japan, in *Introduction to the Reading of Hegel*, pp. 161–62. This long note is Kojève's fullest attempt to characterize posthistorical existence; it is remarkable how this analysis anticipates the terms in which postmodernism was later to be defined. Reading this note, one realizes that Kojève's notion of the posthistorical is basically what contemporary theorists mean by the postmodern.

28. This consideration may explain why Beckett chose to subtitle *Waiting for Godot* "a tragicomedy in two acts." The play takes place in a world in which even the distinction between tragedy and comedy has been effaced.

29. This passage is from section 5 of the Prologue to Nietzsche's *Thus Spoke Zarathustra*, quoted in the translation of Walter Kaufmann, *The Portable Nietzsche* (New York: Viking Press, 1954), p. 130.

30. Accordingly, Francis Fukuyama entitled his Kojèvian book *The End of History and the Last Man* so as to include a Nietzschean critique of Hegel in his presentation. Nietzsche offers a serious philosophical challenge to Hegel and especially the leveling effect of his view of history. Nietzsche tried to restore a sense of an order of rank in society and, indeed, to reconstitute notions of mastery and slavery. But Nietzsche does not in this respect return to a pre-Hegelian position; he steadfastly refused to ground the order of rank on either a natural or a divine principle. Rather, the order of rank in Nietzsche rests solely on the principle of will, what he calls the will to power. In that sense, Nietzsche accepts the Enlightenment and its demythologizing of traditional aristocracy. In Nietzsche, the order of rank that used to be accepted unthinkingly must now become a product of conscious human will. One might say that the great magic trick of Nietzsche's philosophy is to reestablish the ancient principle of aristocracy on the basis of the modern democratic principle of will. Nietzsche's aristocracy has a subjective basis, not an objective one as in traditional thought. This consideration explains why it has been possible for the Left to appropriate the essentially right-wing doctrines of Nietzsche in our day.

31. See Jameson, *Postmodernism*, p. ix: "Postmodernism is what you have when the modernization process is complete and nature is gone for good."

32. Vladimir must search his mind to come up with "damned" as "the contrary of saved" (9). Consider also Vladimir's comment on p. 55: "Well just fancy that: I could have sworn it was just the opposite."

33. In what sounds like a parody of Beckett's own principle, Robinson (*Long Sonata*, p. 250) reports that "Beckett told Harold Hobson: 'One of Estragon's feet is blessed, and the other is damned.'"

34. On the connection between snobbery and posthistorical existence, see Kojève, *Introduction to the Reading of Hegel*, pp. 161–62, n. 6. For an insightful analysis of the connections among snobbery, democratic politics, and modern literature, see René Girard, *Deceit, Desire, and the Novel: Self and Other in Literary Structure*, trans. Yvonne Freccero (Baltimore: Johns Hopkins University Press, 1965), especially p. 70: "Snobbism begins with equality. . . . The snob bows before a noble title which has lost all real value. . . . The more arbitrary the imitation the more contemptible it seems. . . . All concrete difference has disappeared."

35. In this context it is interesting to note that *Waiting for Godot* presents an all-male world. Beckett thus avoids having to deal with the difference between men and women, a

difference that appears to be rooted in biological nature and that accordingly has provided a natural basis for dramatic conflict throughout the history of world literature.

36. See Kojève, *Introduction to the Reading of Hegel*, p. 159, n. 6.

37. Even Yeats seems to have grown disillusioned with his vision of a revived aristocracy toward the end of his life. His late works, like *The Death of Cuchulain*, "The Black Tower," or "Cuchulain Comforted," point in the direction of Beckett.

CONTRIBUTORS

MARTHA BAYLES has been television critic for the *Wall Street Journal* and literary editor of the *Wilson Quarterly*. She is the author of *Hole in Our Soul: The Loss of Beauty and Meaning in American Popular Music* (1994) and *Ain't That a Shame?: Censorship and the Culture of Transgression* (1996). She is currently the director of the Gould Seminar at Claremont McKenna College.

ROBERT BRUSTEIN is artistic director of the American Repertory Theatre Company, director of the Loeb Drama Center, and drama critic for the *New Republic*. His most recent books are *Who Needs Theatre: Dramatic Opinions* (1987), *Reimagining American Theatre* (1991), and *Dumbocracy in America: Studies in the Theatre of Guilt* (1994).

PAUL A. CANTOR is professor of English at the University of Virginia. He is the author of *Shakespeare's Rome: Republic and Empire* (1976), *Creature and Creator: Myth-Making and English Romanticism* (1984), *Shakespeare: Hamlet* (1989), and *"Macbeth" und die Evangelisierung von Schottland* (1993).

STANLEY CROUCH is a freelance critic whose work appears regularly in the *New York Daily News*, the *Los Angeles Times*, the *New Republic*, and the *New Yorker*. Since 1987, he has served as artistic consultant for jazz programming at the Lincoln Center for the Performing Arts. His most recent books are *Notes of a Hanging Judge* (1990) and *The All-American Skin Game, or, The Decoy of Race* (1995).

ARTHUR C. DANTO is Johnsonian Professor Emeritus of Philosophy at Columbia University and art critic for *The Nation*. His most recent books are *The Philosophical Disenfranchisement of Art* (1986), *Beyond the Brillo Box: The Visual Arts in Post-Historical Perspective* (1992), and *After the End of Art: Contemporary Art and the Pale of History* (1997).

ANNE HOLLANDER is an independent scholar and writer. She is the author of *Seeing through Clothes* (1978), *Moving Pictures* (1989), and *Sex and Suits* (1994).

GREIL MARCUS writes monthly columns for *ArtForum* and *Interview*. His most recent books are *Dead Elvis: A Chronicle of a Cultural Obsession* (1991), *Ranters and Crowd Pleasers: Punk in Popular Music* (1993), *The Dustbin of History* (1995), and *Invisible Republic: Bob Dylan's Basement Tapes* (1997).

ARTHUR M. MELZER is professor of political science at Michigan State University. He is the author of *The Natural Goodness of Man: On the System of*

Rousseau's Thought (1990). He is a director of the Symposium on Science, Reason, and Modern Democracy and an editor of its first three volumes of essays, *Technology in the Western Political Tradition* (1993), *History and the Idea of Progress* (1995), and *Multiculturalism and American Democracy* (1998).

JOHN ROCKWELL is editor of the Sunday Arts and Leisure section of the *New York Times*, where he has also served as classical music critic, chief rock critic, and European cultural correspondent. From 1994 to 1997, he was director of the Lincoln Center Festival at the Lincoln Center for the Performing Arts. He is the author of *All American Music: Composition in the Late Twentieth Century* (1983) and *Sinatra: An American Classic* (1984).

JOHN SIMON is drama critic for *New York Magazine* and film critic for *National Review*. He has published five volumes of film criticism, including *Reverse Angle: A Decade of American Films* (1982) and *Something to Declare: Twelve Years of Films from Abroad* (1983). He is also the author of *Paradigms Lost: Reflections on Literacy and Its Decline* (1980) and *Dumbing Down: Essays on the Strip Mining of American Culture* (1996).

GIANNI VATTIMO is professor of philosophy at the University of Turin. His books include *The End of Modernity: Nihilism and Hermeneutics in Postmodern Culture* (1988), *The Transparent Society* (1992), *The Adventure of Difference: Philosophy after Nietzsche and Heidegger* (1993), and *Beyond Interpretation: The Meaning of Hermeneutics for Philosophy* (1997).

JERRY WEINBERGER is professor of political science at Michigan State University. His books include *Science, Faith, and Politics: Francis Bacon and the Utopian Roots of the Modern Age* (1985) and a new edition and interpretation of Francis Bacon's *The History of the Reign of King Henry the Seventh* (1996). He is a director of the Symposium on Science, Reason, and Modern Democracy and an editor of its first three volumes of essays, *Technology in the Western Political Tradition* (1993), *History and the Idea of Progress* (1995), and *Multiculturalism and American Democracy* (1998).

CARROLL WILLIAM WESTFALL is chairman of the School of Architecture at the University of Notre Dame. His writings include *This Most Perfect Paradise: Alberti, Nicholas V, and the Invention of Conscious Urban Planning in Rome, 1447–1455* (1974) and (with Robert Jan van Pelt) *Architectural Principles in the Age of Historicism* (1994).

A. B. YEHOSHUA is professor of Hebrew and comparative literature at Haifa University. His most recent novels are *Five Seasons* (1989), *Mr. Mani* (1992), and *Open Heart* (1996). His short stories have been collected in *The Continuing Silence of a Poet* (1991). He has also published a study of Jewish-Arab relations, *Between Right and Right* (1981).

M. Richard Zinman is professor of political theory in James Madison College at Michigan State University. He is executive director of the Symposium on Science, Reason, and Modern Democracy and an editor of its first three volumes of essays, *Technology in the Western Political Tradition* (1993), *History and the Idea of Progress* (1995), and *Multiculturalism and American Democracy* (1998).

INDEX